LOOKING AT PHOTOGRAPHS

LOOKING AT PHOTOGRAPHS

100 Pictures from the Collection of
The Museum of Modern Art

BY JOHN SZARKOWSKI

Distributed by New York Graphic Society • Boston
THE MUSEUM OF MODERN ART • NEW YORK

Copyright © 1973 by The Museum of Modern Art
11 West 53 Street, New York, New York 10019
Library of Congress Catalog Card Number: 72-82885
ISBN: 0-87070-514-8 (clothbound)
ISBN: 0-87070-515-6 (paperbound)

Printed in the United States of America
by Rapoport Printing Corporation
Type set by Boro Typographers, Inc.
Bound by Sendor Bindery, Inc.
Designed by James Wageman

Third printing 1976

To David H. McAlpin,
good friend of photography and photographers,
first Trustee Chairman of the Museum's Department of Photography,
and a constant supporter of its purposes

CONTENTS

INTRODUCTION

This is a picture book, and its first purpose is to provide the material for simple delectation. Beyond this it hopes to show something of the character and intent of the Museum's photography Collections, and to suggest some of the ways in which the study of photography touches the broader issues of modern art and modern sensibility.

The book is not a history, although it involves historical concerns, nor does it attempt a systematic critical view. It is, more modestly, a visual interim report— though a highly foreshortened one—on the results of more than forty years of collecting photographs at The Museum of Modern Art.

The first and distinguishing function of an art museum is that of collecting and preserving works that are, in its judgment, particularly fine, or particularly instructive in reference to the evolution of art. If preserved, these works can be exhibited, reproduced, studied, interpreted, re-evaluated, enjoyed, and—perhaps most important—borrowed from, by younger artists.

Works that are worth collecting are often identified by a broad and time-honored consensus. Etchings, for example, have long been understood to be collectible art objects; Picasso the printmaker is thus the heir and beneficiary of Rembrandt, commercially as well as artistically. Photographs, on the other hand, although often admired, have seldom been seriously collected. As a result, the work of Alfred Stieglitz is less fully preserved, and less well-known, than that of Rembrandt, done three centuries earlier.

Since its invention, photography has been the world's ubiquitous picture-making system. It has in the process effected a profound transformation of our knowledge and opinions concerning the structure and meaning of visual experience. Nevertheless, the medium has received little serious study. The common-placeness of photography, and the radical differences between it and the tra-ditional arts, has made it a refractory problem for theorists, and one that has not submitted with grace to the traditional intellectual apparatus of art historical study. For an art museum, even today, to make a serious commitment to the art of photography requires some imagination, and the willingness to accept some intellectual risks. In 1929, when the acquisition of a painting by Cézanne was still considered adventurous, the proposition that photography deserved serious critical study would have been simply unintelligible to the leaders of most art museums.

Alfred H. Barr, Jr., who became the founding Director of The Museum of Modern Art in that year, believed that the visual arts were so intimately inter-dependent that one medium could not be properly studied in isolation. It was his conception that a genuinely modern museum must pay serious attention to architecture, film, industrial design, and photography, as well as to painting,

sculpture, drawing, and traditional prints. He is reported to have once said that his chief interest was in contemporary things before they became respectable. As a matter of record, the twenty-third work to enter the Museum Collection, in April, 1930, was a photograph. Lehmbruck: Head of a Man, *by Walker Evans.*

In 1937 the Museum opened the historic survey exhibition Photography 1839–1937, *directed by Beaumont Newhall. The exhibition provided the foundation on which Newhall's seminal* History of Photography *was based; it also marked the effective beginning of a systematic and coherent commitment to photography by the Museum. The Department of Photography was officially established as an independent curatorial function in 1940. Following Beaumont Newhall, those staff members who have directed the Museum's photography program have been Nancy Newhall, Willard Morgan, Edward Steichen, and the writer.*

The one hundred photographs reproduced in this book represent less than one per cent of the Museum's photographic holdings. This selection is thus a small sample of a tiny part of photography's achievement. In considering what the character of this sample should be, I had first to answer this question: Should it concentrate on the medium's heroic figures, representing each by a selection of works that would suggest in rough outline the scope of his unique contribution, or should the selection be broadly inclusive, and attempt to describe photography from a somewhat more liberal and exploratory perspective? I have elected to attempt the latter. The Museum's photography Collection has not been conceived as an enclave of immutable masterpieces, but rather as a tool that might contribute to a fuller understanding of the medium's achievements and potentials. Photography has learned about its own nature not only from its great masters, but also from the simple and radical works of photographers of modest aspiration and small renown. These photographers have contributed not only out of their talent, but by virtue of their numbers, their industry, and their occasional good luck. Their work also deserves, and repays, study.

It was therefore decided that no photographer be represented here by more than one work, regardless of the importance of his contribution, or the richness of the Museum's holding of his work.

It might be added that it is somehow unsatisfactory to sum up in half a dozen prints the meaning of the life's work of an Atget or a Stieglitz or a Weston. Although such a selection might represent the basic visual ideas that were explored throughout a lifetime, the process of abstracting to so economical a core seems inimical to the spirit of photography, which is generous and fecund, and which delights in the inexhaustibly various guises in which a single idea will reveal itself. To properly sketch out the work of one of photography's greatest figures requires not six or ten pictures, but a hundred.

Any student of the subject will have his own considerable list of distinguished photographers whose work is not included here. Where these men and women are represented in the Collection, they have been omitted with genuine regret. The

nineteenth-century portion of the Collection, especially, has been most brutally abridged. The possibility of excluding entirely work before 1900 was considered, and rejected. The focus of the Museum's concern is of course on the art of the twentieth century; in photography, however, no arbitrary date can be set to represent the beginning of a modern era. On the contrary, many of the most innovative workers of the past generation have found inspiration and precedent by leap-frogging backwards, beyond the time of their immediate predecessors, to a more distant photographic past. As a rule, photography has not developed in a disciplined and linear manner, but has rather grown like an untended garden, making full use of the principles of random selection, laissez-faire, participatory democracy, and ignorance. Thus, several generations of photographic thought have existed simultaneously, with little real knowledge of each other. (It is not unlikely that Jacques Lartigue, in his early teens, and Eugène Atget, in his fifties, saw each other photographing in the Bois de Boulogne, in the years before the First World War.)

Unrepresented here are those photographers whose most important work has been in color—a complex and largely distinct issue that requires and deserves separate consideration. Recent scientifically oriented photography was for similar reasons finally and regretfully passed over. For the author, the most painful omissions were of those splendid pictures that were left out because it was necessary to move on to a new decade, and to a different genus and species.

Finally, it must be assumed that some unforgivable omissions are invisible to me, and are the result not of a conscious ordering of priorities, but of ignorance. Although the Museum has always sought to maintain an international perspective, it is true that the Department of Photography, at least, knows the work of the United States much better than that of the rest of the world. This is due in part to the fact that few foreign museums have systematically collected, studied, exhibited, and published the photography of their own countries. Happily, this situation has recently shown some signs of changing. In this context one might speculate that the vitality of American photography in recent decades, like that of American painting, has been in some measure caused by the availability, through seriously considered exhibitions and publications, of the decisive work of a living tradition.

It would require pages merely to list the names of all those who have contributed significantly to the growth of the Museum's photography Collection, and those who have helped would surely prefer that those pages be reserved for pictures. Acknowledgment must be, for the most part, generic. First I would like to thank the photographers themselves, who have recognized the seriousness of the Museum's commitment to their medium, and have responded as collaborators in a common cause. This cooperation has often included the gift of prints, on those frequent occasions when the Department's appetite has been larger than

its pocketbook, but perhaps even more important has been the willingness of serious photographers to keep the Department abreast of their work, generally with little prospect of material advantage.

The counsel and support of the Department's Trustee Committee have been no less vital. The Committee has with conviction and constancy represented the claims of the photography program to the Museum Board, and to the larger outside world. Its Chairmen of many years, David H. McAlpin, James Thrall Soby, and Henry Allen Moe, deserve especially grateful thanks. Many members of the Committee have in addition made generous contributions to the Collection, both in the form of prints from their own collections, and through purchase funds for new acquisitions. Many other donors, only a few of whose names are acknowledged in the credit lines of the pictures reproduced here, have contributed to making the Museum's photography Collection the irreplaceable cultural resource that it has, print by print, become.

Finally, acknowledgment must be made of the contribution of the many staff members of the Department during the past generation, whose ideas have helped shape the Collection, and whose day to day work has preserved it and made it available to a broad audience. I am confident that each of these has considered himself enriched and rewarded by intimate contact with what is surely one of the richest and most puzzling of all the arts.

Collectors of Roman coins or Impressionist paintings know the satisfaction and the despair that come with the realization that their tasks might, at least in theory, be finally completed, with each crucial specimen of a finished series nestled securely in its round niche of plush, or hung on its own proper and permanent wall. The collecting of photographs is a different and riskier sort of search, filled with mysteries and contradictions and unexpected adventures. Even photography's eternal verities are provisional, and its future is as unpredictable as that of any other living species. Nineteenth-century masters are still being discovered—artists of exceptional talent who are destined to remain as faceless as the Master of the Amsterdam Cabinet. Meanwhile young photographers dispute fiercely the direction of their art's future, offering their best works as evidence of the correctness of their own intuitive understandings of its past.

It can be said with certainty only that photography has remained for a century and a quarter one of the most radical, instructive, disruptive, influential, problematic, and astonishing phenomena of the modern epoch. It has in addition been the chosen vehicle of major artists as divergent in their perspectives as Alfred Stieglitz and Eugène Atget.

The future of this beautiful, universally practiced, little-known art will be determined by young and unborn photographers, who will decide how best to build on their rich and ambiguous tradition. A small part of that tradition is reproduced on the following pages.

LOOKING AT PHOTOGRAPHS

WILLIAM SHEW
American [?], active 1840–1903

[Mother and Daughter] 1845–1850
Daguerreotype, sixth-plate, 3⅛ x 2⅝
Gift of Ludwig Glaeser

When Daguerre announced his great invention to the public in the summer of 1839, he explained how it worked but not really what it was for. The process was obviously a miracle of the age of science, and like any miracle it was self-justifying. Painters did say that it would be a great aid to art, and physicists said it would be a great aid to science, but the important thing, on which everyone agreed, was that it was astonishing. Pictures of exquisite perfection had been formed directly by the forces of nature.

What the daguerreotype was in fact used for was recording the faces of millions of people. Of the countless thousands of daguerreotypes that survive, not one in a hundred shows a building or a waterfall or a street scene; the rest is an endless parade of ancestors. Most of these people were, outside their own family circles, nearly as anonymous when alive as their portraits are now. Nevertheless it is interesting to consider the fact that after Daguerre every man's family acquired a visual past: a tangible link with the history of the species. It is unfortunate that the picture opposite has been lost to its rightful heirs. Who would not feel better for having two women as handsome, strong, and proud as these in his past?

An original daguerreotype is a small picture, generally smaller than the palm of one's hand, and exists on a surface of highly polished silver. The image, though infinitely detailed and subtle, is elusive. The picture should be looked at with its case not fully opened, preferably in private and by lamplight, as one would approach a secret.

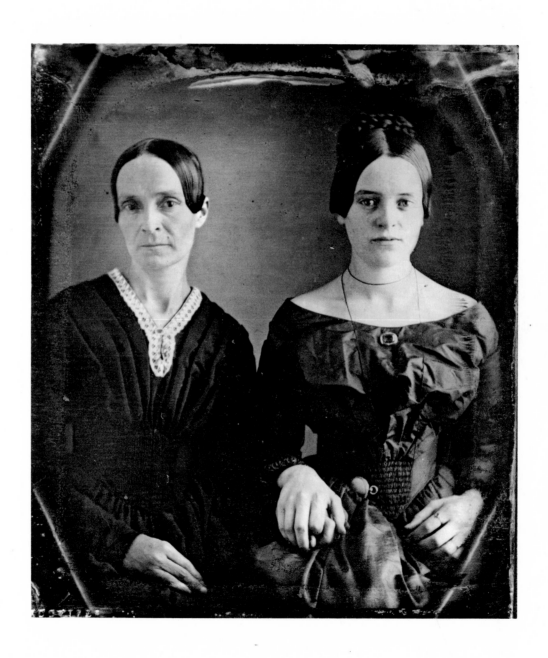

DAVID OCTAVIUS HILL
British, 1802–1870
ROBERT ADAMSON
British, 1821–1848

[D. O. Hill and W. B. Johnstone] c. 1845
Calotype, 7⅝ x 5⅝
Gift of Edward Steichen

David Octavius Hill was a properly trained painter, a member in good standing of the British art establishment, who understood how Van Dyke and Gainsborough had done it, or at least how the academy thought they had done it. Hill took up photography (with the assistance of the young chemist Robert Adamson) as a sketching medium, in order to produce likenesses of 470 Scottish clerics, which he would incorporate in a monstrous historical painting commemorating the founding of the Free Church of Scotland. When the painting was finally finished in 1866, twenty-three years after the first photographs were made, it established Hill as one of the first artists to have converted good photography into bad painting.

Happily, Hill (or Adamson, or both) came to love and use photography for its own sake, and by some unknown combination of their talents they made some of the finest photographic portraits that the medium has thus far managed.

They used a technique called calotypy, which had been developed by William Henry Fox Talbot during the same years in which Daguerre was perfecting his process. Talbot's technique was a two-step system: The picture exposed in the camera formed a negative image (black for white, and vice versa) on a transparent paper base; this negative image was then used as a filter through which a second piece of sensitized paper was exposed to the light, thus reversing the tonal values. Each daguerreotype was unique, but the calotype negative, like the etcher's plate, could be used to produce an indefinite number of prints, limited only by the degree to which the photographer overestimated his market. The calotype image was diffused slightly by the texture of the paper through which it was printed and consequently was less sharply detailed than the daguerreotype. But what Hill had learned from the great dead painters allowed him to compose his pictures broadly and simply, and turn the limitations of the system to his advantage.

In the picture opposite, the man on the left is Hill himself, who in fact appears— a handsome and distinguished figure—in a good number of the Hill and Adamson pictures. Adamson, obviously the junior partner, does not appear in many.

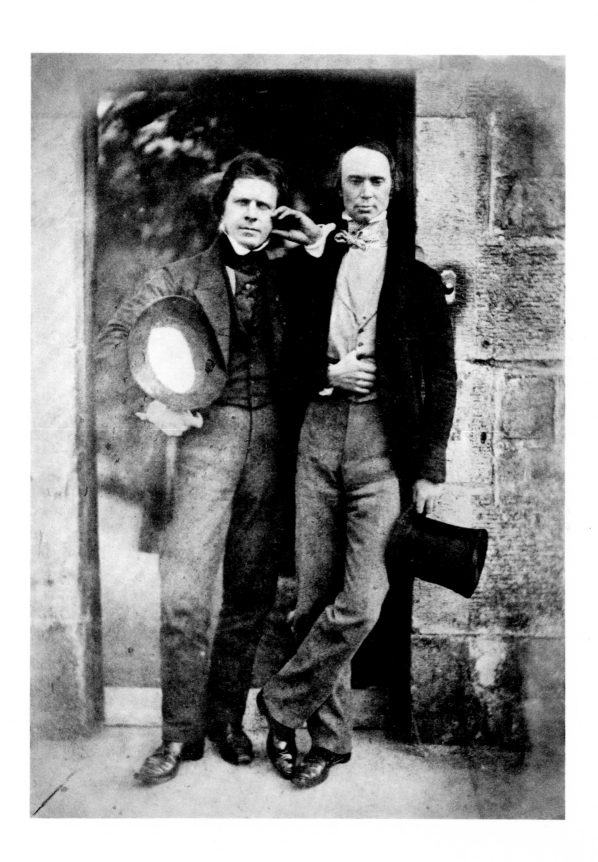

WILLIAM ENGLAND
British, died 1896

Niagara Suspension Bridge. 1859
Albumen print, 9½ x 11½

In 1851 the Englishman Frederick Scott Archer made a radical improvement on the principle of the calotype, by learning how to fix the light-sensitive silver salt to glass rather than paper. These glass negatives could, like the calotype, yield an indefinite number of prints, and they could record detail virtually as fine as that of the daguerreotype. This meant that pictures containing enormous amounts of precise information could be produced in quantity, and photography entered the world of publishing.

During its first generation, photography recorded scores of the great works and legendary places that formerly had been known to the outside world only through the interpretations of a few scholars and travelers. The objectivity and accuracy of these photographs were so implicitly—and naïvely—trusted that they were regarded virtually as surrogates for the subjects themselves. Very rapidly, the world was made a small and familiar place.

One of the most peripatetic of early photographers was William England, who between the mid-fifties and mid-sixties made pictures in most of the countries of Europe and in the United States. England's pictures were sold by the thousands, not because they were art but because they were filled with new and exciting information.

The picture reproduced here reflects almost perfectly the chief interests of mid-nineteenth-century photography: On a single plate England has given us a scenic wonder, a group portrait, a triumph of modern engineering, a railroad train, and (if one looks closely) a horse and buggy. He has included everything of the most favored subject matter of the period except an ancient architectural monument—generally unavailable to photographers working in this country.

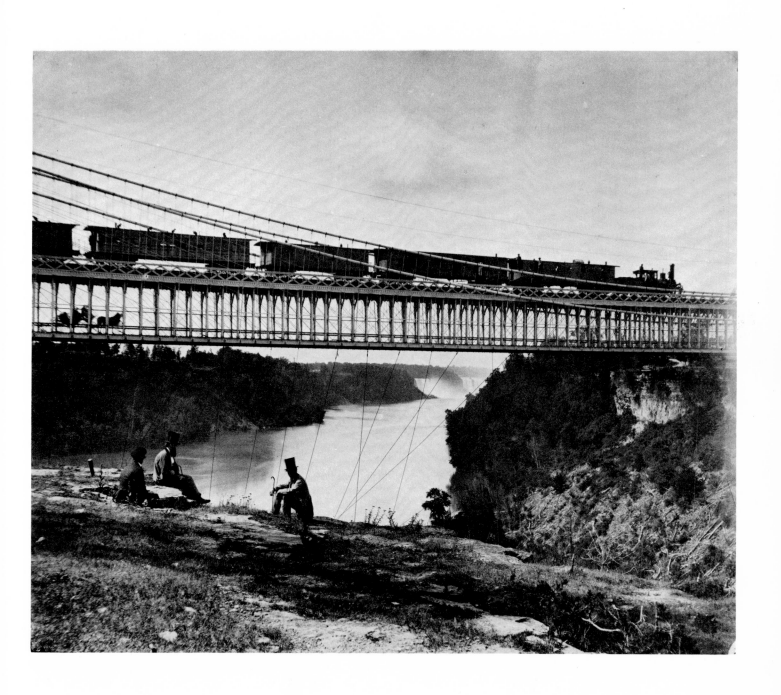

CARLETON E. WATKINS
American, 1829–1916

Arbutus Menziesii Pursh. 1861 [?]
Albumen print, 14⅜ x 21⅜

It is self-evident that a truly radical invention is one that nobody knows how to use. In 1839 there were no photographers, only experimenters; ten years later every town of even modest pretensions had at least one daguerreotype gallery. This army of photographers had come from the ranks of a hundred trades and crafts, most of which were not even remotely related to the science or the art of photography.

Carleton E. Watkins was a clerk in a San Francisco department store when he was hired in 1854 by the daguerreotypist R. H. Vance to tend his gallery in San José, whose operator had unexpectedly quit. It was expected that Watkins would serve as little more than temporary caretaker, but within a week he had learned the rudiments of the craft and was kept on. Fourteen years later he was awarded the first prize for photographic landscapes at the Paris International Exposition. He remained an active photographer for half a century. In 1906, while he was negotiating for the sale of his life's work to Stanford University, his studio and collection were destroyed by the fire that followed the San Francisco earthquake.

Most ambitious photographers of the time moved freely from one promising subject to another, but Watkins did not travel far from California, where he spent summer after summer photographing Yosemite and the great trees of the Mariposa Grove on glass plates ranging in size up to 18 x 22 inches. On his early trips into Yosemite, a twelve-mule train was required to carry Watkins's equipment.

Watkins was a student of his subjects. He entitled the picture reproduced here by the tree's proper botanical name, rather than simply calling it "Strawberry Tree." His surviving work provides a historic and scientific document of his time and place, a record that is clear, precise, detailed, and coherent.

His photograph of the strawberry tree is as simple as a Japanese flag, and as rich as a dictionary.

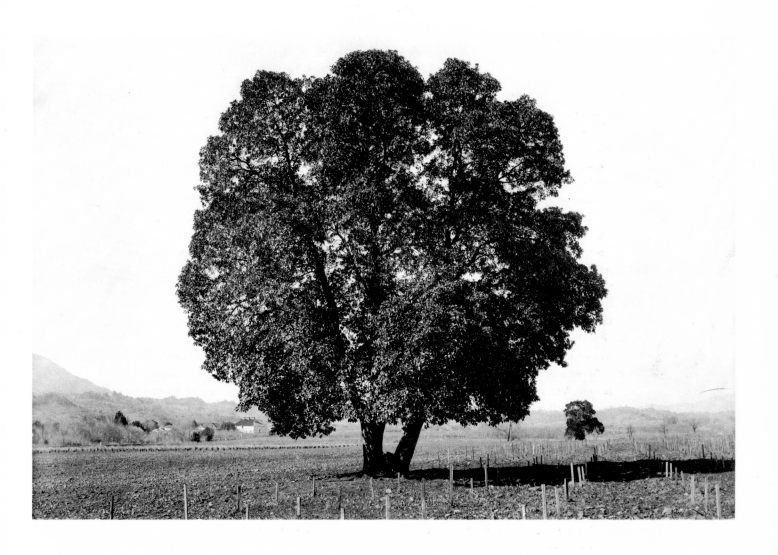

[Untitled] No date
Ambrotype, sixth-plate, 2¾ x 3¼

The ambrotype reproduced here is a rather scrofulous little picture made by an unknown photographer of an unknown subject in an unidentified country. Even assigning an approximate date to the picture is problematic: Although the costumes offer rather little specific data, they would suggest a date of about 1870 to 1875; the picture was made, however, by the ambrotype process, a technique that is thought to have been generally obsolete by about 1863.

In other words, the picture is one of the many thousands of unpedigreed photographs that still survive of the enormously greater number that were made during the middle of the nineteenth century. There is nothing to distinguish it as remarkable, except the visual character of the image itself. In these terms it might be called a very early snapshot, made several years at least before the first hand cameras made their appearance.

Pure photography is a system of picture-making that describes more or less faithfully what might be seen through a rectangular frame from a particular vantage point at a given moment. The attempt to produce coherent and useful pictures within the limitations imposed by these uncompromising rules produced a new kind of image, which in traditional terms often seemed casual, if not chaotic. The ambrotype reproduced here is an excellent example. The picture's composition—or what would at the time have been regarded as its lack of composition—is characteristic of the kind of image structure that resulted when photographers left their studios to work with subject matter that could not easily be posed. The seemingly arbitrary cropping of figures by the picture edge, the unexpected shapes created by overlapping forms, the asymmetrical and centrifugal patterning, the juxtaposition of busy and empty masses—these qualities constitute a visual definition of what is meant, in large part, by the phrase "photographic seeing."

If the picture suggests the work of Edgar Degas, it is perhaps less because of its obvious iconographic relationship to paintings such as *Carriage at the Races* (c. 1872) than because of the fact that Degas, himself an amateur photographer, was deeply interested in picture structure that was conceived visually rather than sculpturally or choreographically: structure in which the relationship of figure to figure was less centrally important than the relationship of figure to ground and frame. This is, perhaps coincidentally, the essence of the design problem in photography.

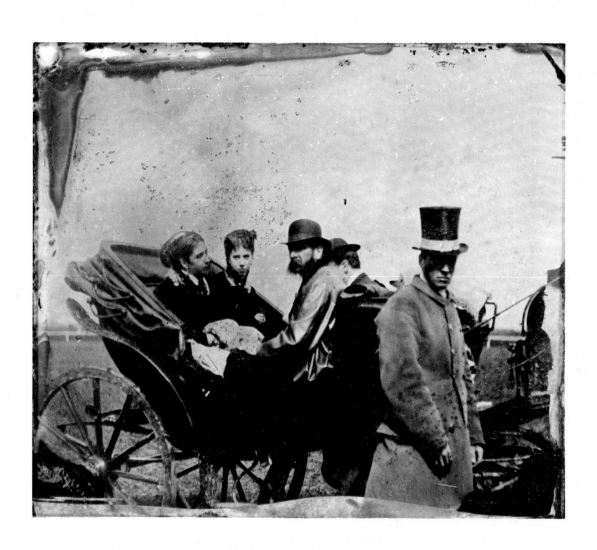

NADAR
[Gaspard Félix Tournachon]
French, 1820–1910

Baron Isidore Taylor. c. 1865
From *Galerie contemporaine*. 1876–1884
Woodburytype, 9½ x 7½

Nadar was a writer, a caricaturist, a balloonist, a part-time political activist, a photographer, and a friend of the painters, writers, and intellectuals in Paris during the time of Napoleon III. He is remembered as a photographer, for the portraits that he made of his great contemporaries.

It was only proper that Nadar should have considered painters his friends, since he learned so much and borrowed so freely from their traditions. He did this with great understanding and skill; the hand and coat front of Baron Taylor, opposite, might have been admired by Ingres himself. On the other hand, no painter would have recorded Taylor's magnificently dyspeptic face with the unremitting truthfulness of Nadar's photograph. Nadar understood that the fidelity of photography was a mixed blessing, and preferred not to make portraits of women, since the results were "too true to nature to please the sitters, even the most beautiful."

The Museum's print of the Taylor portrait is a woodburytype, a kind of print in which the image is formed by ink that has been transferred from a lead intaglio plate. Unlike modern systems of photomechanical reproduction, the woodburytype did not use a halftone screen, and thus achieved a truly continuous scale of gray values. The process produced prints of great beauty and exceptional permanence, and was practical for making editions of several hundred prints from a single plate. Unhappily, the technique was abandoned after the introduction of the halftone reproduction in the late nineteenth century.

In 1874, when Nadar's best work as a photographer was behind him, he earned a footnote in the art history texts by lending (or perhaps renting) his studio to a group of dissident painters for an independent exhibition. The show was generally conceded to be a failure. Renoir, one of the group, said, "The only thing we got out of it was the label 'Impressionism,' a name I loathe."

ALEXANDER GARDNER
American, 1821–1882

Home of a Rebel Sharpshooter, Gettysburg. July, 1863
Plate 41 from *Gardner's Photographic Sketchbook of the War.* 1862–1865
Albumen print, 7¾ x 8⅞
Gift of David H. McAlpin

The American Civil War, among its various distinctions, was the first war to be massively described by photography. Until relatively recent years, the authorship of this enormous document was generally attributed to Mathew Brady, whose name stood, like *Homer*, as a generic label for the product of many men's work. Brady did conceive first and most ambitiously the role that photography could play in recording the conflict; he was also the man who gambled and lost a considerable fortune in the pursuit of his splendid idea. Nevertheless, most of the photographs were actually made by others, whether members of his staff, or disaffected former members of his staff, or independent operators who may or may not have been inspired by his example.

One of those who left Brady was the Scottish-American Alexander Gardner. According to tradition, Gardner left Brady in protest over the fact that his photographers received neither individual credit nor profit for their own pictures. In any event, Gardner took several of Brady's best men with him and went into business for himself. After the War Gardner published the best of his group's pictures in the classic two-volume work *Gardner's Photographic Sketchbook of the War*. Most of the negatives had been made by other photographers, who were punctiliously credited on the picture mounts. Alex Gardner was also credited on the mount of every picture as the maker of the positive, meaning the print. The term positive was doubtless more impressive.

Among the pictures that Gardner made himself is the one reproduced here. Like many Civil War photographs, it showed that the dead of both sides looked very much the same. The pictures of earlier wars had not made this clear.

A generation later Stephen Crane studied the photographs of the War, and perhaps pondered their reticence and ambiguity. In *The Red Badge of Courage* the youth sometimes sees the War as though he were a camera: "His mind took a mechanical but firm impression, so that afterward everything was pictured and explained to him, save why he himself was there."

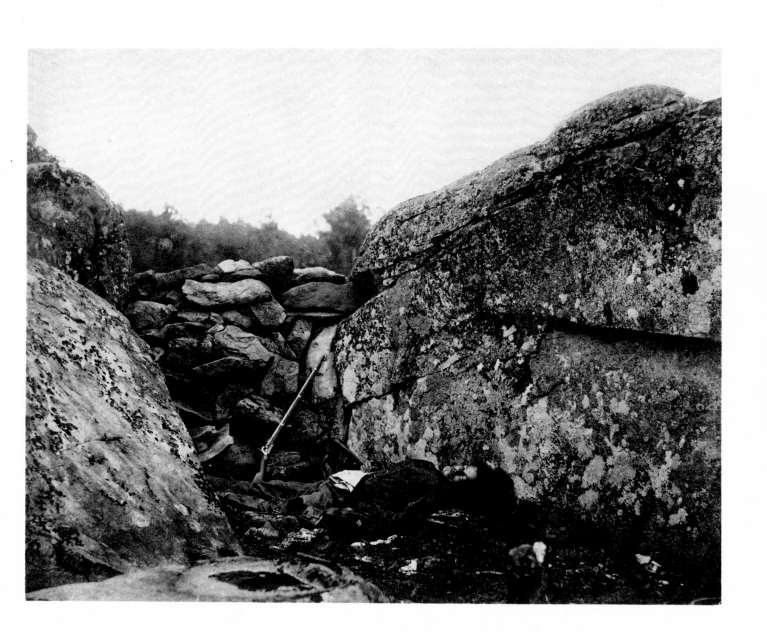

GEORGE N. BARNARD
American, 1819–1902

Scene of General McPherson's Death. 1864 or 1865
From *Photographic Views of Sherman's Campaign.* 1866
Albumen print, 10 x 14⅛

The photographers of the Civil War could not describe the quick and volatile action of battle. The photographic technique of the time—the wet-plate process—required that the photographer coat his glass plate in a portable darkroom, then expose it in his waiting camera, and develop it before the coating had dried. Under these conditions photography was a conceptual art: the content of the picture was determined minutes before the exposure was made.

Many of the best of the Civil War photographs must be read as the fossils of earlier events: The caissons with their mud-encrusted wheels, the dead on the field, the empty landscapes, all speak of deeds already past. Such a picture is not so much a document as a talisman or relic—like a piece of the True Cross.

George Barnard worked during the War as official photographer for the Union Army's Division of Mississippi. Most of his work was probably routine—the copying of maps and documents and similar necessary but unexciting jobs—but when the opportunity presented itself he photographed the larger perspectives of the War. Beginning in 1864, he traveled with Sherman's army. It would seem that he followed the campaign well behind the battlefront. Some of his pictures were in fact made after the War had ended, and all are composed carefully and deliberately, by a photographer who did not fear for his life. The spirit of the pictures is retrospective and contemplative.

This picture describes the place where General McPherson fell. Its naïveté persuades us that it is true: He fell at the edge of this oak wood; the horse's skull was the skull of his horse; the shot on the ground brought him down. For General McPherson, this was the place where the issue was met.

JULIA MARGARET CAMERON
British, 1815–1879

Madonna with Children. c. 1866
Albumen print, 10⅝ x 8⅝
Gift of Shirley C. Burden

Julia Margaret Cameron was a largely talented, highly intelligent, free-spirited, eccentric, financially comfortable Englishwoman who took up photography as a personal adventure, as she might have taken up philanthropy or rose culture. It is said that she was the plain sister in a family of beauties, but that her charm and intelligence made her the most formidable of the six daughters. She and her husband—a high British civil servant—counted among their friends many of the creative heroes of early Victorian England, and Cameron's best-known and most praised works are the portraits that she did of these men. She took them one by one into her studio, a converted chicken coop, where they sat and suffered under the hot skylight until she got them exactly right. Tennyson, Darwin, Carlyle, G. F. Watts, Longfellow, Herschel, and many others suffered her uncompromising attentions, and sometimes later compared among themselves the degree of their suffering. She, on the other hand, said: "When I have such men before my camera, my whole soul has endeavored to do my duty towards them, in recording faithfully the greatness of the inner, as well as the features of the outer man."

Most of her work, however, was done between the holiday visits of these great men, when she made photographs that concerned beauty, King Arthur, myth, the poetry of Tennyson, and the painting of Raphael, as she understood it. For models she used her friends and maids and their friends and children, and converted them by act of will into Biblical heroines, Renaissance cherubs, and Arthurian maidens.

These pictures by Cameron have been something of an embarrassment to her most sympathetic critics during the past generation, a period when photography has seemed ill-adapted to the functions of fiction. Nevertheless, the picture opposite—admittedly one of the less insistently anecdotal of her allegorical works—seems today a splendid picture: strongly constructed, well described, and, more important, strangely moving. The three models are very beautiful, and if the central figure was in fact a teen-aged virgin, she became, for the minutes during which this picture was made, a most persuasive *donna*.

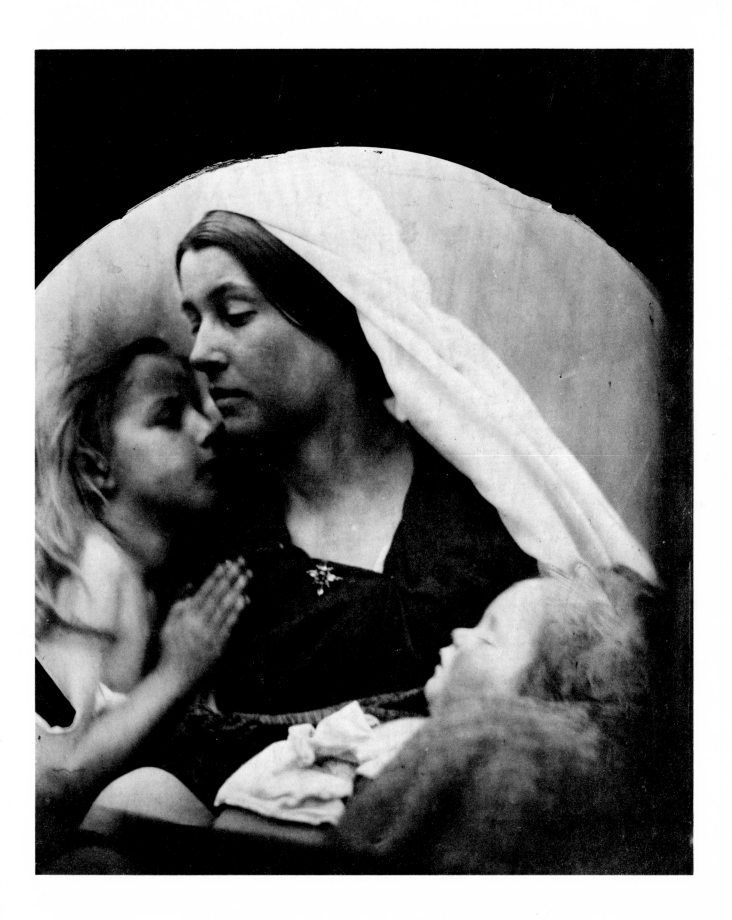

WILLIAM HENRY JACKSON
American, 1843–1942

Crater of the Deluge Geyser. Red Mountain Basin. 1871
Albumen print, 4⅜ x 7⅝

Recollecting his boyhood, William Henry Jackson could not remember a time when he had not drawn for pleasure. When he was ten years old, his mother gave him a copy of J. G. Chapman's *American Drawing Book*. Eighty-seven years later he said that the book was the most important single thing in his life. From it he learned how to indicate receding space and how to draw a figure that would stand on the ground rather than float above it. When Jackson was fifteen, he took a part-time job as a photographer's retoucher, and gradually learned the mysteries of the wet-plate process.

After serving briefly in the Union Army, Jackson set out to see the country, working his way westward as a bullwhacker, and back eastward as far as Omaha as a horsewrangler. At this point, his taste for adventure temporarily slaked, he settled down as a photographer, documenting the new railroads and making Indian portraits, as well as doing standard commercial assignments.

In 1870 Dr. Ferdinand Hayden invited Jackson to become the photographer for Hayden's section of the U. S. Geological Survey the next year. In this capacity Jackson was the first person to photograph the Yellowstone area, which was made the country's first national park in 1872. Jackson's function with the survey was less that of scientist than of publicity man. In his splendid biography *Time Exposure*, Jackson puts the matter very clearly:

"Hayden knew that Congress would keep on with its annual appropriations [for the Survey] exactly as long as the people were ready to foot the bill, and he was determined to make them keep on wanting to.

"That was where I came in. No photographs had as yet been published, and Dr. Hayden was determined that the first ones should be good. A series of fine pictures would not only supplement his final report but tell the story to thousands who might never read it."

Jackson had the imagination to recognize the magnitude of his opportunity. His subject matter was new, and unburdened by the weight of earlier successful pictures. He worked exuberantly and confidently, with a sure grasp of the essential qualities of his medium. He loved the grandeur of the wild Rockies, and the adventure of trying to describe the place clearly and simply.

It has been said that Jackson's pictures were instrumental in persuading Congress to set aside the area as a preserve, and the claim is plausible. Only a few men had seen the Yellowstone area, and maybe only the gullible had believed their fantastic tales of steaming fountains, and great plumes of water erupting from fissures in the rock.

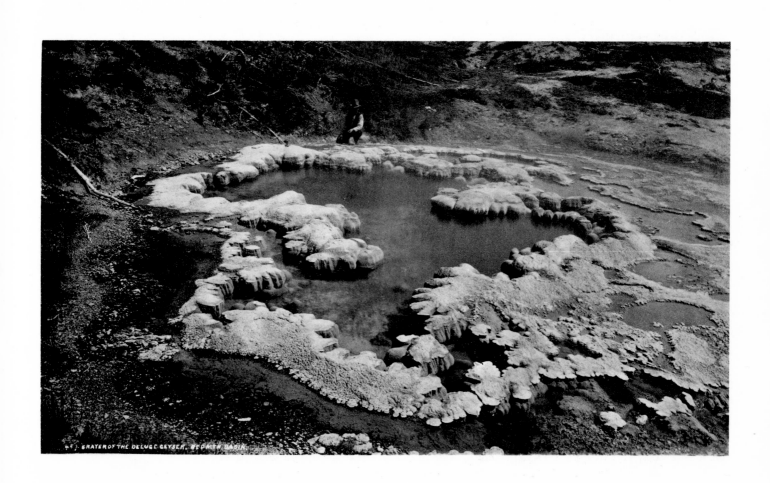

CRATER OF THE DELUGE GEYSER, BEDPATH BASIN.

TIMOTHY H. O'SULLIVAN
American, 1840–1882

Black Canyon, Colorado River. 1871
From *Explorations and Surveys West of the 100th Meridian.*
1871, 1872, and 1873
Albumen print, 8 x 10⅞
Gift of Ansel Adams in memory of Albert M. Bender

Timothy H. O'Sullivan was perhaps the best of the Civil War photographers, and he was better still when he went west after the War as photographer for the government explorations of the Fortieth Parallel (1867–1869) and the One Hundredth Meridian (1871, 1873–1874). Perhaps the War had prepared O'Sullivan for the conditions of work, and of survival, that he met in the West: the extreme heat and cold, dangerous water to travel on, or no water at all, mosquitoes that drove men half crazy, hostile or treacherous Indians, immense distances, and the intermittent suspicion that one might be hopelessly lost.

There was also frequent failure. On the 1871 expedition, O'Sullivan made about three hundred negatives that were good enough to keep. (Mediocre pictures were scraped from the plates to save the glass for another attempt.) Almost all of those he had kept were destroyed when several of the expedition's boats capsized in the Colorado River.

Under such circumstances it would not seem that artistic talent was the first requirement of a photographer, but perhaps the best ones met the hardships successfully because they loved picture-making. About his work in the Humboldt Sink, O'Sullivan said: "Viewing there was as pleasant work as could be desired; the only drawback was an unlimited number of the most voracious and particularly poisonous mosquitoes that we met with during our entire trip. Add to this the . . . frequent attacks of that most enervating of all fevers, known as the 'mountain ail,' and you will see why we did not work up more of that country. . . . Which of the two should be considered as the most unbearable it is impossible to state."

Particularly in his landscape work, O'Sullivan had a wonderfully original eye. His intuitively inventive approach to the formal problems of photography can be seen in the way he handled his skies. The wet plates of the day were sensitive only to blue light; sky areas were thus automatically overexposed, and rendered as blank white. Photographers who insisted on a conventional spatial rendering of the sky solved the problem by printing in clouds from a separate negative. O'Sullivan, on the other hand, accepted the white sky and used it as a shape, enclosed in tension between the picture's visual horizon and the edges of the plate.

His landscapes are as precisely and as economically composed as a good masonry wall. It is as though every square inch of the precious glass plate, carried so far at so great an effort, had to be justified completely.

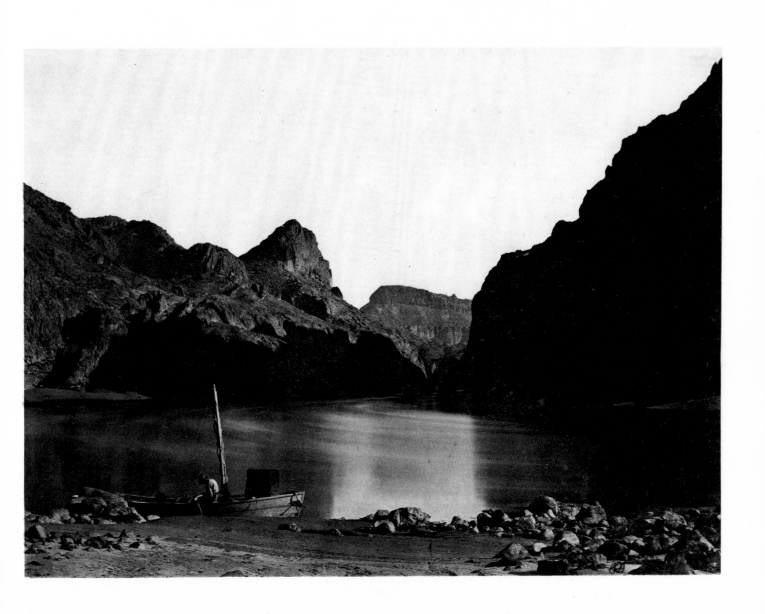

JOHN THOMSON
British, 1837–1921

Old Furniture
From *Street Life in London.* 1877
Woodburytype, 4⅜ x 3⅜
Gift of Edward Steichen

John Thomson's book *Street Life in London* differed from the photographic books that had preceded it in that it dealt not with great ancient monuments, or with a great war, or with great and powerful personages, but rather with the humble and ubiquitous poor and near-poor.

In the ninety-five years since Thomson's book was published, characteristic photographic subject matter has changed radically, to the point where it has often seemed that the poor are the photographer's chief stock-in-trade. Nevertheless, it is difficult even today to name a photographic book that describes the common people of a city with the justice, objectivity, grace, and unsentimental sympathy that identify Thomson's work.

It might be objected that the book is fundamentally a view from above, and it is true that Thomson does not claim to be one of the poor, or a surrogate spokesman for them, but describes his subjects from a friendly but nonetheless distant perspective, similar to that of an ornithologist who is genuinely fond of birds. Whatever the limitations of this perspective, it has the great virtue of encouraging precisely accurate description, a quality that photography is remarkably well adapted to achieve.

The original book includes thirty-six beautiful woodburytypes (see page 24) of men and women who were flower-sellers, dustmen, street musicians, shoe-blacks, sweeps, or members of other street trades that are now either exotic or extinct. Like Thomson's pictures, the accompanying text by Adolphe Smith is richly informative in content, and universal in view. In considering the meaning of the street trades it touches on social utility, economics, technology, philosophy, politics, and even morality. About the picture reproduced here, the text says of used furniture dealers that they are as a rule men who take "... a hard and uncharitable view of mankind. They are accustomed to scenes of misery, and the drunkenness and vice that has led up to the seizure of the furniture that becomes their stock. Then they have also to be thoroughly acquainted with the various forms of swindling practised in auction rooms. ... At the same time, it is only fair to add that these shops afford facilities to persons whose means are very restricted, and enable them to furnish a home and thus obtain an established position. ... A good second-hand article is generally preferable to the new shoddy ware sold at a higher price...."

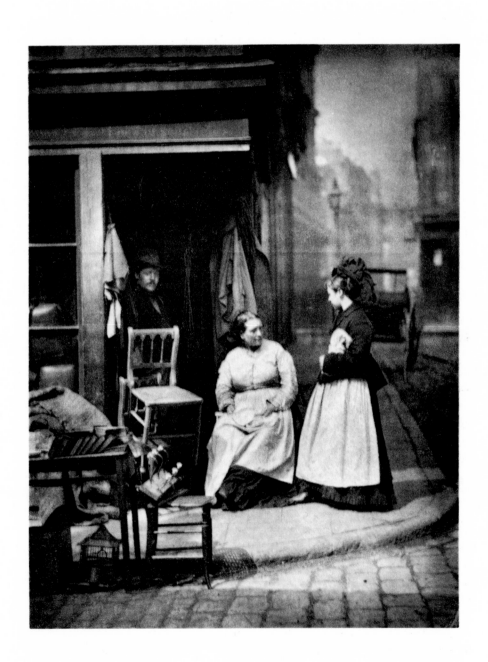

WILLIAM McFARLANE NOTMAN
Canadian, active from 1880 or earlier

Blackfoot Brave with Pony. 1889
Albumen print, 9 x 7⅜

The subject of this picture is a traditional one, relating to Van Dyck's *Charles I* and John Trumbull's *George Washington*, and countless galleries-full of other warriors with their steeds. The picture's design, however, is characteristically photographic. A painter would have included the horse's front legs, thus locating the animal in space, and making a fine inverted S-curve of its neck and shoulder. In the photograph the horse's head, cropped as it is by the picture edge, is oddly two-dimensional, like an element in a collage, attached to the picture structure by the bridle reins and the tepee's chimney pole.

The identity of the photograph was discovered only a few days before this book went to press. The following paragraphs were written prior to that discovery:

The name of the photographer who made the picture is unknown to the Museum, as are its subject and date. Because the picture is a photograph, it can be said with confidence that it was made no earlier than 1873, for the Indian's rifle is the .44 caliber Winchester, first made in that year, and not the very similar 1866 or 1876 model. The apparently silver ornaments that hold the man's fur neckpiece seem to have been borrowed from another, earlier function; they suggest perhaps the bit branches of a fancy Spanish bridle. Dr. John C. Ewers says that the brave's costume and accouterments are not diagnostic of a specific tribe, but thinks that the subject is a member of one of the northwestern Plains tribes, and adds that other photographs from the eighties show Blackfoot wearing belts and knife scabbards that were also heavily studded with brass tacks.

It is likely that the picture was made after the battle of Little Bighorn (1876) and before the so-called battle of Wounded Knee (1890). One's sense of the picture itself does not contradict this guess. The Indian in the picture would seem pushed to a situation of precarious extremity, but not yet finally beaten.

The brave is indeed a Blackfoot. He was photographed in the Stony Creek Reserve, in the foothills of the Alberta Rockies. The metal ornaments are thought to be the cocking levers of rifles of a much earlier date. It is said that the Indians of the area had at first intended to join in the 1885 rebellion led by the half-breed Louis Riel, but were persuaded not to by the local Indian Agent— indicating perhaps that the Blackfoot had indeed been finally beaten.

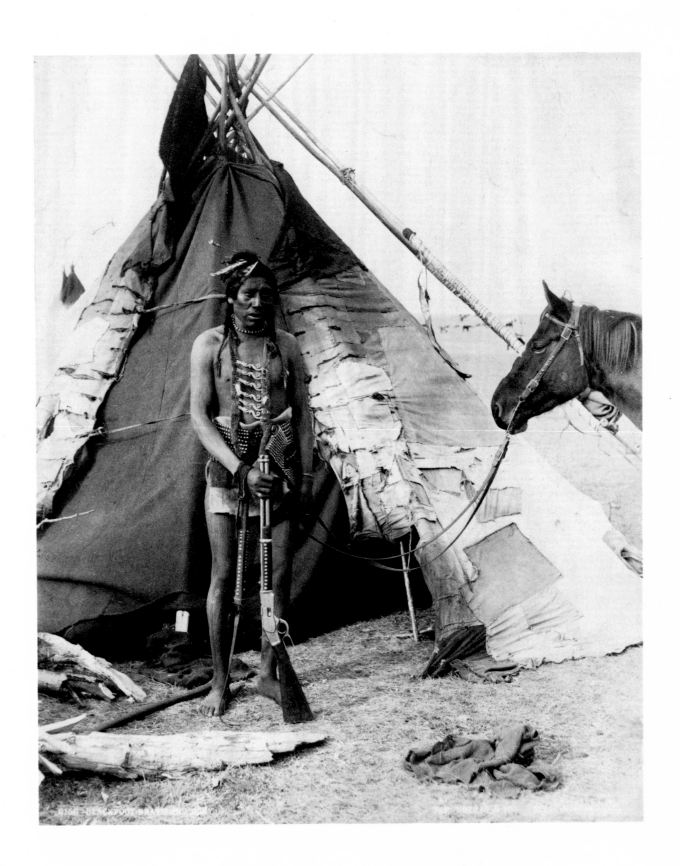

PETER HENRY EMERSON
British, 1856–1936

Poling the Marsh Hay
Plate 17 from *Life and Landscape on the Norfolk Broads.* 1886
Platinum print, 9 x 11⅜
Gift of David H. McAlpin

Peter Henry Emerson was a splendid and original photographer and, perhaps unfortunately, a dedicated and energetic theorist. His theories eventually caused him to give up photography in favor of other interests, including rowing.

Many of Emerson's best photographs concerned the lives and land of the farmers and fishermen of East Anglia; the pictures were objective, richly informative, visually satisfying, and often moving. Emerson must have been deeply fascinated by his subjects, and sincerely interested in the quality of their lives; without reference to its high artistic quality, Emerson's work would be important by virtue of its sensitivity as an ethnographic study. He also loved photography, and learned almost to match the magically opalescent image on the groundglass in his subtle, exquisite platinum prints.

Unlike his photographs, his theories were very wide-ranging, and touched on the whole history of art, the physiological basis of perception, and the relationship of art, nature, and science. These aspects of his thought were, however, merely servants of his main thesis, which was that photography, used as he said it should be used, was a full equal of the traditional fine arts, and that its recognition had been thwarted by wrong-minded critics and by photographers who attempted to imitate painting.

In fact Emerson's own work bears a strong resemblance to that of the naturalistic painters of the preceding generation—especially that of J. F. Millet, whom he especially admired. After Emerson's shrill insistence on the issue of artistic status, his followers were even more deferential to the aesthetics of painting than their predecessors had been; they merely rejected the earlier model of genre painting in favor of a kind of tonal impressionism.

Only five years after he had first sounded the attack, Emerson recanted. After discussing the matter with an unnamed "great Painter," he published a pamphlet saying that he was sorry, but he had been wrong. Photography was in fact a very minor art.

It was too late for retractions. Emerson had served as the Luther of photography; he was in large part responsible for the schism that developed between the high-minded, status-conscious amateurs and the pragmatic, experimental professionals. In retrospect, the separation seems to have been a disaster for both camps.

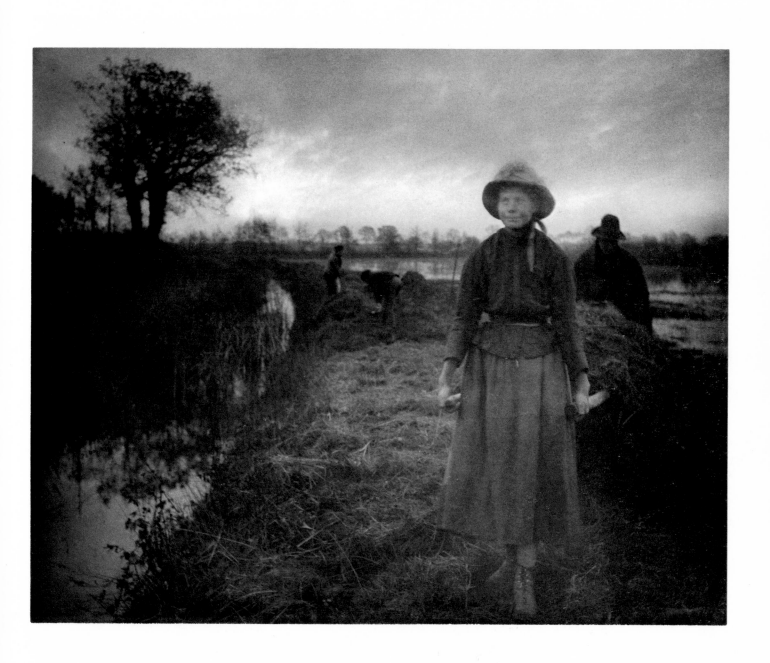

EADWEARD MUYBRIDGE
American, born England, 1830–1904

Woman. Kicking.
Plate 367 from *Animal Locomotion.* 1887
Collotype, 7½ x 20¼
Gift of the Philadelphia Commercial Museum

The story about Muybridge and Leland Stanford, whether apocryphal or not, is a satisfactory one: Stanford, former Governor of California and a serious horse fancier, allegedly bet a friend, one Frederick MacCrellish, twenty-five thousand dollars that a running horse at one point in his stride had all four feet off the ground simultaneously. Since the issue was not resolved by direct observation, Stanford commissioned Muybridge, a California photographer famous chiefly for his landscapes, to settle the issue through photography, which could not lie.

Six years later, after several near-successes (and an interruption during which Muybridge was being tried for the murder of his wife's lover), the photographer proved conclusively that Stanford was right about the four-feet-off-the-ground question, although the horse's position—with his feet bunched beneath him—was doubtless as much of a surprise to Stanford as to everyone else. Considering the length of time Muybridge had spent on the project, plus the expense of photographic equipment and legal fees, it is questionable whether Stanford profited from his bet, but he probably derived great satisfaction from being proved right.

The issue was then less academic than it seems today; painters of the time frequently included horses in their pictures, and like Stanford they also wanted to be right. Within months of the publication of Muybridge's pictures, the hobby-horse convention that had been honored by artists for centuries was abandoned, except on that last bastion of conservatism, the carrousel.

Muybridge's most important motion studies were published in 1887 as *Animal Locomotion*, a collection of 781 plates that described, in sequential frames, human beings and other creatures engaged in diverse characteristic activities. As the distinguished art historian E. H. Gombrich has made clear, artists had never really painted what they saw; they painted rather what they had learned to paint. The most talented among them had challenged some part of the convention that they had inherited, and had modified and enriched it. By the nineteenth century a properly trained painter knew how to draw a head or a hand in as many as ten or twelve perspectives, each of which looked as true as ancient wisdom. Muybridge's work, on the other hand, recorded many thousands of individual optical facts, almost all of which looked unfamiliar. Perhaps nothing since Daguerre had so unsettled the painter's established certainties.

One might ask why, in the plate opposite, the model is kicking a pith helmet. Presumably, someone forgot the volleyball, and with 781 pictures to make, substitutions were allowed.

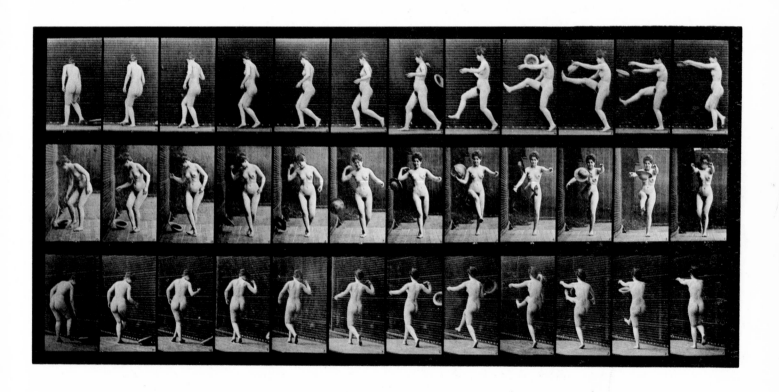

HENRY HAMILTON BENNETT
American, 1843–1908

Sugar Bowl with Rowboat, Wisconsin Dells. c. 1889
Modern print by Rolf Petersen from the original negative
lent by the H. H. Bennett Studios, 15¾ x 16

Like most working photographers of the latter nineteenth century, Henry Hamilton Bennett did much of his work in the form of stereographic views: a pairing of two prints of a subject made from two slightly different angles of view, corresponding to the perspectives of two eyes. When viewed through a viewing device called the stereoscope, these pictures gave a remarkably persuasive sensation of three-dimensional space. Stereoscopes were an almost universal fixture in Victorian and Edwardian parlors, and stereo views were produced in enormous quantities. Like television, their function was perhaps not so much to educate as to divert, and when skillful photographers worked with their stereo cameras, their first objective was to produce a viscerally exciting depiction of deep space. These pictures were, of course, also looked at without the aid of a viewer, and seen in this way they are frequently among the boldest and least conventional compositions to be found in nineteenth-century photography. The picture by Bennett is a case in point.

An object with its reflection on water is more complex and more interesting than a simple ink blot, since the result is never quite symmetrical, every point on the object being seen from two distinct perspectives simultaneously. The resulting form (object plus reflection) is intriguing also because of the spatial ambiguity that it creates. A glance at the reader's own reflection in a mirror will help clarify the issue: One sees one's face not in the plane of the mirror, but behind it, at an optical distance twice as great as that from eyes to mirror. It is impossible to focus on both the mirror and the reflection at the same time. Photography however can record in sharp focus both near and distant objects (the mirror and the reflection). The physiological basis for depth perception has in this situation been subverted, and only psychological clues such as relative size and overlap indicate what is close and what distant. In the case of Bennett's photograph, we tend to read the island and its reflection as a flat shape, standing in a plane. But in what plane? Visually the bottom of the reflection seems to occupy the same space as the picture's immediate foreground. Both the island and the man in his boat hover equivocally in a dreamlike, insubstantial space.

A contemporary of the frontier landscapists O'Sullivan and Jackson, Bennett worked a generation behind the frontier, in the vacation town of Wisconsin Dells. From 1865 until 1908 he made, with variation and refinement, what was essentially the same picture. It showed a fairy-story landscape, rugged and wild in half-scale, with enchanted miniature mountains and cool dark grottos. Almost invariably he included in his picture a human figure: a picnicker, in but not quite of the landscape, and yet with friendly feeling toward it. It was a portrait of the American discovering the poetic uses of the wilderness.

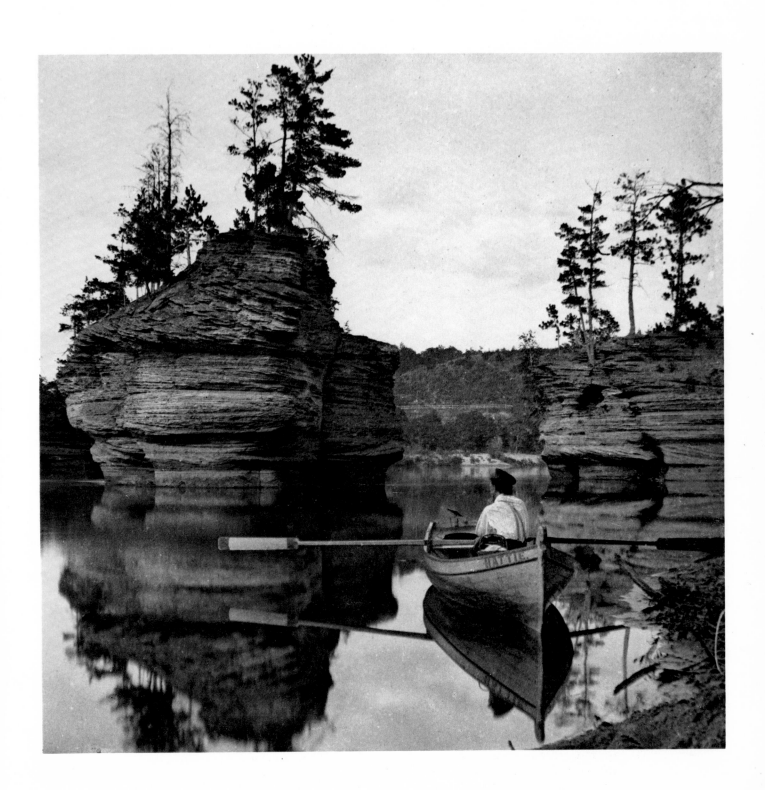

FREDERICK H. EVANS
British, 1853–1943

A Glade in the New Forest. 1891
Platinum print, 7⅞ x 5¾
Anonymous gift

Until he was forty-five years old, Frederick H. Evans was an amateur photographer and a professional bookseller. His was not an ordinary bookshop; Evans knew the books he sold and apparently did his best to impose his own literary judgments on his customers. George Bernard Shaw, to whose books Evans was partial, considered him an ideal bookman.

In middle age he retired from the book business to pursue his photography, especially his interpretations of the English Gothic churches. He is remembered, with good reason, as the best of architectural photographers. His document on the English cathedrals is a persuasive critical statement, reflecting a coherent, personal understanding of the objective facts. Since the pictures were formed by intelligence rather than blind system, they cannot, of course, claim to be "objective records"—whatever that phrase might mean. While another photographer might with equal reason have seen the cathedrals as stone constructions, Evans saw them as light and space. To define with exactitude this sense of his subject, it was necessary that Evans be a consummate craftsman. His platinum prints are exquisitely subtle and precisely just.

As his cathedral pictures were photographs not of stone but of space, so the picture reproduced here is not of the trees but of the forest. Even the great sycamores are scarcely substantial—not matter but image, elements in a structure of light.

Evans's forest is not the forest of a botanist or a hunter, but of a literary man. It is a sublime forest, free of stinging nettles and poisonous insects, in the depths of which a man of books might meet all the ancient ghosts of Hampshire.

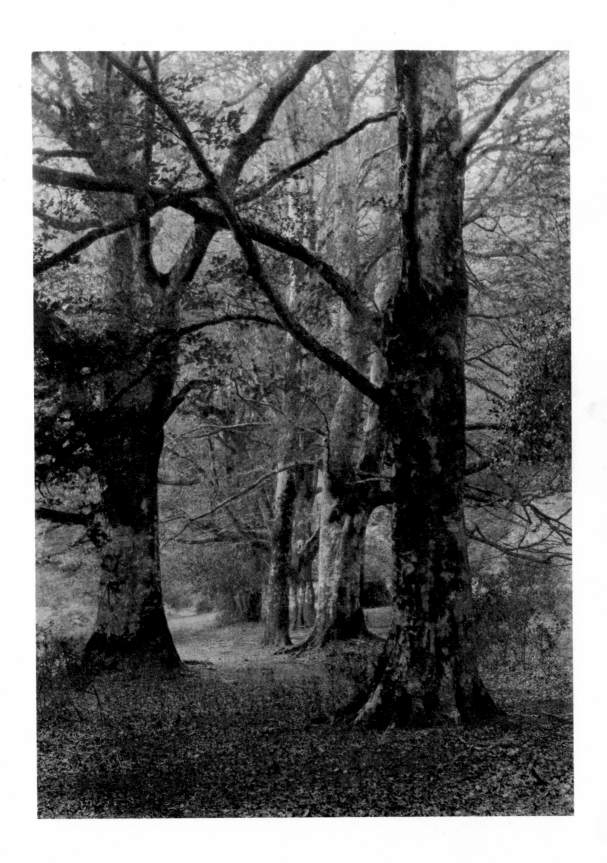

JACOB A. RIIS
American, born Denmark, 1849–1914

Police Station Lodger, A Plank For a Bed. c. 1890
Modern print by Rolf Petersen from the original negative lent by the
Museum of the City of New York, 4¾ x 6¼

Jacob A. Riis was a newspaper reporter by occupation and a social reformer by inclination. He was a photographer rather briefly and apparently rather casually; it seems beyond doubt that he considered photography a useful but subservient tool for his work as reporter and reformer. It is clear that he had no interest in "artistic" photography, and equally clear that the artistic photographers of his time had no interest in him.

This situation was of course entirely to Riis's advantage, for it allowed him to make the photographs that he wanted to make, without concerning himself with the fact that they were beneath the notice of those concerned with artistic expression. Nevertheless, it does seem somehow unjust that a man who was presumably disinterested in pictures as pictures made so many great ones. (It is as though the muse were a callow girl, repelled by the attentive suitor, and attracted to the one who ignores her.) Perhaps it would be closer to the truth to say that Riis was intuitively interested in problems of form without identifying these as artistic problems, as the bridge builder makes intuitive judgments concerning scale, proportion, and line without thinking of his work as architecture.

Even so, one cannot consider a body of Riis's pictures without being impressed by his luck, which seemed to work so regularly for him, and so seldom against him. In the picture opposite, Riis did not intend to include the hand in the upper right (not the hand of fate, but that of his assistant, who has just lighted the flash powder). It would strain credibility to believe that he anticipated the forms created by the shadows cast by the flash, or that he considered the amorphous plaster patch to be a part of his picture, or even that he visualized the powerful and mysterious graphic force of the dark plank, standing like a nameless monument beside the almost spent human life.

Suffice it to say that Riis did not, through pride, reject chance; he knew the habits and the habitat of photographer's luck, and he did his best to make himself available to its gifts.

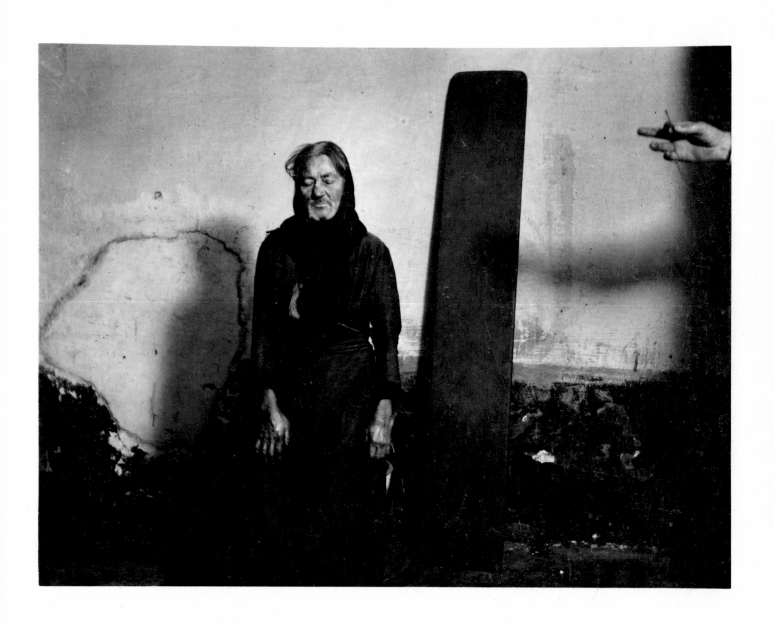

CLARENCE H. WHITE
American, 1871–1925

Miss Grace. c. 1898
Platinum print, 7⅞ x 5⅝
Gift of Mrs. Mervyn Palmer

Clarence H. White was one of those artists who, at recurring intervals, re-establish the fact that talent is more important than good ideas. White's ideas, formulated from the sources available to him in Newark, Ohio, were a mixture of Whistler-by-reproduction, turn-of-the-century *japonaiserie,* and the largely narcissistic attitudes of those American photographers who, after 1902, called themselves the Photo-Secession. From the late nineties onward for two decades, White's name appears in the lists of almost every important photography exhibition held in America; at this time and later, he was an effective and influential teacher at Columbia University and at the school that bore his own name. During his long, fruitful career it seems that he made not one memorable statement concerning his sources, his intentions, or his methods.

Surrounded by theorists, prophets, and publicists, White remained merely an artist. Of the artist-photographers of 1900, he seems today the best. His range was narrow: He did not photograph the large outside world, or even real people; his work seems dedicated to the hope that an abstract, attenuated grace and elegance might continue to exist, in miniature, even in the modern industrial world, provided one did not focus too sharply.

White's work redeemed his hope. He renewed the shopworn schema that he had inherited by virtue of his appreciation of the ornamental qualities of light, and especially by his sure and original graphic sense. Consider the marvelous white shape of Miss Grace's dress, and its perfect, precarious balance among the other elements of the picture.

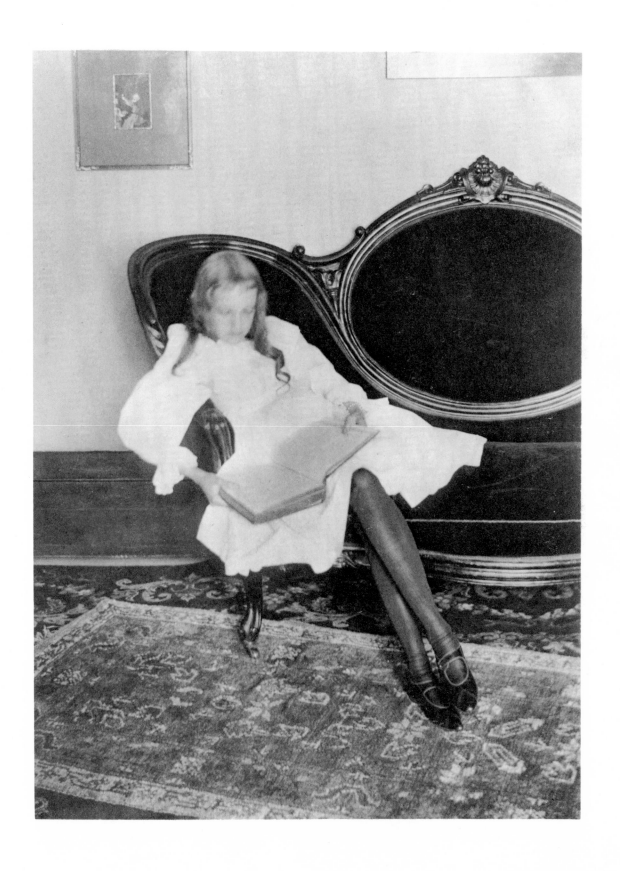

FRANCES BENJAMIN JOHNSTON
American, 1864–1952

Agriculture. Mixing Fertilizer. 1899 or 1900
From *The Hampton Album.* 1900
Platinum print, 7½ x 9½
Gift of Lincoln Kirstein

The importance of women as photographers has been much greater than one would guess on the basis of a straight statistical projection. As a nonscientific measure of this claim, it might be observed that the work of at least thirteen women is included among the one hundred pictures in this book, a percentage which is surely larger than that of women among those seriously committed to photography during most of the period involved.

There are several possible explanations for the fact that women have been more important to photography than their numbers alone would warrant. One explanation might be the fact that photography has never had licensing laws or trade unions, by means of which women might have been effectively discriminated against. A second reason might be the fact that the specialized technical preparation for photography need not be enormously demanding, so that the medium has been open to those unable to spend long years in formal study.

A third possible reason could be that women have a greater natural talent for photography than men do. Discretion (or cowardice) suggests that this hypothesis is best not pursued, since a freely speculative exploration of it might take unpredictable and indefensible lines. One might for example consider the idea that the art of photography is in its nature receptive, or passive, thus suggesting that women are also.

Surely Frances Johnston, for one, was not. She was a drill sergeant among photographers. In her photographs no head or hand moves during the long exposures; no undisciplined individualist clowns for the camera; no property, no matter how interesting in itself, is allowed to violate the taut, flat planes of her compositions. The order of Arcadia, as Poussin had imagined it, was more important to Johnston than the ephemeral and accidental realism of the moment.

Her carefully constructed tableaux might easily have seemed ludicrously false, except that she made them so marvelously well. She ordered life to assume a pose that conformed to her own standards. That she made this odd procedure work so well does not necessarily prove the validity of the standards—except for her own purposes—but it demonstrates beyond doubt that she was a formidable artist.

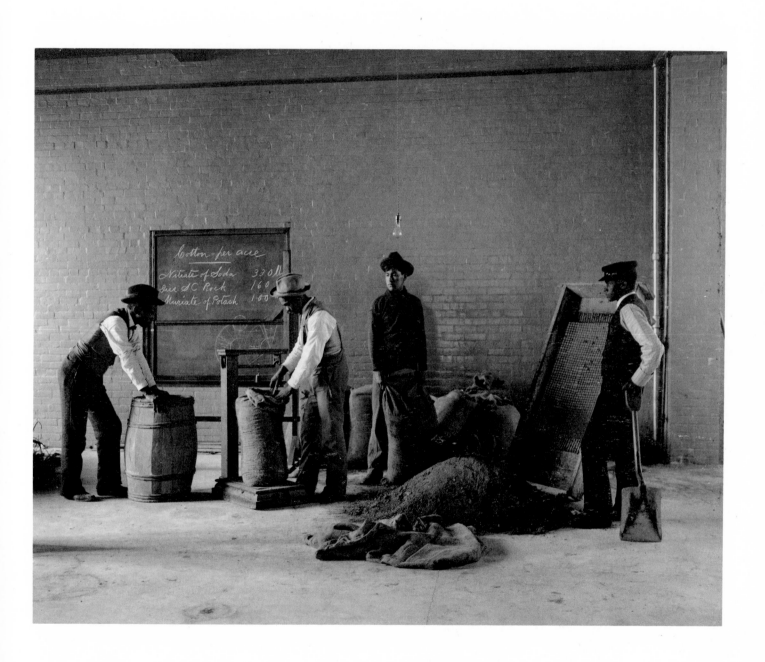

ARNOLD GENTHE
American, born Germany, 1869–1942

Street of the Gamblers [Chinatown, San Francisco] 1896 or later
9¾ x 11⅞
Gift of Albert M. Bender

Unposed street photographs of one sort or another had been made since the 1850's; the relatively small negatives of the stereograph allowed the use of short focal-length lenses that gave adequate exposure at snapshot speeds, which more or less stopped normal street action if the photographer kept his distance. These were basically photographs of places—generally famous avenues, plus an insect-like pattern of people and carriages. If, on the other hand, the photographer wished to describe the people on those streets, and something of the quality of their lives (as John Thomson had in 1877; page 37), he posed the photograph.

The nature of the photographer's problem was changed radically about 1880 by the widespread introduction of dry plates, which could be purchased ready to use and held for weeks between exposure and development. The new process was incomparably easier and more convenient than the old one; more important, it changed the photographer's philosophy of shooting, for he could now take risks. Once the wet-plate photographer had made his exposure, he was out of commission until that plate had been developed and a new one prepared; with dry plates the photographer could stay with his subject, make a half-dozen exposures, and hope. Perception and exposure could now be virtually simultaneous, so the camera stand was no longer necessary. Thus, the dry plate spawned the hand camera, with which the photographer could move freely, changing his vantage point until the very instant of exposure.

One is tempted to state flatly that Arnold Genthe's Chinatown picture could not have been made without the dry process and the hand camera. It seems clear that he worked secretly, without attracting the attention of his subjects. Beyond this, he captured that fleeting intersection of time and vantage point at which the visual anarchy of the street was transformed into something permanent and purposeful, something similar to theater.

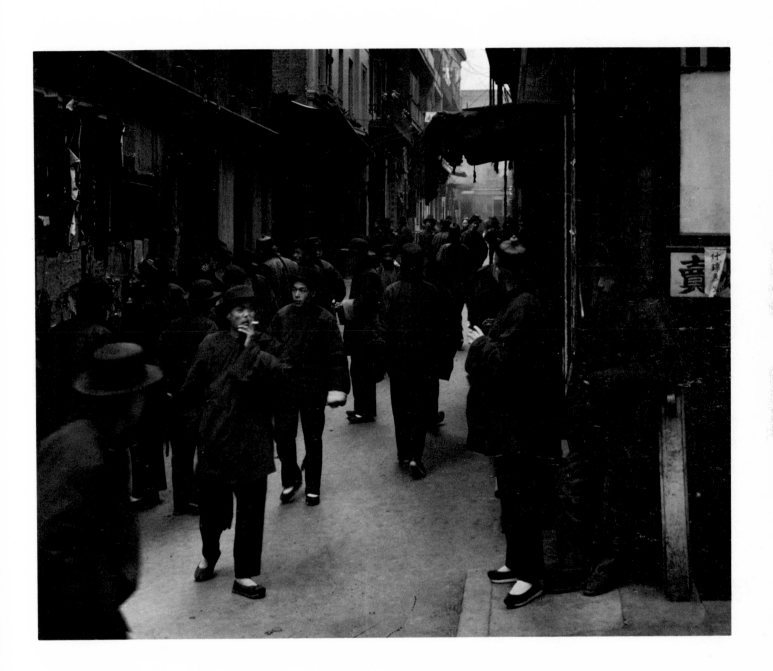

GERTRUDE KÄSEBIER
American, 1852–1934

The War Widow. No date
Platinum print, 8⅞ x 7¼
Gift of Mrs. Hermine Turner

The titles of pictures made by the Photo-Secessionists are frequently puzzling. It cannot be assumed that the woman in the picture reproduced here was actually a war widow, or even the child's mother; photographers like Gertrude Käsebier loved to make photographs that were essentially, and frankly, fictions. (Certainly adequate precedent had been set by Julia Margaret Cameron, who had photographed Sir Henry Taylor not only as himself but as Friar Laurence, with Juliet, as Prospero, with Miranda, and as Ahasuerus, with Queen Esther.) One is tempted to believe that if the woman *had* been a war widow, Käsebier would have considered it tasteless to say so, in which case the picture might have been entitled "Elegy."

Today we are perversely charmed by the sentimentality and naïveté of the picture's nominal content. The picture's true content, however, has to do less with widowhood than with the visual mechanics of picture construction. On these grounds it is a highly sophisticated and challenging picture.

One's immediate response to the photograph is that something is out of joint; the effect is upsetting, even menacing. On analyzing the picture visually we note that it is composed of two closely related light forms on a dark ground. One is created by the white dresses of the woman and child, the other by the overlapping shapes of the table and window. The window and table read as a single form— an opening, or negative space. As a result the dark shapes surrounding the table leg become positive, or projecting, forms. The signals from our eyes contradict our knowledge, and it is only by an act of will that we can maintain a rational orientation to the picture's very ambiguous space.

It is not necessary to assume that Käsebier analyzed the question in these terms. It is more likely that she saw the image upside-down on her groundglass and said to herself: "*That* is a very strange and interesting design."

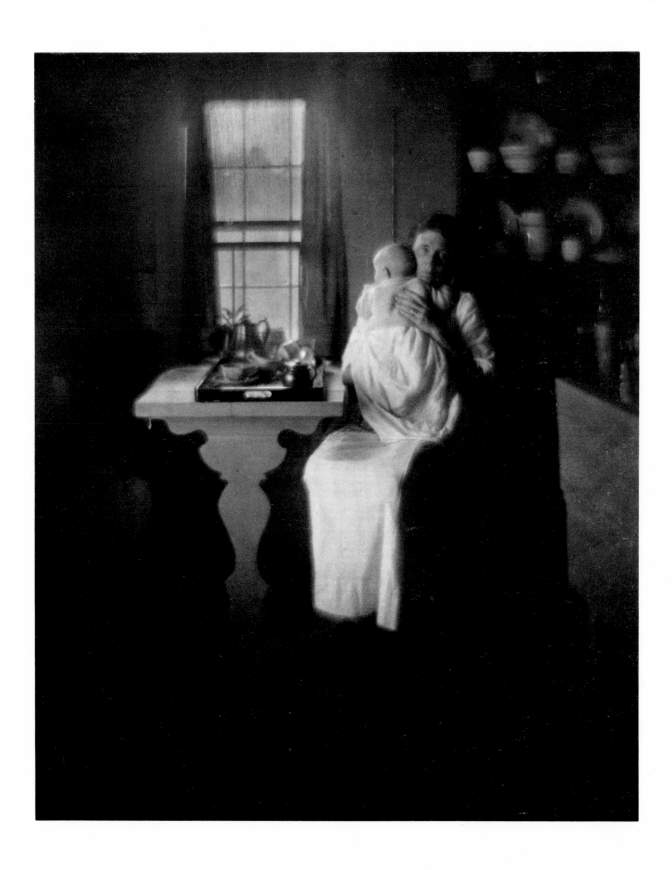

Photographer unknown
American [?]

Apples Grown by Irrigation at Artesia, New Mexico. 1907 or earlier
Postcard, halftone reproduction, 3½ x 5⅜
Gift of Henry Wessel, Jr.

Among the characteristics to be noted about traditional painting are that it was slow, difficult, rare, and expensive, and was therefore used only to record things of great importance, such as religious sacrifices, kings and condottieri, ancient myths, and the rich. (The Dutch, especially, also painted good things to eat, but generally along with good silver and good linen, making the subject a subcategory under *the rich*.)

Photography, on the other hand, was quick, easy, ubiquitous, and cheap, and was used to record everything, most of which seemed, by painters' standards, evanescent and trivial. It is true: Most of what photography recorded *was* trivial. Nevertheless, once the pictures were made a curious thing happened: By the very fact of being transfixed these trivial things were somehow elevated, and became part of formal history and tradition. Many of these odd, scrubby pictures finally came to rest on the walls of painters' studios, where their strangely compelling qualities might be contemplated and abstracted.

The postcard reproduced here was postmarked 7 P.M., July 27, 1907, Artesia, New Mexico. It was sent by Jim A. to Annie Schrock of Toyah, Texas. The picture itself would, in retrospect, be moving, memorializing as clearly as it does the triumph of a dead, unheralded pomologist and the sincere and simple construction of an anonymous provincial photographer. But it is better still by virtue of Jim A.'s beautiful line: "Miss Annie How are these for apples?"

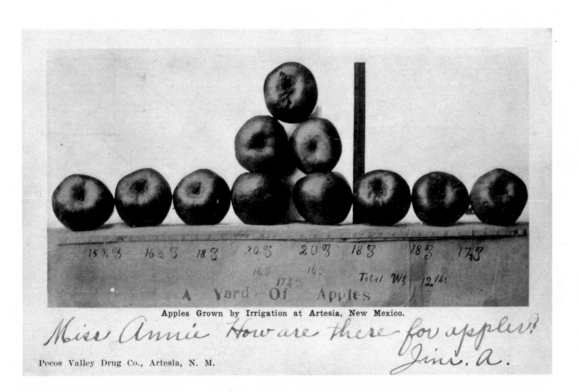

A Yard Of Apples

Apples Grown by Irrigation at Artesia, New Mexico.

LEWIS W. HINE
American, 1874–1940

Macon, Georgia. 1909
4¾ x 6⅝
Stephen R. Currier Memorial Fund

Lewis Hine was educated as a sociologist at the University of Chicago, during the years when John Dewey and Thorstein Veblen were on its faculty. He continued his education at New York and Columbia Universities, and taught at the School of Ethical Culture. (Among his students there was Paul Strand, whom Hine introduced to photography.) Hine was past thirty when he seriously took up photography; by instinct and by training he conceived of the medium as a means of studying and describing the social conditions around him. He is today spoken of perhaps more often as a social reformer than as a picture-maker. He realized, however, that his pictures "proved" nothing; if they were to contribute to social change they must first affect the sensibilities of those who saw them. Much of Hine's work is not a protest but a celebration of people who had nerve, skill, muscle, and tenacity. There is in his pictures little pity and much love and respect for those who were casually called the common people.

Hine was one of the masters of a splendid new camera called the Graflex. For the first fifty-odd years of photography, the photographer had to compose and focus his picture upside-down on a groundglass in the back of his camera, then insert the holder that held the sensitive plate. Once the plate was in the camera, the photographer was shooting blind, unable to change either his framing or his focusing. With the Graflex on the other hand, he saw his picture just as the camera would record it until the very instant that he pushed the trigger. This meant that he could frame his subject boldly, to the very edges of the plate; he could change his angle of view at the last moment; he could focus selectively on the most important plane of his subject, allowing the nearer and farther planes to be recorded out of focus. The picture opposite is characteristic of the new kind of graphic economy and forcefulness that Hine helped discover for photography.

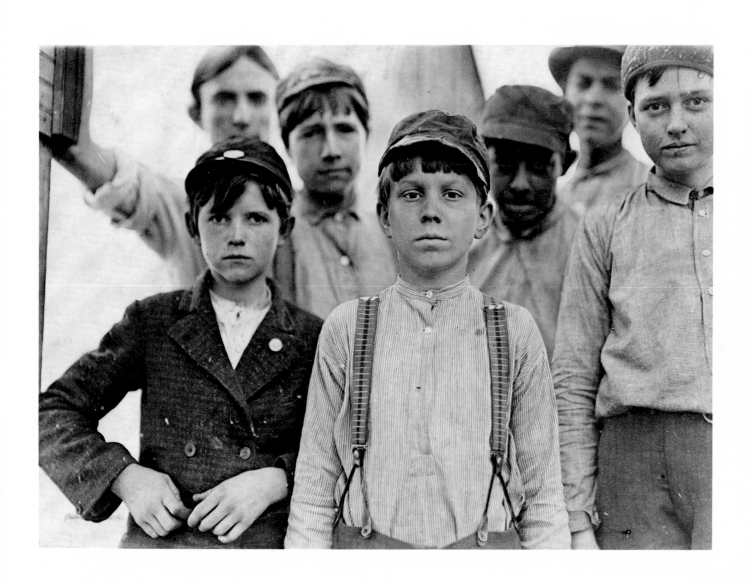

ALVIN LANGDON COBURN
British, 1882–1966

[Untitled] No date
Plate 3 from *The Cloud*. 1912
Platinum print, 6½ x 5

For those around the turn of the century who were seriously committed to the potentials of photography as a creative art, the fundamental stumbling block seemed to be the medium's uncompromising specificity. If allowed to follow its natural bent, the camera described not Man but men, not Nature but countless precise biological and geological facts. This tendency was not in harmony with the artistic spirit of the time, which preferred an idealized view, and which sometimes confused vagueness with poetry.

In retrospect it seems that there were two possible ways of dealing with photography's preference for the particular: One could accept the fact and make use of it (as Atget did), or one could find ways partially to evade it, or at least to soften its hard edges.

This latter approach was more compatible with the intuitions of Alvin Langdon Coburn. Coburn was one of the first—perhaps *the* first—to pursue consciously the possibilities of photography as a tool for exploring abstract form. The most thoroughgoing of his experiments in this direction were the pictures he called *Vortographs* (1917), which he made by pointing his camera at various objects through a triangular tunnel of mirrors. Coburn was clearly trying to emulate abstract painting, but the similarity between his *Vortographs* and Cubism was, to put it generously, more apparent than real. Nevertheless, the pictures clearly demonstrated Coburn's wish to free himself of the insistent significance of particularized facts. His friend Ezra Pound, writing in 1917 about Coburn's abstractions, claimed that they were consonant with Walter Pater's dictum that "all arts approach the condition of music." Ironically, Coburn's best representational pictures, such as the cloud picture reproduced here, seem today more satisfactory from a purely plastic point of view than do his abstractions.

Clouds were a particularly good subject for an artist like Coburn who sought the broad poetic view of things. Granted that no two clouds are the same; nevertheless, their meanings (except to farmers and meteorologists) were sufficiently imprecise and generalized to allow Coburn to use them as abstract visual elements. Coburn used the skies as children and poets use them, and as Leonardo used stained old walls: as an analogue model of imaginary worlds. They provided him with an inexhaustible supply of infinitely variable forms, richer and less predictable than the images formed by his little box of mirrors.

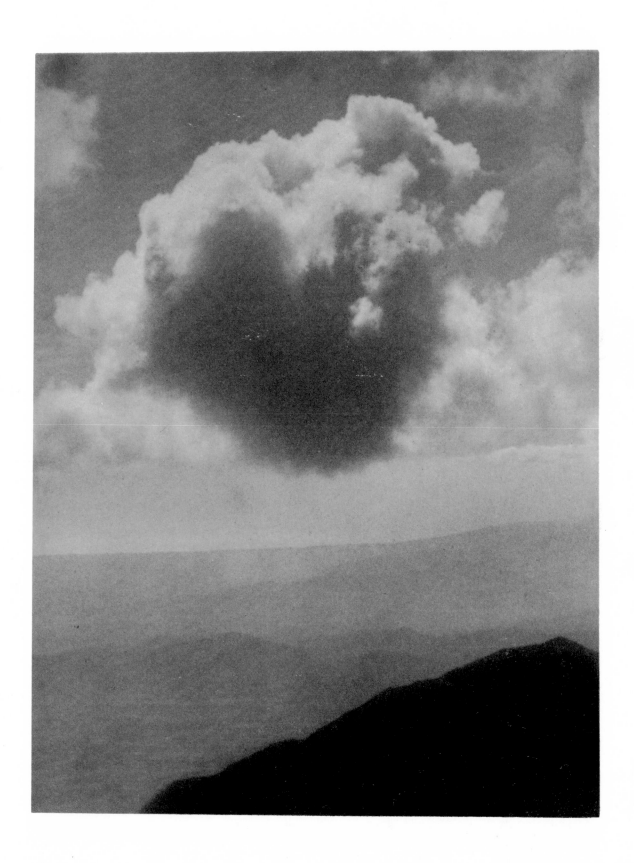

EUGÈNE ATGET
French, 1857–1927

Versailles—Vase. No date
Printing-out paper, 8½ x 7
Abbott-Levy Collection. Partial gift of Shirley C. Burden

The life and the intention of Eugène Atget are fundamentally unknown to us. A few documented facts and a handful of recollections and legends provide a scant outline of the man: He was born in Libourne, near Bordeaux, in 1857, and worked as a sailor during his youth; from the sea he turned to the stage, with no more than minor success; at forty he quit acting, and after a tentative experiment with painting Atget became a photographer, and began his true life's work.

Until his death thirty years later he worked quietly at his calling. To a casual observer he might have seemed a typical commercial photographer of the day. He was not progressive, but worked patiently with techniques that were obsolescent when he adopted them, and very nearly anachronistic by the time of his death. He was little given to experiment in the conventional sense, and less to theorizing. He founded no movement and attracted no circle. He did however make photographs which for purity and intensity of vision have not been bettered.

Atget's work is unique on two levels. He was the maker of a great visual catalogue of the fruits of French culture, as it survived in and near Paris in the first quarter of this century. He was in addition a photographer of such authority and originality that his work remains a bench mark against which much of the most sophisticated contemporary photography measures itself. Other photographers had been concerned with describing specific facts (documentation), or with exploiting their individual sensibilities (self-expression). Atget encompassed and transcended both approaches when he set himself the task of understanding and interpreting in visual terms a complex, ancient, and living tradition.

The pictures that he made in the service of this concept are seductively and deceptively simple, wholly poised, reticent, dense with experience, mysterious, and true.

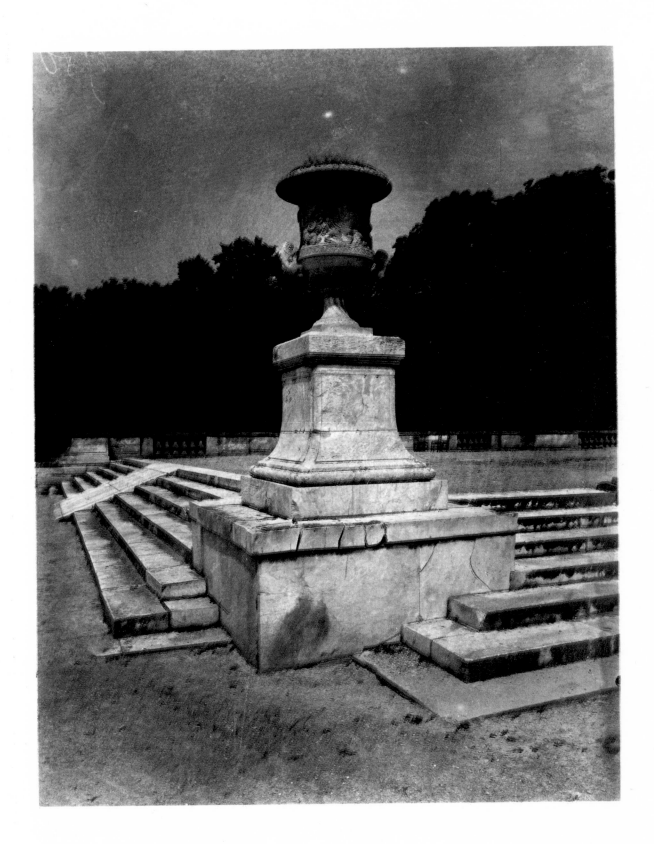

JACQUES HENRI LARTIGUE
French, born 1894

Avenue du Bois de Boulogne, Paris. 1911
11⅝ x 15⅝
Gift of the artist

The word amateur has two meanings. In its classical sense it is the antonym of professional, and refers to those who pursue a problem for love rather than for the rewards the world may offer. In this sense the word often identifies the most sophisticated practitioners in a field; many of photography's greatest names have been amateurs as pure as the crocuses of spring, and many others, though mercenaries during the week, have done their best work on weekends.

The other and more popular meaning of the word identifies one who plays at his work: one not only less than fully competent, but less than wholly serious. (The professional is allowed to be less than competent, but never less than serious.) This second variety of amateur is generally handicapped by ignorance of the craft and the traditions of the medium, and is therefore wholly dependent on his or her native, God-given, unique talent and sensibility. This is almost never enough.

There are, however, rare occasions on which exceptional talent, the right horoscope, and an unexploited new technique all coincide at a point occupied by one as naïve and unprejudiced as a child. In such cases the results can be astonishing.

In 1911 Jacques Henri Lartigue was not merely as unprejudiced as a child; he *was* a child. The picture reproduced here was made when Lartigue was fifteen, but it was not one of his early works; by the time he was ten he was making photographs that anticipate the best small-camera work of a generation later.

Lartigue was a privileged child, and he made the best of it. From the subjects of his pictures one would assume that the life of his family was dedicated wholly to the pursuit of amusement: the beach, the racetrack, beautiful women in elegant costumes, heroic motor cars and daredevil drivers, flying machines, and all manner of splendid games—including photography itself. Even if Lartigue had been an ordinary photographer, his document of these things would be precious, but he was in fact a photographer of marvelous talent. He caught memorable images out of the flux of life with the skill and style of a great natural athlete—a visual athlete to whom the best game of all was that of seeing clearly.

Lartigue had no perceptible effect on the development of twentieth-century photography, since his work was virtually unknown until a half-century and more after the best of it had been done. When his work came to light, it seemed to confirm the inevitability of what had happened in photography much later, when more mature and sophisticated photographers came to understand what the child had found by intuition.

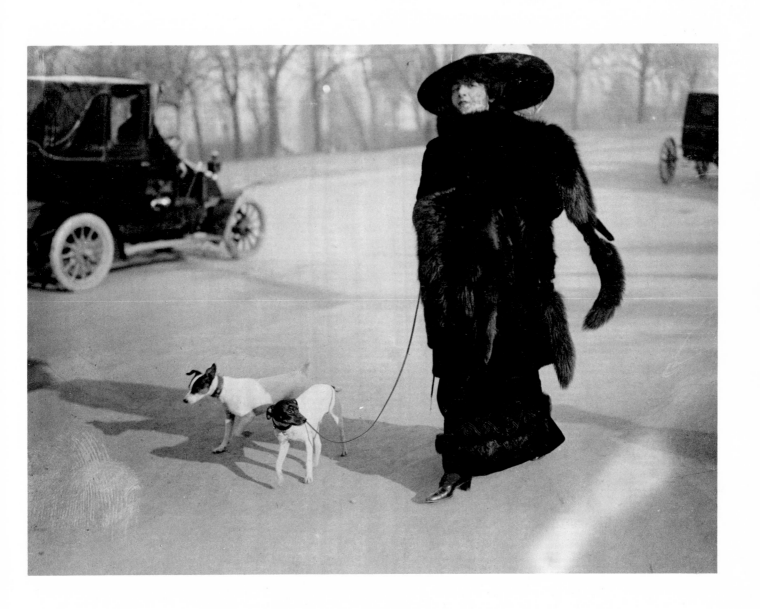

E. J. BELLOCQ
American, 1873–1949

[Untitled] c. 1912
Modern print by Lee Friedlander from the original negative
Printing-out paper, 7⅝ x 9⁹⁄₁₆
Gift of Lee Friedlander

Our knowledge of E. J. Bellocq barely transcends the level of rumor. This is true in the case of many exceptional photographers of the past, and it is especially true of professional photographers, who were less likely than amateurs (and perhaps less able) to write articles for the journals, or otherwise explain and publicize their work.

It is known that Bellocq was a commercial photographer in New Orleans during the early part of this century. During the First World War he was making what photographers call nuts-and-bolts pictures for a local shipbuilding firm. He is reported to have been a strange man in appearance and behavior: misshapen, anti-social, and humorless. He was regarded by his acquaintances as no more than a competent commercial photographer. As an old man, after retiring from the photography business, he is said to have walked the streets of New Orleans, attempting unsuccessfully to master the intricacies of the modern hand camera.

But Bellocq had also had a secret life. After his death a collection of about one hundred plates was discovered in a drawer of his desk. The plates were portraits of New Orleans prostitutes, dating from about 1912. It is possible that the pictures were made as a commercial assignment, but this seems unlikely; they have about them a variety of conception and a sense of leisure in the making that identify them as work done for love.

A good photographic portrait is the result of a successful collaboration between the photographer and the sitter. The remarkable individuality of Bellocq's portraits is the individuality of his subjects. With Bellocq's help, the women have realized themselves in pictures.

The prostitute portraits comprise the only fragment of Bellocq's work to have survived. About fifteen years after Bellocq's death the plates were shown to the photographer Lee Friedlander, who greatly admired them and later bought them. Since none of Bellocq's own prints survived to serve as models, Friedlander printed the plates in a process widely used sixty years ago, and appropriate to the character of Bellocq's negatives. Friedlander was thus the third collaborator to contribute to the work reproduced here.

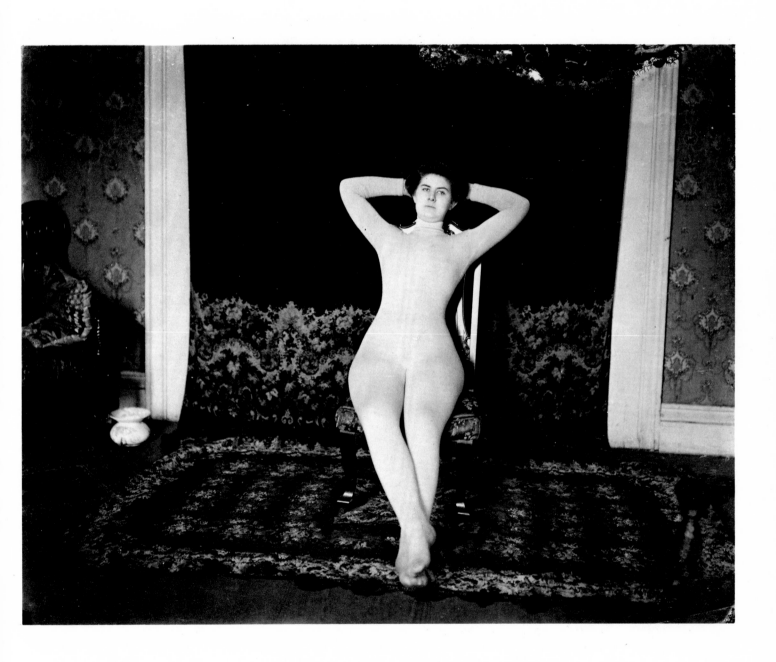

Photographer unknown

[Aerial reconnaissance photograph, Lavannes, World War I] 1917
6½ x 8⅞
Gift of Edward Steichen

The use of aerial photography for intelligence purposes began during the First World War and was developed with astonishing speed once its potential was recognized. The first reconnaissance photographs were little more than snapshots from airplanes, and the information they contained was qualitative, not quantitative. Soon however it was found that serial photographs made from a given altitude at given intervals could yield enormous amounts of precise information.

It also became apparent that the reconnaissance photograph was of use only after it had been interpreted, and that interpretation was a highly sophisticated specialty. In the photograph reproduced here, a trained interpreter would immediately recognize the wiggly white line in the center of the picture as a major trench; the straight line to its left, dotted with the shadows of poplar trees, is the main road through the area; the longer curve across the picture's lower left-hand corner is a railroad, and the crescent that connects the railroad with the highway is a new rail spur under construction; the white starlike figures scattered in the area of the rail spur are shell craters. The small trench leading from the main trench, just to the left of the picture legend, may indicate that the army below is preparing to move eastward. By comparing a picture such as this with others made of the same area on preceding days, the interpreter could sometimes correctly guess the enemy's intentions.

Accurate measurements can be made from this photograph. Since the altitude was 5,000 meters and the lens of 50 centimeters' focal length, the scale of the picture in the contact print is 1 cm $= 100$ m. By measurements on the print we can thus easily determine that the poplar trees had been planted 10 meters apart.

The picture was made at 11 A.M. on June 4, 1917, near Reims. It does not show that this was a time of crisis for France. A million of her men were dead, General Nivelle's offensive of April and May had failed, and French soldiers in the trenches were in mutiny.

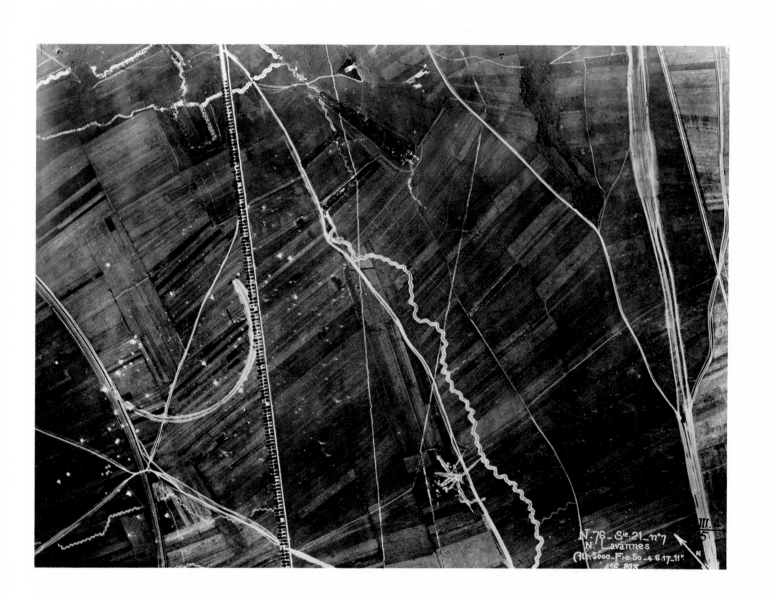

Photographer unknown

[Aerial reconnaissance photograph, World War I] October 10, 1916
5⅞ x 7¾
Gift of Edward Steichen

The photograph reproduced here was made from a French reconnaissance plane during the First World War, somewhere on the Western Front. The serpentine form near the bottom and left edges of the picture is a badly damaged trench. The scattered dark shapes are shell holes. The little light shapes are men. Considerable numbers of them are visible outside the trench, indicating that an attack is in progress.

The most radical war photographs—those that have shown us what we had not before known—seldom concern the traditional humanistic values that painting had found in martial subjects. Heroism, cowardice, victory, defeat, high purpose, or villainy are seldom visible in war photographs, except in fragmentary and ambiguous symbol. What they do show us is the strange impersonality of war, and its incoherence.

Honoré Daumier said that photography described everything and explained nothing. This is often true. In some cases it is perhaps an improvement over the habit of traditional painting, which often explained everything and described nothing.

ALFRED STIEGLITZ
American, 1864–1946

Georgia Engelhard. 1921
10 x 8
Alfred Stieglitz Collection. Gift of Georgia O'Keeffe

Most good artists have spent their lives exploring one idea: transposing, adjusting, and refining it, applying it to different specific problems, disassembling and reconstructing in all possible configurations the component parts of the basic conception. In photography, perhaps because of the speed with which the medium itself has changed, only a very few workers have been able to maintain the vitality and plasticity of their conception for a full working lifetime. The genuinely creative period of most photographers of exceptional talent has rarely exceeded ten or fifteen years.

Alfred Stieglitz (like his younger friend and rival Edward Steichen) is a conspicuous exception to the rule. Stieglitz (like Steichen) avoided stagnation not by remaining constant to a single concept throughout his long lifetime, but rather by pausing at least twice in his maturity to reconsider his goal and rechart his course. Stieglitz lived at least three lifetimes as a photographer, each producing a body of work that was formidable and distinct from the others.

Until Stieglitz was past forty, most of his photographs were strongly influenced by aesthetic values inherited from traditional painting. Only occasionally did his interest in difficult technical problems lead him to radically photographic imagery.

Sometime before 1910, after a period of relative inactivity, the character of his work changed. It is as though the earlier pictures were ideas recorded by his camera, and the new ones ideas discovered within it; in conception and execution the portraits and cityscapes of this period had a directness and immediacy that made most earlier art-motivated photography seem once-removed from real experience.

After the early twenties Stieglitz's work turned more and more inward and became increasingly personal, pure, and self-contained; at times indeed it expresses the imperious and secretive loneliness of genius confronting death.

Stieglitz made this portrait of Georgia Engelhard when he was in his mid-fifties, and at the height of his creative powers. The picture poses and resolves several of the central issues that had occupied Stieglitz throughout his career: It is first of all a compelling portrait, remarkable for the physical and psychological presence of this beautiful child of summer. Within the basic format of the common snapshot Stieglitz has contrived a design of great eloquence; the gesture of the girl's body and the line of its silhouette express the poise and the potential of a taut spring. The detail of her right arm suggests the tortuous beauty of his great cumulative portrait of Georgia O'Keeffe. And the picture is made whole by light, also a presence—no tone or texture is unresolved; from corner to corner, like an insubstantial tapestry, the light justifies a perfect space.

EDWARD STEICHEN
American, born Luxembourg, 1879

Pillars of the Parthenon. 1921
Platinum print, 20¼ x 13½
Gift of the artist

When in 1963 Edward Steichen prepared his autobiography *A Life in Photography*, he selected 241 of his own pictures to be reproduced. The earliest had been made in 1895, the most recent in 1959. The span of time that they bridged represented over half of the total history of photography.

For over half a century Steichen was repeatedly an innovator and prime mover on not one but many of photography's frontiers. The lyrical impressionist landscapes of his youth, the bold formal experiments and brilliant portraits of his middle years, and the heroic documentary projects and thematic exhibitions that he directed in his maturity constitute in sum a staggering individual contribution to photography's achievement.

No period in his long career was artistically more rewarding than the decade of the 1920's. During the War Steichen's experience in aerial reconnaissance photography had given him a new appreciation of the beauty and force of factual, unmanipulated photography, with its psychologically compelling detail and its rich and brilliant range of tones. When he returned to his personal work after the War, he revised his photographic style radically, to make full and frank use of these distinctive qualities of the medium. The surprisingly abstract quality of aerial photographs (they deal basically with only two dimensions) may have also contributed to the more rigorous, muscular sense of form that appears in Steichen's subsequent work.

In the previous decade, photographers—most especially Paul Strand and Charles Sheeler—had begun consciously to explore the expressive potential of the photographic detail: the part that would represent the whole. This approach produced a new breadth and simplicity in photographic design, and equally important, a new poetic ellipsis in photography's approach to significant content. This new intuition allowed photographers to use the camera directly and realistically, and at the same time abandon the kind of leisurely, discursive literalness that had characterized most earlier straight photography.

From a typical nineteenth-century photograph of the Parthenon, one might have built a rough imitation of the original—and in fact thousands of rough imitations *were* built largely on the basis of photographic evidence. Steichen's picture, on the other hand, would not be of much use to an architectural plagiarist, but it conveys a tangible and immediate sense of the space and scale and drama of the great construction. It deals not with the concept of architectural styles, but with the adventure of building grandly—and with confidence, heroism, eternity, and time.

BARON ADOLPHE DE MEYER
American, 1868 [?]–1946

Helen Lee Worthing. 1920
Platinum print, 9½ x 7½
Gift of Richard Avedon

For most of the first century of its existence, photography was a branch of publishing, and photographers were small publishers. They produced in their own shops postcards, stereo views, celebrity portraits, landscapes, and records of notable events. These pictures were produced as original photographic prints, often in sizable editions, and were distributed locally or regionally by the photographer himself. As late as the 1930's, the postcard display in a typical provincial drugstore was likely to be dominated by photographic prints made of local scenes by a local photographer. This was however the vestigial last stand of the photographer as publisher; by this time the brightest and most talented of his fellows were making photographs for a much larger audience, and for much larger fees.

The revolution had been caused by the development of modern photomechanical reproduction, which could more or less reproduce a photographic image, in large quantities, for a tiny fraction of the cost of a photographic print. The halftone plate, which could reproduce photographs along with type, had reached an advanced state of development by the 1890's; after the First World War the more progressive magazines were regularly reproducing photographs as an important part of their content.

To the photographer, the new situation meant that he was now a member of a team, speaking to a large audience that he did not know, about issues that were generally assigned from above. On the other hand, he could spend more time and money on a single picture; more important, he could believe that his work was useful to the larger world.

Among the first magazines to make inventive use of photography were the fashion magazines, and Baron De Meyer was probably the first photographer of exceptional talent to turn this opportunity to advantage. De Meyer's picture of Helen Worthing is distinguished by its frank and luxurious use of artificial light; the techniques and the glamour of the theater had been adapted to photography.

De Meyer himself was something of a mystery; his birthdate and birthplace are unknown, and whether "Baron" is to be considered a title (either inherited or self-assigned) or a given name was never made clear. In the world of high fashion such ambiguities were perhaps not rare.

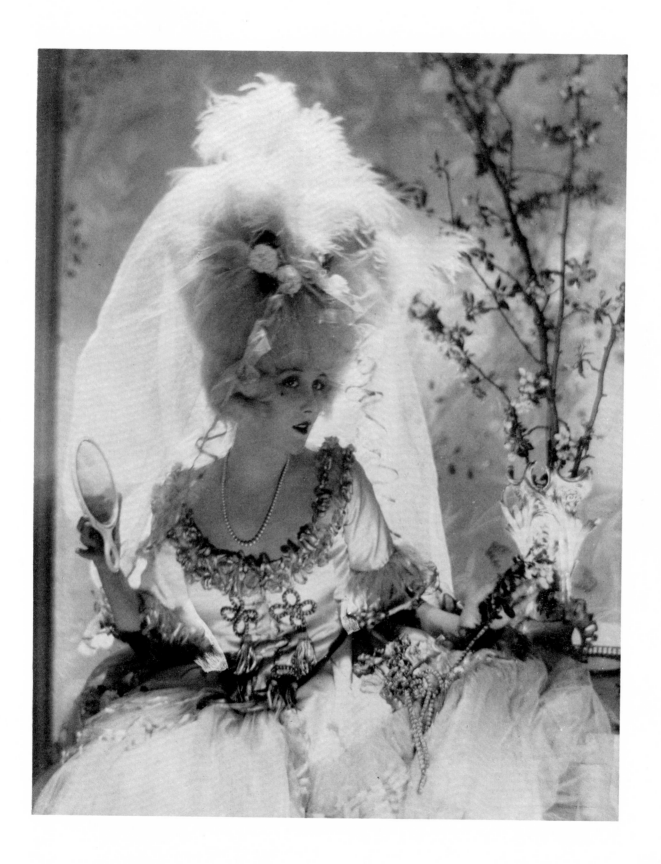

PAUL OUTERBRIDGE
American, 1896–1958

Untitled. 1922
Platinum print, 3½ x 4½
Gift of David H. McAlpin

During the thirties and forties Paul Outerbridge was a famous and successful commercial photographer, noted especially for the high quality of his color illustrations, which were done in those years by means of an extremely complex and recalcitrant process called the carbro print. In all the arts, work that is praised when new because of its difficulty is often forgotten once the technical problem has been simplified. Such is the case with most color photography of a quarter century ago, including that of Outerbridge.

He was, nevertheless, a photographer of exceptional talent, and it is perhaps a comment on the profession rather than on Outerbridge to say that his best work was done when he was a youthful student in the Clarence White School of Photography. These pictures exhibit an original sense of abstract photographic form, which remains impressive even in the work of the twenties—a decade in which pure graphics was a central preoccupation of adventurous photography.

The photograph reproduced here is a puzzle—literally and surely intentionally. A three-dimensional form (apparently but not assuredly a bricklike form, with parallel edges) rests on or floats in a plane or space that cannot be rationalized. The puzzle is made more challenging by virtue of the very real and specific quality of light that falls on the subject. In sum, the picture is a challenge to our naïve trust in the evidence of our senses.

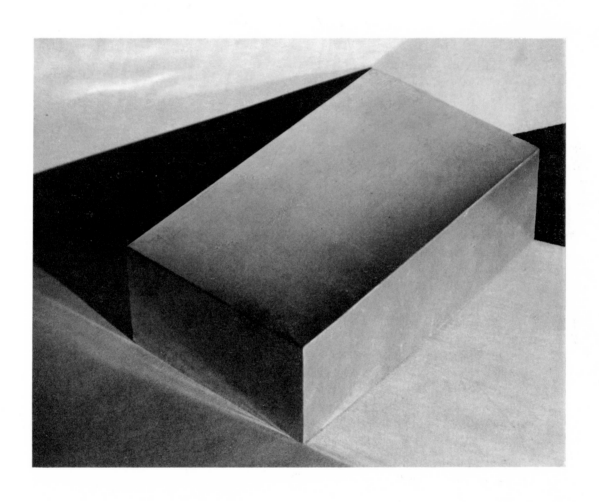

MAN RAY
American, born 1890

Rayograph. 1922
Photogram. 10⅞ x 11¾
Gift of James Thrall Soby

It is perhaps appropriate to note here that there is no satisfactory and simple definition of the word photography that is not a tautology: *e.g.*, photography is the process by which photographs are made. Whether one attempts a more meaningful definition in terms of chemistry, optics, or graphic traditions, the result will surely exclude works that are, by tradition, parentage, and common sense, photographs. Actually, the word photography stands for a family of processes united by the fact that they produce images through the agency of natural energies.

Man Ray's picture is made without using a camera or a lens. In the strict sense it should not be called a print (not even a monoprint) since it is not transferred from a matrix. It was made by exposing a piece of photographic paper to the light of a bare bulb, which cast onto the paper the shadows of intervening objects. The blackest areas are those that were exposed longest to the light; the whitest areas occur where no light struck the paper. Man Ray made this picture by exposing the paper at least three times, casting, in turn, shadows of the two heads, the hands, and the two vaselike rectangular forms.

It is impossible to say which planes of the picture are to be interpreted as existing closer or deeper in space. The picture is a visual invention: an image without a real-life model with which we can compare it.

The issue of transparency was of interest to artists in all media during the early twentieth century. Transparency implies spatial ambiguity: The wall of a modern glass building is simultaneously window, skin, and mirror. The multiple perspectives and spatial inversions of Cubism, the time-lapse studies of the Futurists, and the montages of film-makers like Podovkin, all challenge the idea of solid and continuous forms existing in a discrete Euclidian space. The photogram was an ideal tool for the exploration of the new non-sculptural space. Moholy-Nagy called it "the most completely dematerialized medium which the new vision commands."

Making photograms was also fun. The final image was never precisely predictable; unexpected gradations in tone created imaginary vistas that were surprising and delightful. For Man Ray, to whom art was a sublime kind of play, the technique was perfect.

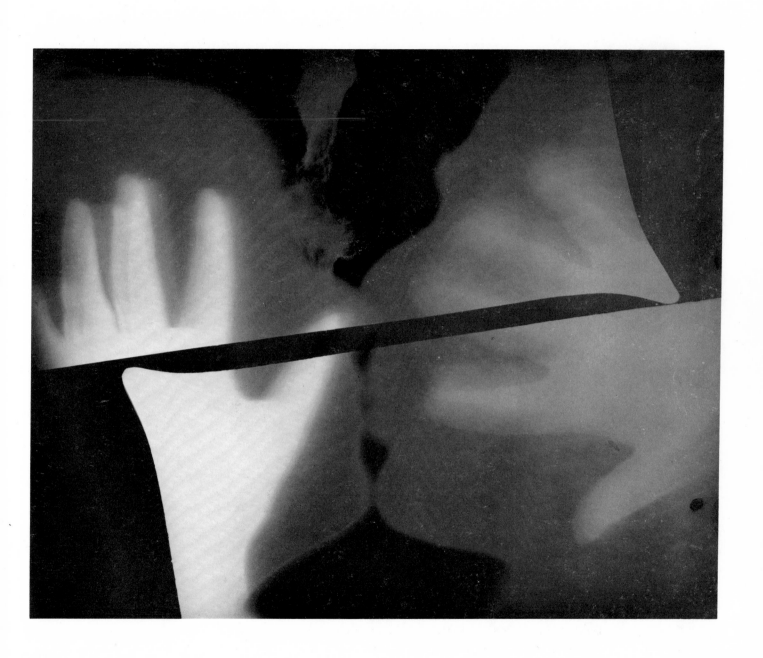

EDWARD WESTON
American, 1886–1958

Torso of Neil. 1925
Platinum print, 9⅛ x 5½

Photography is a matter of eyes, intuition, and intellect. For eyes and intuition, no photographer was ever more richly endowed than Edward Weston.

Weston had been a skillful and successful photographer for more than a decade when in the early twenties his own unique vision began to reveal itself. By 1930, when he was forty-five, he had produced a body of work that would come to identify him as a major artist, a man whose work has changed our perception of what the world and life are like.

It was as though the things of everyday experience had been transformed for Weston into organic sculptures, the forms of which were both the expression and the justification of the life within. The exhilarating visual power of Weston's work is the product of a deeper achievement: He had freed his eyes of conventional expectation, and had taught them to see the statement of intent that resides in natural form.

The nude torso of Weston's son Neil is not a simile but a statement of fact; the boy's flesh is not like alabaster or bronze or the cheek of a peach; his body is not formed like a stone column or a wineskin or a root vegetable. This startlingly beautiful photograph is the more surprising because it describes with precision what we might have thought we already knew.

On formal grounds alone it is an eloquent picture. The profile of the body on the right side of the picture draws a beautiful line. The effect of this line depends on its closeness to the frame, the baseline against which its undulation is measured. A teacher of drawing once pointed out to his students, in trying to persuade them to use the whole sheet of paper, that a peanut in the bottom of a barrel was merely a spot, whereas a peanut in a penny matchbox was a piece of sculpture.

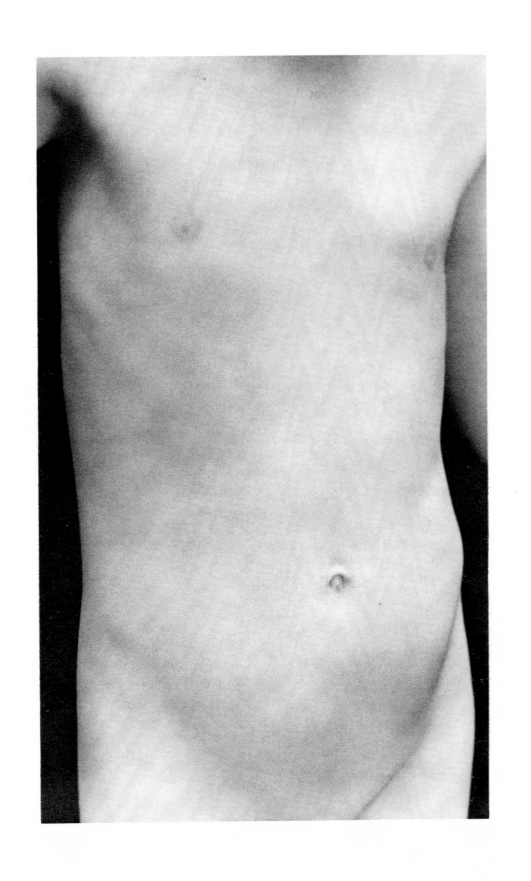

TINA MODOTTI
Italian, 1896–1942

Staircase. c. 1923–1926
Platinum print, 7⅛ x 9⅜
Anonymous gift

Most of Tina Modotti's work that is known to the photography world was done in Mexico in the years 1923 through 1926, when she lived and worked with Edward Weston. She apparently continued to work after 1926, at least until 1930, when she was deported from Mexico for Communist activity.

The photograph reproduced here is entitled "Staircase," but it is only in the most abstracted sense an architectural photograph; it is concerned with a different kind of structure, related perhaps to folded paper birds and geometric puzzles. It is a picture of space becoming pattern—a construction of lines and triangles stretched very tightly toward two dimensions—in which depth is both precisely described and subtly denied.

Two technical aspects of the picture are interesting in terms of their relationship to Modotti's conception. The two-dimensionality of her picture has been strongly emphasized by the very heavy exposure of her negative, which has raised the values of the planes of the picture to a narrow range of light grays; only the thin straight lines of joinery are described as black. In addition, she has photographed her subject from a greater than normal distance (*i.e.*, with a long focal-length lens), thus minimizing the effect of diminishing perspective. The pattern of the picture approaches the quality of an isometric projection— a perspective drawing made from an infinite distance.

Although it is doubtless (or probably) irrelevant to the issue at hand, Modotti was surely one of the most fascinating women of her time, even without reference to her talent as an artist. She was an actress, a sometime revolutionary (by design or circumstance, or both), a great beauty, and a great mystery. The available evidence would suggest that everyone who crossed her path was profoundly impressed. Kenneth Rexroth identified her as a Kollontai type, and was terrified, but nevertheless called her the most spectacular person in Mexico City.

LÁSZLÓ MOHOLY-NAGY
American, born Hungary, 1895–1946

Ascona. 1926
14⅜ x 10⅞
Anonymous gift

László Moholy-Nagy possessed one of the liveliest and most versatile minds to come out of the revolution in artistic thinking that occurred in Europe after the First World War. In addition to being a painter, designer, and photographer, Moholy was perhaps the most persuasive and effective theoretician of the concept of art education that grew out of the Bauhaus, the experimental design school that flowered briefly in Germany during the days of the Weimar Republic. Through his own work, his teaching and writing, and through the influence of his colleagues and followers at the Chicago Institute of Design (which Moholy founded in 1938), his ideas have had a profound effect on the art and art theory of the past generation.

In none of the areas of his concern has his influence been greater than in photography. His deep interest in the photogram and the photomontage, techniques that stood as a halfway house between photography and painting, provided a challenging option to the doctrine of straight photography, which, especially in the United States, dominated serious photography. Nevertheless, Moholy's own straight photography was extremely interesting and distinctive. It was in fact straight only in the technical sense that the pictures were unmanipulated prints of images recorded by the camera; in terms of the perception that the photographs recorded, they were ambiguous, contrary, and wittily devious. Moholy's love of the camera was based on the fact that it demonstrated so persuasively that nothing was as it seemed. Judged by academic standards, his photographs were outrageously bad. Inevitably, the nominal subject of the picture was half lost in a maze of apparently accidental forms, distorted by unfamiliar perspectives, and framed as though the photographer had not finally decided what his subject really was. Such a judgment of the picture reproduced here would be natural enough if one thought that it was a photograph of two children, but it is not: It is a photograph of an unfamiliar visual experience, in which space contests with pattern for primacy. The effort to resolve the contradictory claims of the picture plane and the illusion of space has been one of the central preoccupations of twentieth-century art. The photographs of Moholy are a fascinating part of that history.

NICKOLAS MURAY
American, born Hungary, 1892–1965

Babe Ruth. c. 1927
13⅜ x 10⅜
Gift of Mrs. Nickolas Muray

Some artists—the greatest ones—are remembered as prophets, persons beyond their own time. These we regard with something like awe, and not always with comfort, as though they might reach out even from the grave to demonstrate that we have missed the point, utterly. Others are remembered as being wholly and contentedly of their time; with these we deal confidently, on a first-name basis, so to speak.

Nickolas Muray was not a notably innovative photographer; he was simply an excellent and dedicated one. For his portraits of Eugene O'Neill and George Bellows and Claude Monet and a score of others we are in his debt.

Muray's picture of the great George Herman Ruth perhaps is innovative after all. The patent artificiality of the situation (suggesting somehow a bull being photographed in a china shop) emphasizes the direct natural force of the subject: a lion at rest. The retoucher has smoothed and softened Ruth's face slightly, but the hungry mouth and eyes might still inspire nightmares in aged baseball pitchers. The eyes seem unusually far apart; perhaps this improved his binocular vision, and enabled him to follow better the twisting little ball, as it came toward him as fast and hard as the other man could throw it.

Here is the great athlete at the height of his powers. The next season he hit three home runs in the deciding game of the World Series, causing *The New York Times* to forget both its reserve and its syntax. He had, the paper said, scaled "a baseball Matterhorn where no foot had ever trod before."

ANDRÉ KERTÉSZ
American, born Hungary, 1894

Montmartre. 1927
6⅛ x 8⅛

Perhaps more than any other photographer, André Kertész discovered and demonstrated the special aesthetic of the small camera. These beautiful little machines seemed at first hardly serious enough for the typical professional, with his straightforward and factual approach to the subject. Most of those who did use small cameras tried to make them do what the big camera did better: deliberate, analytical description.

Kertész had never been much interested in deliberate, analytical description; since he had begun photographing in 1912 he had sought the revelation of the elliptical view, the unexpected detail, the ephemeral moment—not the epic but the lyric truth. When the first 35mm camera—the Leica—was marketed in 1925, it seemed to Kertész that it had been designed for his own eye.

Like his fellow Hungarian Moholy-Nagy, he loved the play between pattern and deep space; the picture plane of his photographs is like a visual trampoline, taut and resilient. In the picture opposite half of the lines converge toward a vanishing point in deep space; the other half knit the image together in a pattern as shallow as a spider web, in which the pedestrian dangles like a fly.

In addition to this splendid and original quality of formal invention, there is in the work of Kertész another quality less easily analyzed, but surely no less important. It is a sense of the sweetness of life, a free and childlike pleasure in the beauty of the world and the preciousness of sight.

ALEXANDER RODCHENKO
Russian, 1891–1956

Assembling for a Demonstration. 1928
19½ x 13⅞
Mr. and Mrs. John Spencer Fund

One might believe that the photograph reproduced on the opposite page was made by Moholy-Nagy, or Kertész, but it would be difficult to believe that it was made before the twenties. Certain possibilities concerning the appearance of the world first surfaced at that time, just as different possibilities had revealed themselves in previous periods, and would reveal themselves in future periods. It is, if one focuses on the fact, astonishing that no one had drawn or painted or photographed a picture quite in this spirit before 1920 A.D., although there was no technical reason why it should not have been done half a millennium earlier, in the square of San Marco.

Perhaps the point is that new pictures are derived from old pictures, just as in biology new species are derived from existing species. In both cases, deductive leaps are not really possible. Although there are many missing links in our art historical knowledge, none was skipped as the chain was forged.

Pictures from high vantage points were not really new in the twenties; it is rather a question of what one sees from one's vantage point. Alexander Rodchenko called his photograph "Assembling for a Demonstration," but he has inverted the hierarchical importance of the elements of his picture, and shows us chiefly a woman with a dustpan, sweeping, another woman watching, a vertiginous perspective, and a pattern of spots on the street, the most important of which are not the demonstrators but the stains left, perhaps, by a leaky street sweeper.

Rodchenko was one of the most important of the modern Russian artists who emerged after the revolution. He was a distinguished avant-garde painter, graphic designer, and photographer during the heady period of the twenties in Russia, when artists' faith in the revolution had not yet seriously eroded.

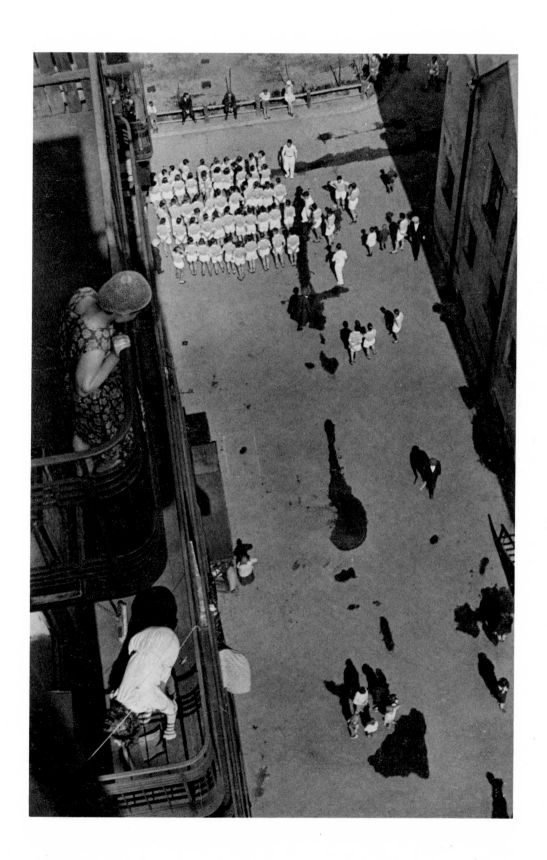

PAUL STRAND
American, born 1890

Toadstool and Grasses, Georgetown, Maine. 1928
9⁹⁄₁₆ x 7⁵⁄₈
Gift of the artist

In 1917 Paul Strand said that if one were to use photography honestly he must have "a real respect for the thing in front of him," which he would express "through a range of almost infinite tonal values which lie beyond the skill of human hand." The last half of the statement has to do with photographic aesthetics, the first half with photographic morality. "A real respect for the thing in front of him" implies that the subject is not merely the occasion but the *reason* for the picture. This stern creed (rather than technical and aesthetic positions) was perhaps the real cornerstone of belief in straight photography. It was a proposition more or less accepted by most advanced photographers, especially in the United States, between the two World Wars. Accepted at least in theory. Practice was another matter; photographers had after all become photographers because they enjoyed the mysterious and often nonrational excitement of picture-making.

It is interesting that Strand himself conformed to his theory more strictly as he matured. His work before 1920 exhibits a highly abstract bent and an obvious pleasure in graphic adventures. As the years passed his pictures became progressively more natural and more calm.

One of the most beautiful and most influential parts of Strand's heroic oeuvre is the series of closeup nature studies that he began in the early twenties. These pictures are not merely descriptions of particular botanical or geological forms; they are, rather, miniature landscapes, organized with the same rigor and described with the same sensitivity to light and space that Strand would have accorded a grand vista. When the great wild continent had been finally conquered, Strand rediscovered the rhythms of the wilderness in microcosm.

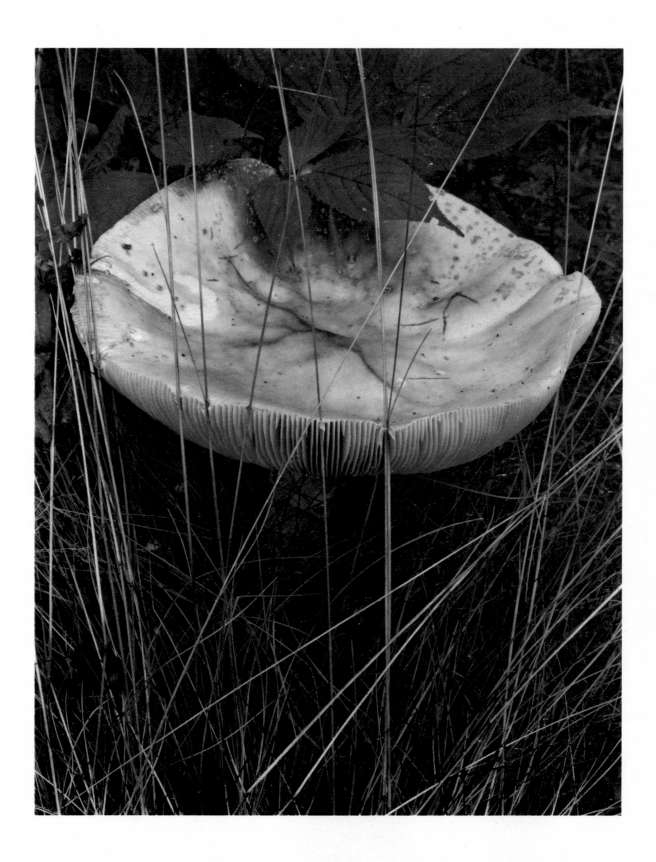

BERENICE ABBOTT
American, born 1898

James Joyce. 1928
13½ x 10⅜
Stephen R. Currier Memorial Fund

Berenice Abbott was one of the tiny horde of Midwestern Yankee Americans who in the 1920's temporarily reversed the Course of Empire, and transferred the center of American cultural life to Paris. She arrived there in 1921 as a sculptor, and continued her studies with Émile Bourdelle. In 1923 she became an assistant in the photography studio of Man Ray, and two years later she first saw the photographs of Eugène Atget. She was irrevocably marked by the pure photographic authority of his work, and any remaining question as to her own life's work was settled.

In 1926 she opened her own portrait studio, and for the next three years photographed with honesty and grace the great and the famous of that city's intellectual world. In Paris the supply of artists, artistic celebrities, and *salonistes* seemed inexhaustible, and Abbott photographed many of them.

One of the most moving of her portraits is the one reproduced here of James Joyce. The gray, strangely lifeless, enveloping light finds its way everywhere, describing without emphasis or favor the writer's stickpin, his hands, his right ear, his fine beaver hat, the deep tiredness of his elegant slouch. He seems the survivor of too difficult a battle, shell-shocked by the terrible labor of putting so many words in the precisely proper order. He was burdened at the time not only by exhaustion but by the pirating of his work, by his wife's serious illness, by deadlines, and by his degenerating eyesight. He wrote to Harriet Shaw Weaver: "There are moments when I feel 20 but also half-hours when I feel 965." Possibly he meant 969, Methuselah's final age, but considering the precision of Joyce's mind it is more likely that he meant he felt four years younger than that.

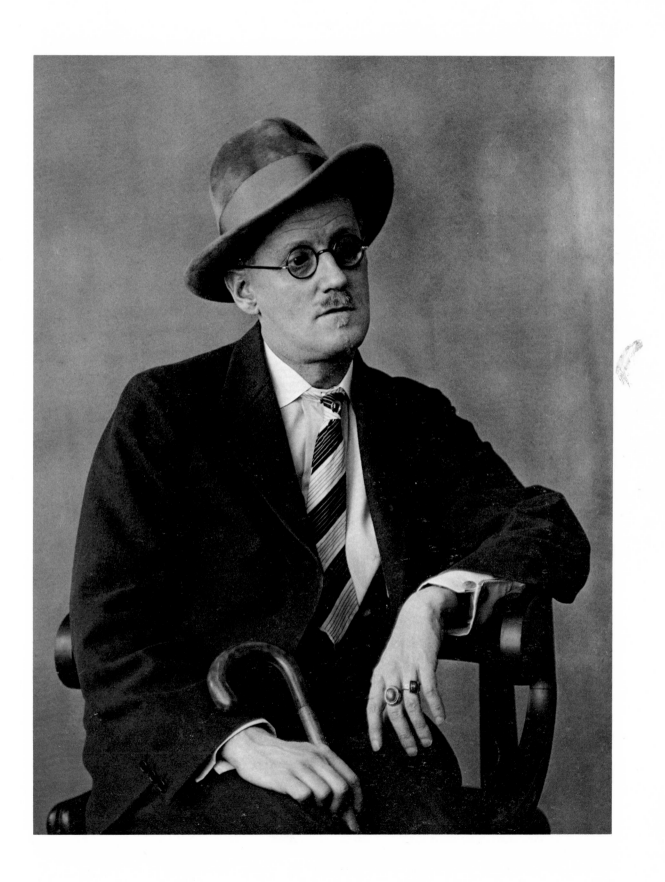

IMOGEN CUNNINGHAM
American, born 1883

Leaf Pattern. Before 1929
9¼ x 7⅛
Gift of Albert M. Bender

It might be interesting to compare Imogen Cunningham's "Leaf Pattern" here with Strand's "Mushroom and Grass" on page 97. In a technical sense both pictures are straight photographs; Cunningham's picture is approximately as faithful a rendering of what her camera was pointed at as Strand's is of *his* subject. It is nonetheless clear that Cunningham was less interested in what the plant was than in what else it might become under pressure, photographed in the right light from the right vantage point. In this sense her picture is more typical of the twenties than Strand's is. Photography in that decade had discovered a battery of new ideas and perspectives that could alter the familiar appearance of things, among which was the closeup, natural-form pattern photograph. It would seem that a million such photographs were made during the period in Germany alone.

Cunningham's spectacularly handsome picture remains exciting because it avoids the vacuous predictability that identifies so many of these design-in-mother-nature photographs. The liveliness and surprise of this image depend upon the fact that she recognized and used not only the forms of the plant itself, but also the temporary and accidental forms created by the interstices between its leaves, and by overlapping, and by the effect of the dramatic—even theatrical—light. Cunningham has discovered a new structure, made half of fact and half of aspect, which amplifies the structure of her subject.

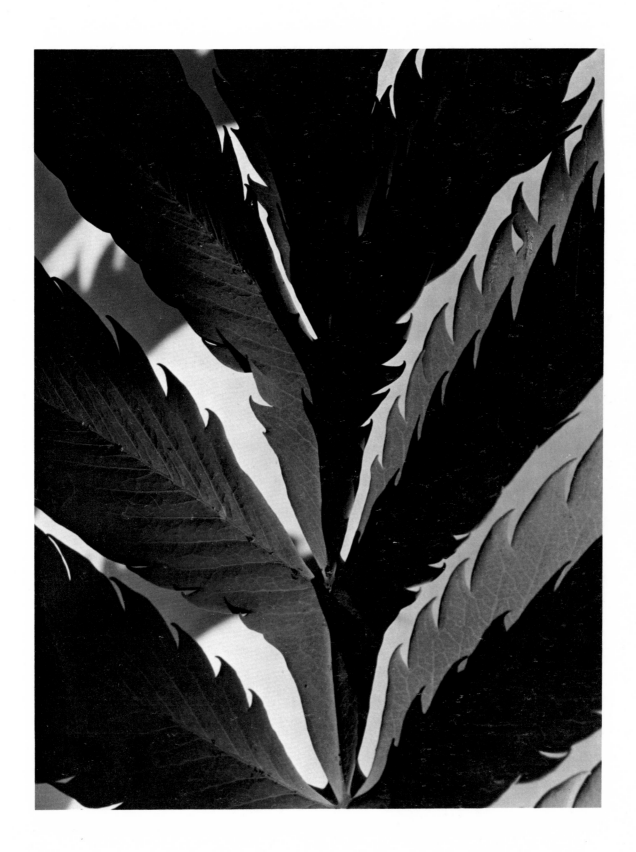

AUGUST SANDER
German, 1876–1964

[Circus People] 1930
8¼ x 10
Gift of the artist

Early in his career, perhaps after tiring of prizes that were too easily won, August Sander set for himself a problem that ranks among the most ambitious in the history of photography: He assigned himself the project of making a photographic portrait of the German people. He set about his task as systematically as a taxonomist, gathering, specimen by specimen, exemplary players of the roles that defined German society. Hod carrier, gamekeeper, confectioner, student, functionary, industrialist—piece by piece Sander collected the elements for his composite portrait.

His concept is almost a caricature of teutonic methodology, and if it had been executed by a lesser artist the result might well have been another dreary typological catalogue. Sander, however, was a very great photographer. His sensitivity to his individual subjects—to expression, gesture, posture, costume, symbol, habitat—seems unerringly precise. His pictures show us two truths simultaneously and in delicate tension: the social abstraction of occupation and the individual soul who serves it.

Sander was a professional portrait photographer, but many of the subjects for his great project surely did not pay him. Some doubtless could not, and others, if paying customers, would have expected to be shown less fully revealed. In his professional role he must have made safe and routine portraits, but there are none among the two hundred or more of his published works.

On the evidence of these pictures, it would seem that he found every station and every individual of consequence.

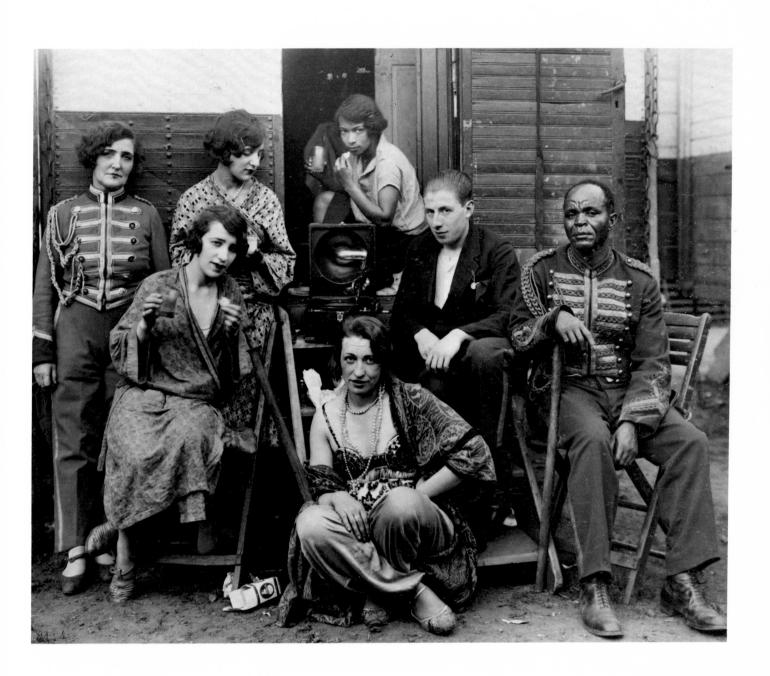

RALPH STEINER
American, born 1899

American Rural Baroque. 1930
7½ x 9½
Gift of Lincoln Kirstein

In the forty-three years since this picture was made, its subject matter has acquired a good deal of nostalgia value, and it is perhaps best to point out for younger readers that the chair in 1930 was not a charming antique, but simply a ridiculous and embarrassing middle-aged mistake, dating perhaps from the administration of William Howard Taft. The porch was also very ordinary, connoting not so much the virtue of simplicity as the vice of conservative provincialism.

This speculation, if accurate, suggests that the picture's content might have been slightly different then from what it is now. The picture may indeed have been half comic: the sow's ear of a chair casting the grandiose, Steinbergian ornament on the humble clapboard wall. The setting of the picture is, furthermore, a funny place to find Cubist projections. (In this connection it is very important that the back of the chair visually touch its shadow. It is likely that Ralph Steiner moved the chair; it could surely not rock in its present position.)

The meanings of pictures change. It is well established, however, that the very best pictures adapt themselves to many changes in meaning.

The other half of the picture's content—the cool and watery softness of the late afternoon light—was presumably no less affecting and beautiful in 1930 than it is today.

104

CHARLES SHEELER
American, 1883–1965

Cactus and Photographer's Lamp, New York. 1931
9½ x 6⅝
Gift of Samuel Kootz

Charles Sheeler liked clean-edged planes and geometric shapes and the clear, airless light that defined them with precision. His best known photographs are from the three series that he made of Chartres cathedral, Shaker architecture, and the Ford plant at River Rouge. These subjects, spread across seven centuries of history, are much alike in Sheeler's pictures; each seems the work of a mathematically inclined constructivist. Even in his own studio (opposite) Sheeler found the same neat chess game of planes and shapes.

Sheeler is doubtless better known as a painter than as a photographer. During the early years of his career, and during slack periods later, Sheeler supported himself as a photographer. When the market for his paintings was secure, Sheeler continued to photograph for pleasure, for basic visual knowledge, and to gather notes for his painting. It might be suggested that if photography supported Sheeler during part of his life, it supported his painting throughout his career. In the same year that Sheeler made the photograph reproduced here, he made a painting of the same subject. In normal black-and-white reproduction, it is not easy to know which picture is which, except that the painting omits the spines on the cactus, making the individual branches look like slightly inflated balloons. It is generally assumed, though perhaps not definitely documented, that the photograph preceded the painting.

ERICH SALOMON
German, 1886–1944

French Statesmen Visit Berlin for the First Time Since World War I. 1931
11⅛ x 14⅛
Gift of Peter Hunter

When cameras became small enough and lenses and films fast enough, the possibility suggested itself that even the immemorially secret aspects of human affairs might be photographed. One such area was that of diplomatic negotiation, which until the late twenties was practiced behind closed doors, often with good brandy and good cigars, but never with photographers. The man who first violated this very sensible convention was a photographer of considerable talent, and evidently enormous persuasive powers named Erich Salomon. Salomon often convinced those in authority that it would be a good thing if the people of the world could see the diplomats around the coffee table, working. It may have been suggested that a greater public interest in the negotiating process might contribute to wiser and more equitable decisions.

On those occasions when Salomon was not allowed entrance to the conference, he sometimes did the best he could by shooting through the window. The picture opposite is in fact one of the most persuasive of his high-diplomacy pictures, for it allows us to believe that if we were inside the room we would understand everything. When Salomon did take us inside the room, he showed us tired and worried middle-aged men in well-cut dinner jackets, often holding brandy and cigars. The pictures are endlessly fascinating, but their contribution to our understanding, if any, had no noticeable practical effect.

The picture reproduced here shows a meeting of European diplomats at the Chancellor's Palace in Berlin, in September of 1931. The man below the left edge of the painting is Aristide Briande. The others are no doubt also very important men.

BRASSAÏ
[Gyula Halász]
French, born Transylvania, 1899

Dance Hall. 1932
11½ x 9¼
David H. McAlpin Fund

Brassaï took his name from the town of his birth, Brasso, in Transylvania, then part of Hungary, later of Roumania, and famous as the home of Count Dracula. He studied art at the academies of Budapest and Berlin before coming to Paris in the mid-twenties. He was completely disinterested in photography, if not scornful of it, until he saw the work being done by his acquaintance André Kertész, which inspired him to take up the medium himself. In the early thirties he set about photographing the night life of Paris, especially at its more colorful and more disreputable levels. The result of this project—a fascinatingly tawdry collection of prostitutes, pimps, madams, transvestites, apaches, and assorted cold-eyed pleasure-seekers—was published in 1933 as *Paris de Nuit,* one of the most remarkable of all photographic books.

Making photographs in the dark bistros and darker streets presented a difficult technical problem. Brassaï's solution was direct, primitive, and perfect. He focused his small plate camera on a tripod, opened the shutter when ready, and fired a flashbulb. If the quality of his light did not match that of the places where he worked, it was, for Brassaï, better: straighter, more merciless, more descriptive of fact, and more in keeping with Brassaï's own vision, which was as straightforward as a hammer.

When *Paris de Nuit* was published, the great photographer and theorist Dr. Peter Henry Emerson, then approaching eighty, wrote Brassaï in care of his publisher, asking Brassaï to please send his proper address, so that Emerson could send him the medal that he had awarded him for his splendid book. It is an interesting comment on the chaotic incoherence of photographic history that Brassaï had never heard of Emerson.

The nature of the misunderstanding between the couple in the picture opposite is too serious and too private to speculate about. In any event it is not important whether their relationship was personal or commercial, or both. The photograph is about the bitter and desperate disappointment of private loss. Who else ever made a picture so full of wormwood?

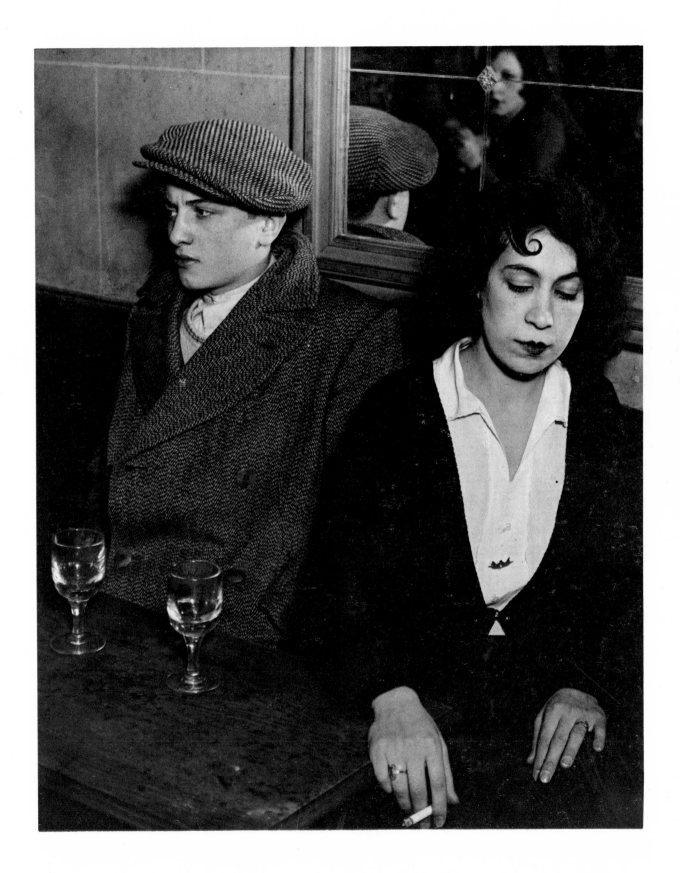

HENRI CARTIER-BRESSON
French, born 1908

Cordoba, Spain. 1933
14⅛ x 9¼
Gift of the artist

Henri Cartier-Bresson has described himself as a photojournalist, a label doubtless no more misleading than any other available. To put the identification in a fuller perspective, it might be added that he is probably the only photojournalist to have studied painting with André Lhote, the chief academician of Cubism, and also that relatively few of his pictures are concerned with journalistic events in the traditional sense. It is also true that many of his finest pictures have been made not on assignment, but out of an amateur's fascination with the world about him; but this is of course true of most important photographers. A photographer's best work is, alas, generally done for himself.

Without minimizing the value of his work as reportage, it must be said that Cartier-Bresson's photographs are revered by other photographers because they are beautiful. They possess grace, balance, surprise, economy, tension, and visual wit: the qualities of a good gymnast or dancer. Or the qualities of a good picture.

This is not to suggest that Cartier-Bresson's pictures are abstractions. They spring from a response to specific life; their formal eloquence is a tribute to their human meaning. If they were less they would be, to Cartier-Bresson, solutions without problems.

The photograph opposite concerns gesture, line, shape, scale, the flatness of the picture plane, and the difference between art and life. To say that the picture concerns these things does not, of course, mean that it explains them.

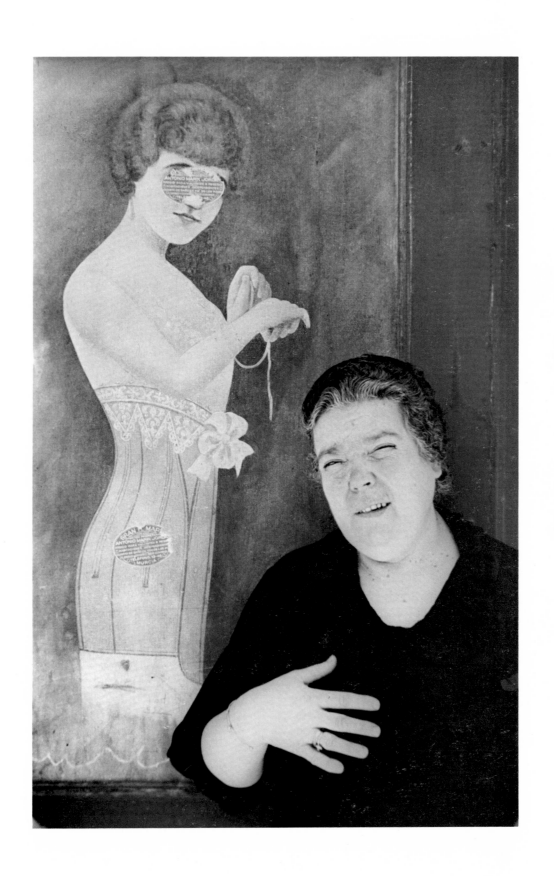

DR. HAROLD E. EDGERTON
American, born 1903

Wes Fesler Kicking a Football. c. 1935
13¼ x 10⅜

Like many of the experimenters of photography's earlier history, Harold Edgerton has used the camera as a tool for the gathering of new technical knowledge. Photography for him has been primarily a servant of his work as scientist, inventor, engineer, and teacher.

In 1931 Edgerton developed a greatly improved version of the stroboscopic light. The principle of the stroboscope is illustrated by the wagon wheel effect in western movies: If the wheel revolves exactly twenty-four times a second, the movie camera will photograph it twenty-four times in the same position, and the wheel will appear stationary when the film is projected. Similarly, if a machine operating at constant speed is illuminated by a light flashing intermittently at the same speed, the machine can be studied as though at rest. This was the main function of Edgerton's light, but because its flash was capable of extreme brilliance and interval speed, and brevity of duration, it was also of great value for photographic motion studies.

These pictures were of two sorts: One sort used the repeating flash to record the cumulative forms described by bodies moving through time. The French physiologist Etienne Jules Marey, and also Thomas Eakins, had made primitive photographs of this sort in the 1880's. A generation later the idea had interested Marcel Duchamp and the Futurists. With Edgerton's sophisticated equipment the analytical potential of such pictures was remarkable. To take a simple example, from a sequence photograph of Bobby Jones hitting a golf ball, one could calculate the acceleration of the club, its speed at impact, the force of impact, and the speed and acceleration of the ball. Had there been a hitch in Jones's swing, it would also be clearly revealed.

The other kind of photograph made possible by Edgerton's electronic flash was the single exposure of extremely short duration, so short that it seemed to show empty spaces between the thinnest slices of time. The picture reproduced here is of this kind.

Although Edgerton's basic motive has been informational, not aesthetic, he has consistently made pictures that have been bold, stylish, and dramatic. It is difficult to know whether this is the natural result of his clear intellectual grasp of the problem, or whether an intuitive aesthetic concern is also at work. Perhaps the two are sometimes more closely related than C. P. Snow and others have led us to believe.

Very high-speed photographs often contain fascinating minor surprises, footnotes to the main idea that we would not have anticipated: The little crescent shape just to the left of the upper end of the football is dust, which a fraction of a millisecond earlier was on the surface of the ball. This illustrates the first law of kinetics, which concerns inertia.

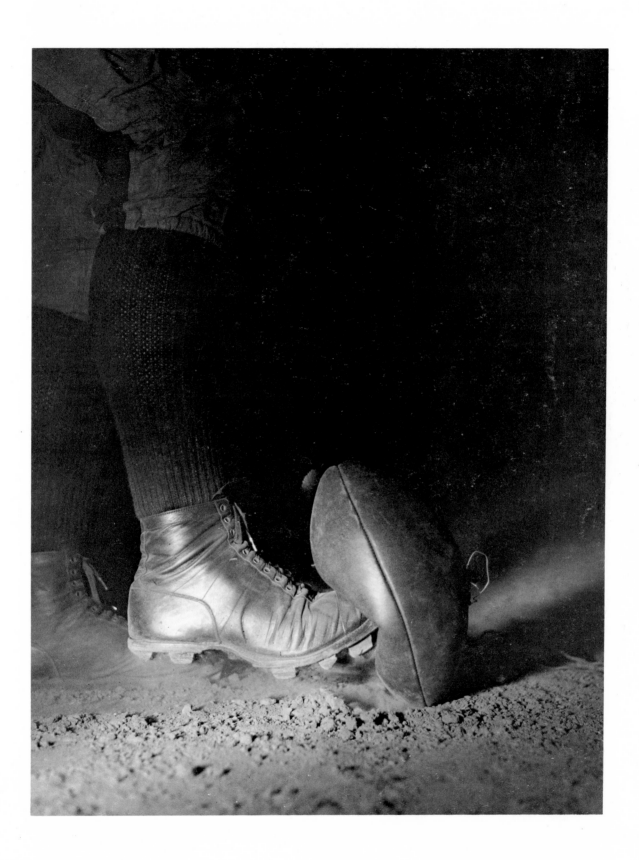

WALKER EVANS
American, born 1903

Penny Picture Display, Savannah, Georgia. 1936
8⅝ x 6⅞
Gift of Willard Van Dyke

The abstract visual games that had entranced and delighted most adventurous photographers during the decade of the twenties had lost much of their charm by the early thirties. Our fondness for historical symmetry makes it tempting to ascribe the change to the problems of the period and to a heightened awareness among artists of social and political priorities. Unfortunately this explanation, neat as it is, does not quite fit the facts, which seem to demonstrate no dependable correlation between realism and social commitment, or between abstraction and social indifference. Moholy-Nagy, deeply committed to the social utility of art, was a formalist; Brassaï, the ultimate realist, seems totally immersed in the specifics of life, and scarcely aware of society. Edward Weston was not only apolitical but basically asocial; Paul Strand on the contrary has always been profoundly concerned with the social fabric. Yet beginning in the latter twenties the work of both men turned toward a more specific realism.

It seems likely that the change that occurred in photography around 1930 was fundamentally a matter of formal evolution—the result of what had gone before in photography. Positions that had been staked out during the preceding twenty years now seemed to offer diminished promise, especially to young photographers about to make their entrance. There were, however, other possibilities, positions that had only been hinted at by earlier work.

It was at this moment that sophisticated photographers discovered the poetic uses of bare-faced facts, facts presented with such fastidious reserve that the quality of the picture seemed identical to that of the subject. The new style came to be called documentary. This approach to photography was most clearly defined in the work of Walker Evans. Evans's work seemed at first almost the antithesis of art: It was puritanically economical, precisely measured, frontal, unemotional, dryly textured, insistently factual, qualities that seemed more appropriate to a bookkeeper's ledger than to art. But in time it became clear that Evans's pictures, however laconic in manner, were immensely rich in expressive content. His work constitutes a personal survey of the interior resources of the American tradition, a survey based on a sensibility that found poetry and complexity where most earlier travelers had found only drab statistics or fairy tales.

The photograph opposite is made through the glass of a provincial photographer's display window. It is an abridged catalogue of American physiognomy, costume, and style, a kind of composite self-portrait bearing on the question of who Americans thought they were in 1936—and a humorous tribute to the unintentional honesty of the photographer and his sitters. It is also a remarkable and original *picture*; unlike the photographer's window, it demands interpretation.

116

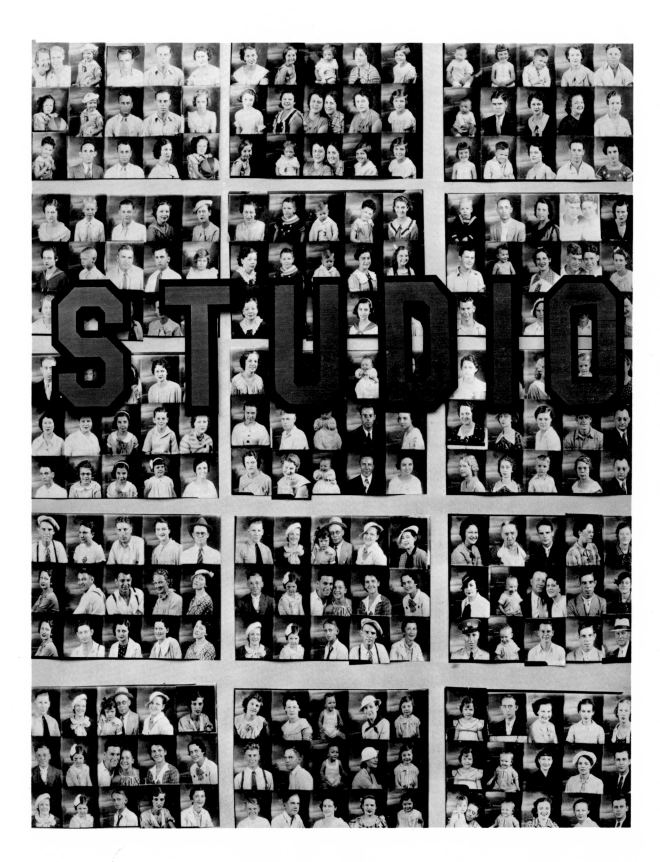

BEN SHAHN
American, born Russia, 1898–1969

New York. 1936
6¾ x 9
Gift of the artist

Ben Shahn picked up photography in the early thirties while sharing a Greenwich Village flat with Walker Evans, with the help of a little casual instruction from the master. It is, however, probably incorrect to suggest that Shahn learned photography from Evans; he had painted from various people's photographs before making his own, and this is perhaps an excellent way to learn how the medium works. After 1935, when he was hired, with Evans, as a photographer for the Federal Resettlement Administration, he presumably learned a little more about the technique of photography, but not very much more.

Shahn did not need to know very much about photography. For his purposes the camera was a magic box; one pointed it and pushed the button. The results, even when approximate, were nevertheless immensely useful to him as a painter. He once said that he wanted to get right in his paintings the difference between the way a cheap coat and an expensive coat hung. For this and a thousand other small verisimilitudes, photography was useful to him. It was even more useful as a means of noting new visual ideas: the character of a hand-lettered sign, or the beautiful, accidental scattering of shapes against a plane.

Shahn's chief strength as a painter was perhaps his graphic sense, and this talent, which is a matter of eye, also made him a formidable photographer, within the limits of his interest. The photograph shown here might be as fine a picture as he ever made, in any medium. It is not remarkable that the painting based upon it resembles it so closely, for to what purpose would he change it? What is remarkable is that the mechanical photograph resembles so closely the character of other Shahn paintings: the same asymmetrical, ceremonial figures, floating elegantly in the same shallow, shadowless space.

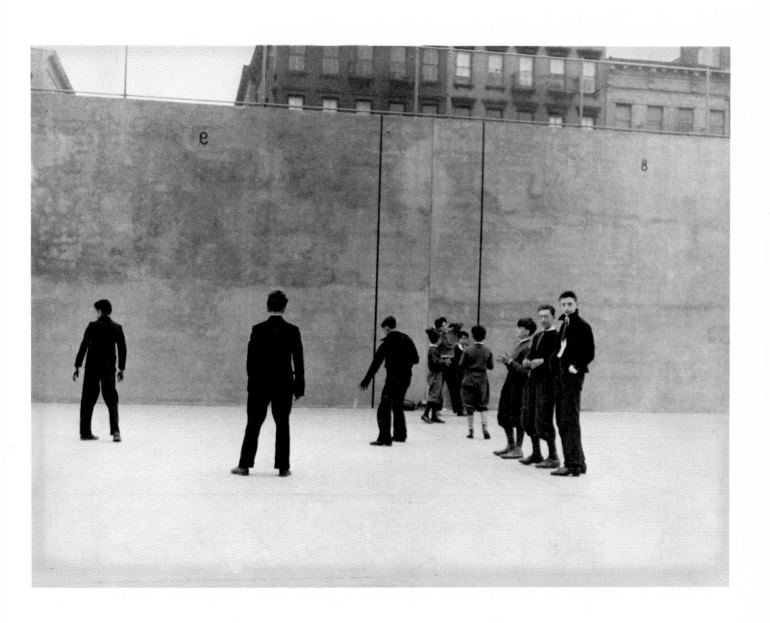

BILL BRANDT
British, born 1905

Young Housewife in Bethnal Green. 1937
26 x 20½

Nonartists often misunderstand the nature of artistic tradition, and imagine it to be something similar to a fortress, within which eternal verity is protected from the present. In fact it is something more useful and interesting, and less secure. It exists in the minds of artists, and consists of their collective memory of what has been accomplished so far. Its function is to mark the starting point for each day's work. Occasionally it is decided that tradition should also define the work's end result. At this point the tradition dies.

For purposes of approximate truth, it might be said that photographic tradition died in England sometime around 1905—coincidentally the year in which Bill Brandt was born. Brandt spent much of his youth on the Continent, and in the late twenties went to Paris to study with Man Ray. There he also discovered the photographs of Atget and the works of the French Surrealist film-makers. His own work already possessed a strongly surreal character—not the intellectually playful *irrationalisme* of his teacher Man Ray, but a mordant, poetic romanticism suggestive of de Chirico and Doré.

When Brandt returned to London in the thirties, England had forgotten its rich photographic past, and showed no signs of seeking a photographic present. In the forty years since, Brandt has worked virtually alone, with only intermittent contact with the main channels of contemporary photography. Such isolation can starve all but the most independent talents, but for these it can provide a sanctuary where radical visions can develop undisturbed. Brandt's work has been consistently separate from the photographic consensus of the moment: reflective when it should have been militant, romantic when it should have been skeptical, experimental and formal when it should have been factual.

In the years following his return to England, Brandt concentrated on photographing his countrymen, of all classes and conditions. These pictures are moving and strange; they express both sympathy and tranquil detachment, as though Brandt were photographing something that had existed long ago. Though unsparingly frank, his pictures seem to refer less to the moment described than to the issues of role, tenacity, courage, and survival.

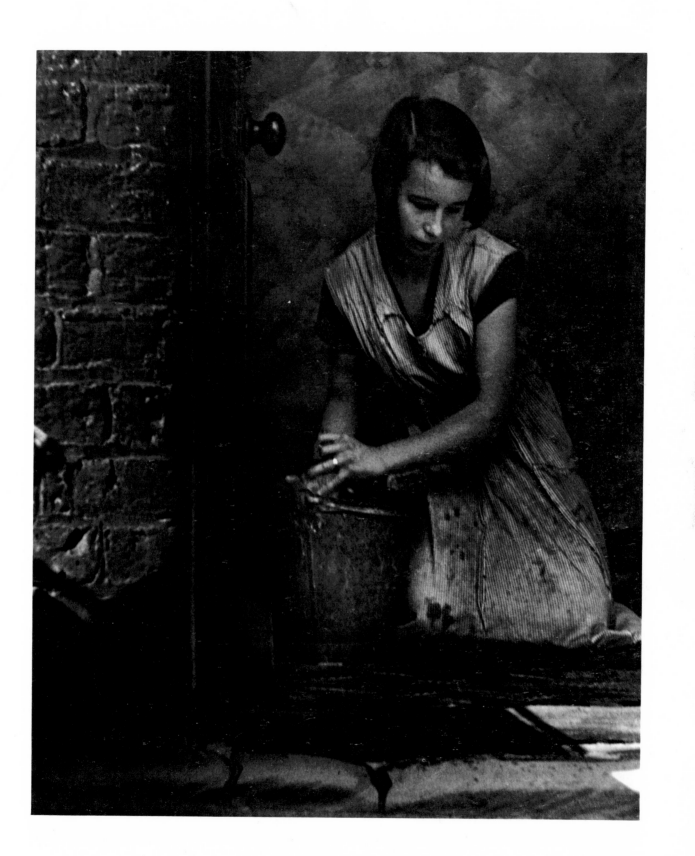

BRETT WESTON
American, born 1911

Broken Window, San Francisco. 1937
7½ x 9⅝
Gift of Albert M. Bender

If one compiled a chronology of photographic subject matter, listing when various subjects were first photographed, and by whom, Brett Weston would almost certainly be listed as the first photographer to make a closeup of a broken window. This was not as easy as it might sound, for it required the ability to see nothing as something. The black shape in the picture opposite is not a void but a presence; the periphery of the picture is *background*. The picture is an inversion—in a sense a negative image—of the conventional relationship of object to ground. Photographers have long been comfortable with various kinds of image inversions, being accustomed to composing their pictures upside-down and backwards (in the groundglass) and evaluating them with their values reversed (in the negative).

Brett Weston was a *wunderkind* of photography. When he was fifteen he worked side by side as an independent artist with his father Edward. By the father's admission, it was not always he who made the more challenging pictures. It seems very likely that among the influences on Edward Weston was the work of his son Brett.

The reverse is, of course, more obviously true. Brett's work has been done within the same conceptual framework as that of his father: the classical 8 x 10 inch view camera, the brilliant, precisely textured prints, the insistence on previsualizing the print before the exposure is made. These broad structural similarities have made it more difficult to recognize the distinctive quality of the younger man's vision. Brett Weston has characteristically seen the world graphically, in terms of pattern. When Edward and Brett photographed the same sand dune, the father made photographs that showed the sensuous, plastic sculpture of natural forms; the son's sand dunes emerged as constructions of flat planes, straight lines, and sharp angles. Many of these landscapes look, in fact, like segments of the broken window picture.

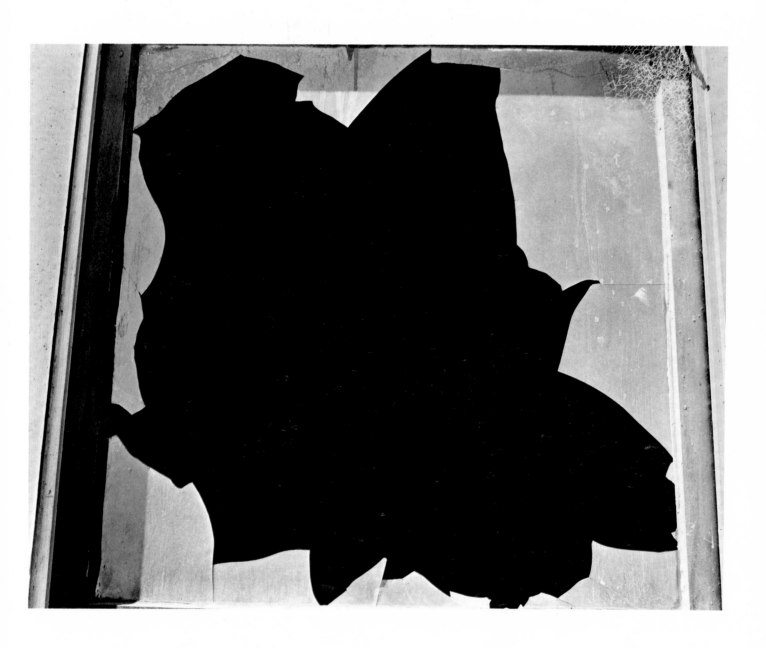

ROMAN VISHNIAC
American, born Russia, 1897

Grandfather and Granddaughter. 1938
16 x 20
Ben Schultz Memorial Collection. Gift of the artist

Henri Cartier-Bresson said that photographers deal in things which are continually vanishing, and which no contrivance on earth can bring back again. Not even photography can bring these things back, except in the memory of those who knew them, or in the imaginations of those who did not.

In 1938 Roman Vishniac photographed the Jewish ghettos of several Eastern European cities. His pictures suggest both the insularity and the universality of the ghetto, as it had been formed by Jewish values and external repression during half a millennium. They also show with remarkable intimacy the quality of the lives that were lived there, lives that expressed respect for form, reverence for religious learning, mutual dependence, and an abiding faith in the ancient promises.

The photograph reproduced here also has to do with the immemorial and universal burden placed on the young by the old—a burden secured by love, and by the human need for continuity. The girl, young and strong, bends to the will of the old man, who is full of the authority of the past, and closer than she, each would have thought, to the future.

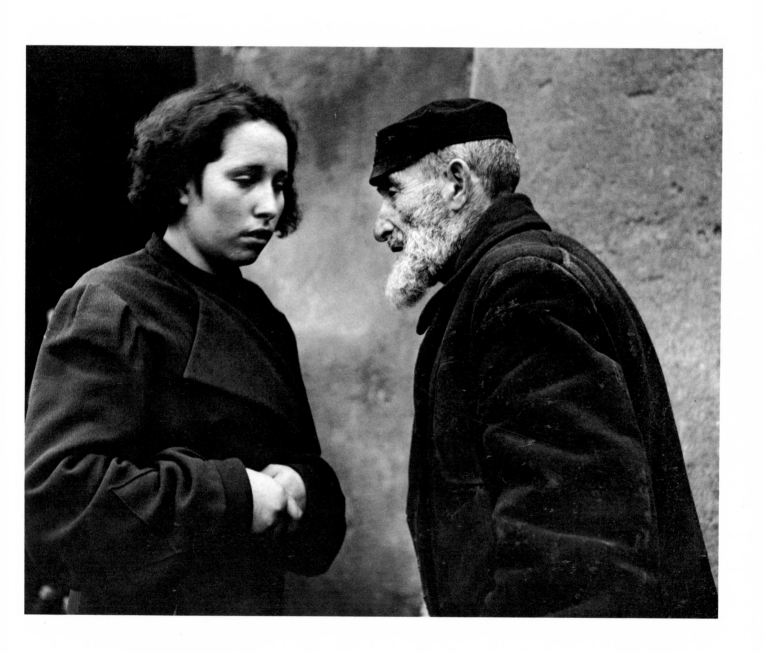

MARGARET BOURKE-WHITE
American, born 1906

Henlein's Parents, Reichenau, Sudeten Section of Czechoslovakia. 1938
7⅛ x 9½
Gift of *Fortune* magazine

Margaret Bourke-White was one of the most famous and most successful photographers of her time. Her combination of intelligence, talent, ambition, and flexibility made her an ideal contributor to the new group journalism that developed during the thirties. Bourke-White was already noted as a photographer of industrial subjects when she joined the staff of *Fortune* magazine in 1929 at the age of twenty-five. When *Life* magazine began publication in 1936, she escaped her industrial specialty and became a distinguished member of that select, glamorous, peripatetic group of photographers who witnessed almost everything (in passing), and photographed it for an audience of millions. During her career at *Life* she photographed both Joseph Stalin and Mohandas Gandhi, and a good sampling of what lay between.

Bourke-White had an excellent sense of simple, poster-like design, and a sophisticated photographic technique, both perhaps the legacy of her apprenticeship in the demanding field of industrial reportage. She was excited by the new opportunities presented by photoflash bulbs, which made possible clear and highly detailed pictures under circumstances that would otherwise have been difficult or impossible for photography. The use of two or three bulbs, synchronized to flash together as the shutter was released, could produce a reasonable simulation of normal interior light. Bourke-White became very skillful at this technique, which required especially delicate calculation when the level of the interior flash had to be balanced against the level of natural light visible through a room's windows. According to the accepted formula the outside landscape should be about twice as bright as the interior; otherwise the images seen through the windows would look like pictures on the wall.

In the case of the picture opposite, the photographer evidently miscalculated a little, but the picture is surely more interesting as it is than it would be if naturalistically correct. The two kindly old people sit in a room that is hermetically sealed with illusions.

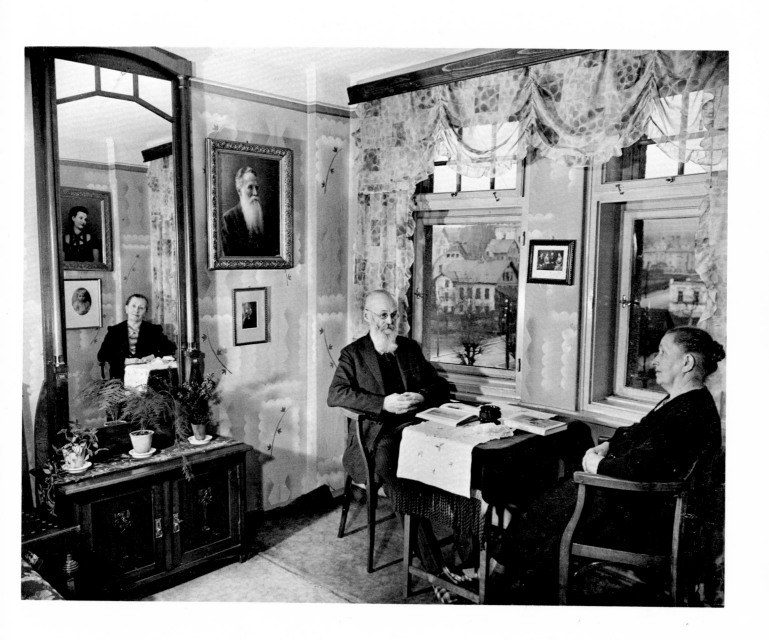

LISETTE MODEL
American, born Austria, 1906

Gambler Type, French Riviera. 1938
13⅞ x 10¼

Henry Miller said of Brassaï that his eye blinked at nothing, neither at beauty nor depravity. The eye of Lisette Model has been slightly more specialized. While one would not wish to label her favorite subjects depraved, it is certainly true that she has demonstrated no noticeable interest in anything resembling conventional beauty. Her most memorable photographs are of people whom one might suspect of being corrupt, mendacious, gluttonous, avaricious, hardhearted, or cruel. It is not easy to be sure whether Model's role as a photographer should be thought of as that of a good witch, exorcising evil with a camera, or more simply that of a collector gathering material for a catalogue of the deadly sins.

The gambler, tanned and sleek and self-contained, waits in the afternoon sun for the adventure of the night. His relaxation is provisional, like a cat's; his eyes watch the photographer as they would watch the dealer or the croupier, alert for a hint of sleight of hand. His own hands are held appropriately close to the vest, cupped as though to gather in his counters.

Model has made her photograph from very close, and from a low vantage point, which foreshortens the gambler's figure. It is an unfamiliar and menacing perspective. If she moves one step closer, he may kick the camera neatly from her hands.

DOROTHEA LANGE
American, 1895–1965

Back. 1938
9½ x 7⅞

It is easier to make clear photographs on a gray day than in the sunshine, partly for the same reasons that it is easier to paint a subject in diffused light; light without hard shadows describes an object as we know it to be, while sunlight describes what it happens to look like at a particular moment, with its permanent form obscured and distorted by the pattern of accidental darks and lights. It took painters many centuries to begin to learn to paint under the sun.

To photograph well in the sun requires an accepting and unprejudiced eye, one that will not be led astray by expectation. If one is good enough to handle the sun, to see truly and precisely the ephemeral fact, even when the subject is shifting and gesturing and perhaps about to move off and walk away forever, then sunlight is one of the most glorious things that a photographer can photograph.

Dorothea Lange was marvelous with sunlight, and she was also marvelous with gesture. Not just the gesture of a hand, but the way that people planted their feet, and cocked their hips, and held their heads. She photographed bodies more clearly with clothes on them than most photographers do when the subject is nude.

The two men were photographed during the summer of 1938. In these years there was often not much work for farmers to do at harvest season, and plenty of time for conversations, on the edges of fields or in the crossroads towns, in which farmers would keep their morale up by pretending to be interested in buying each other's land.

Lange made several fine photographs of men's backs, but none more moving than this one. The man's posture is open and vulnerable and evocative of some other half-recollected memory, perhaps of prisoners of war, or burlesque dancers, or Saint Sebastian.

MANUEL ALVAREZ BRAVO
Mexican, born 1904

Woman Combing Her Hair. 1937–1939
7⁷⁄₁₆ x 9³⁄₈
Gift of Edgar J. Kaufman, Jr.

Why is this beautiful young woman not bathed in a flood of light, illuminating her youth and her pleasure? Because she is a prisoner in the tower. For what pretender prince did this dark Rapunzel let down her hair? Or for what terrific sacrifice is she preparing herself, to placate what cruel spirit? Is it the fringe of her shawl, behind her on the floor, or a scuttling crab?

Manuel Alvarez Bravo was born in the City of Mexico, behind the cathedral, near the place where the temples of the ancient Mexican gods once stood. Diego Rivera said of his photographs that they were Mexican in their format, their content, and their cause, and that they were therefore full of irony and anguish.

Or think of all the pictures of young women with mirrors, all asking the same question: Is my beauty immortal? Or asking, like the ancient Mexican poet, "Will I not leave anything of myself behind me on this earth?"

RUSSELL LEE
American, born 1903

Son of a Sharecropper Combing Hair in Bedroom of Shack, Missouri. 1938
7⅜ x 9½

Like Alvarez Bravo's photograph on the preceding page, this is a picture of the *toilette*, an important subject for artists at least since the Egyptians. The boy, now tall enough to see the part of his hair in the mirror, prepares a face for the outside world. The nature of his circumstances makes the moment no less private or ceremonial.

During the late thirties Russell Lee was a member of the Farm Security Administration photographic project, along with Walker Evans, Dorothea Lange, Ben Shahn, John Vachon, Arthur Rothstein, and a half-dozen other talented photographers. Lee's work of the period had a quality that was unique in or out of the project, a quality that might, at considerable risk, be considered an incorruptible naïveté. His subjects were often so simple that they bordered on banality. His vantage point inevitably seemed the most obvious one. His framing was neither dramatic nor conventionally graceful. When he worked indoors his lighting system was a flashbulb mounted on the camera, which produced a flat, searching light bearing no resemblance to natural effect. His pictures seem as artlessly honest as an underwear button. They are also profoundly moving.

It is risky to call a good artist naïve because it is debatable whether there is such a thing as an artist who is really good and really naïve; perhaps naïveté, like beauty, is in the eye of the beholder, who uses the term to categorize works that he recognizes as fine but cannot rationalize.

The simplicity of photography lies in the fact that it is very easy to make a picture. The staggering complexity of it lies in the fact that a thousand other pictures of the same subject would have been equally easy. Should the picture be made from farther away, or closer? Perhaps only the top of the dresser with the oil lamps and the boy's reflection in the mirror would be better; one step to the left might show the curve of the boy's cheek, but his head now touches the oil lamp, and the tape on the broken mirror falls on the reflection of his face. The feet are necessary. Would a vertical be better? Are the hats and the romantic landscapes on the wall, and the slop pail, part of the picture? How large is the boy and how small the room? What is the proper relationship between them? An infinite number of possibilities present themselves simultaneously, to be instinctively resolved, well or badly, in a moment, while the situation itself continues to change.

No one can now know what other pictures might have been made here, but the one that Russell Lee made is perfect.

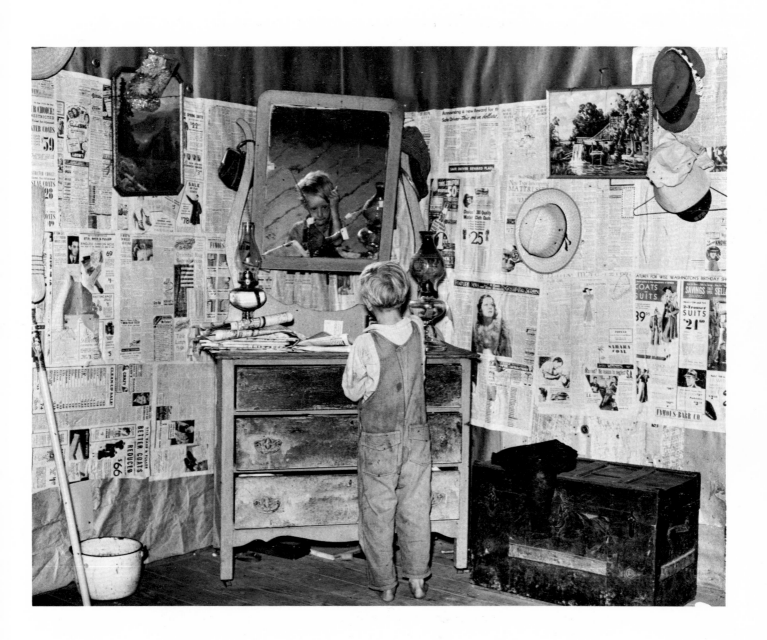

BARBARA MORGAN
American, born 1900

Spring on Madison Square. 1938
Multiple-print photogram, 10⅝ x 13⅝

For the generation of photographers that began work around the time of the Great Depression, conscious abstraction was not a primary concern, and synthetic photography—photography that was not a matter of discovery with a camera, but of picture construction in the darkroom—was viewed by most progressive photographers with something close to disdain.

Barbara Morgan, an artist of irrepressible originality and independence, was not deterred. From the beginning her work sought both a simplification of form and a dynamic, autographic control of content. In formal terms her pictures seem to recall the spirit of the twenties, but Morgan is not a formalist, and her basic concern has been not the mysteries of picture structure but those of human aspiration. Her own talents, the direction of her prior work as a painter, and her fascination with the thought of the Far East and the American Indian inclined her away from the analytical objectivity of the period's photography, and toward an approach to the medium that might attempt to deal in a more direct, less circumstantial way with matters of the spirit.

Morgan's best known work is perhaps that based on the subject of modern dance. Contrary to what is often assumed, these pictures are not a document of the dances as they were publicly performed, but new variations evolved by Morgan and the dancers specifically for the sake of a photographic expression. The subject of the photographs is gesture, form, movement, and space; their intention is a synthesis of the motives and rhythms of life itself.

In these terms Morgan's dance photographs are closely related to her abstract light drawings, her photomontages, and her closeup studies of natural form. The montage reproduced here is in fact also a dance photograph—of a dance performed on a larger stage.

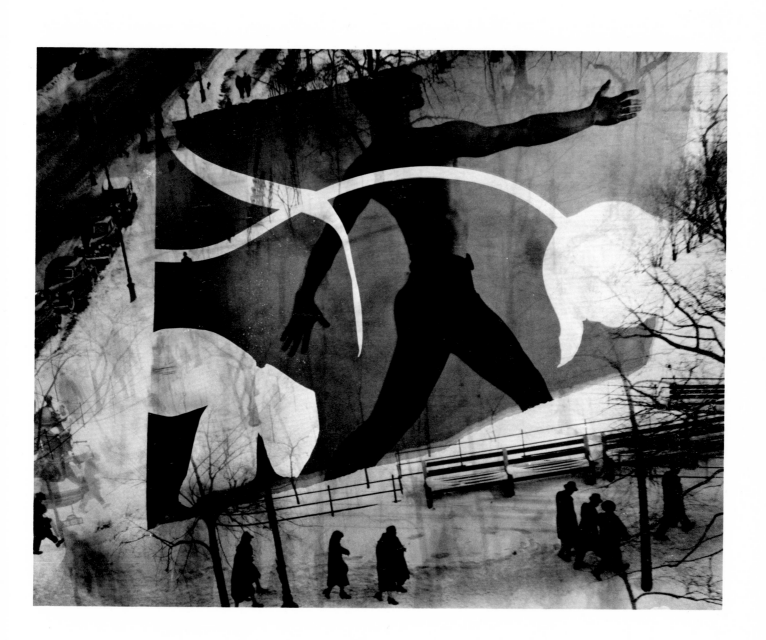

HELEN LEVITT
American

Children. 1940
6½ x 8¹³⁄₁₆
Anonymous gift

During the early 1940's Helen Levitt made many photographs on the streets of New York. Her photographs were not intended to tell a story or document a social thesis; she worked in poor neighborhoods because there were people there, and a street life that was richly sociable and visually interesting. Levitt's pictures report no unusual happenings; most of them show the games of children, the errands and conversations of the middle-aged, and the observant waiting of the old. What is remarkable about the photographs is that these immemorially routine acts of life, practiced everywhere and always, are revealed as being full of grace, drama, humor, pathos, and surprise, and also that they are filled with the qualities of art, as though the street were a stage, and its people were all actors and actresses, mimes, orators, and dancers.

Some might look at these photographs today and, recognizing the high art in them, wonder what has happened to the quality of common life. The question suggests that Levitt's pictures are an objective record of how things were in New York's neighborhoods in the 1940's. This is one possible explanation. Perhaps the children have forgotten how to pretend with style, and the women how to gossip and console, and the old how to oversee. Alternatively, perhaps the world that these pictures document never existed at all, except in the private vision of Helen Levitt, whose sense of the truth discovered those thin slices of fact that, laid together, create fantasy.

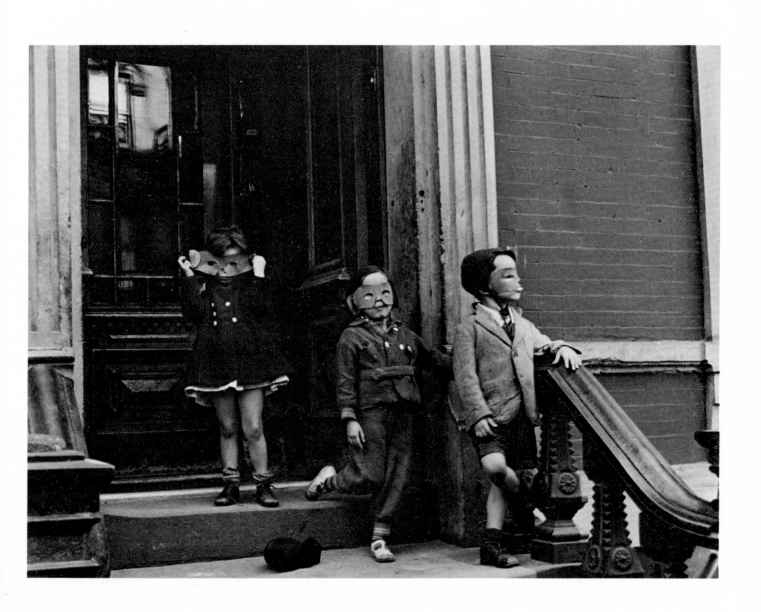

ARNOLD NEWMAN
American, born 1918

Portrait of Yasuo Kuniyoshi |New York City| 1941
7⅝ x 9½
Gift of the artist

In 1857 the photographer Robert Howlett made a portrait of the ship designer I. K. Brunel standing in front of the monstrous anchor chains of one of his ships. This interesting photographic precedent for what later came to be called environmental portraiture bore few progeny, partly because the photographer could make more sittings if the subjects came to the studio, and perhaps partly because most people really didn't want to be identified with what they did.

One would have thought that the miniature camera would make such interpretive portraits common, but it did not work that way. The very ease and availability of the small camera tended to mean that the ship builder was photographed in the Automat, or getting out of an airplane. Howlett's idea depended on a conceptual approach; one thought first and executed afterward.

In the 1940's, at a time when most photographers were discovering the special potentials of the small camera (flexibility, quickness, spontaneity of response), Arnold Newman was learning to use the ancient virtues of the classic stand camera (enforced deliberation, precise framing, exact description) to help him make portraits that might suggest, by their graphics and their symbolic allusions, who the person in the picture might really be, or at the very least, what he might be famous for. One of the best known pictures that Newman made in pursuit of this idea was a portrait of Igor Stravinsky, his head small in a lower corner of the picture, with the great kidney-shaped sounding board of a grand piano silhouetted above him. It was an original and very handsome picture, and doubtless greatly enhanced Stravinsky's popular image as a piano player. Nevertheless, the picture did identify the subject with the world of music and, more important, with a kind of rigorous economy of form, which is saying a great deal.

The portrait reproduced here is more natural and less insistently formalized and symbolized than many of Newman's portraits. If one did not know that Kuniyoshi was a painter, one probably wouldn't guess it from the picture. Although one might. The classical still life with compote, the modified Madame Recamier chaise on the uncarpeted floor, and the gentle skylight quality of the modeling are all suggestive. More important, one would almost surely sense a man who did what he did with a relaxed and stylish elegance.

The chaise may be the one on which he painted those ethereal, alabaster-skinned women.

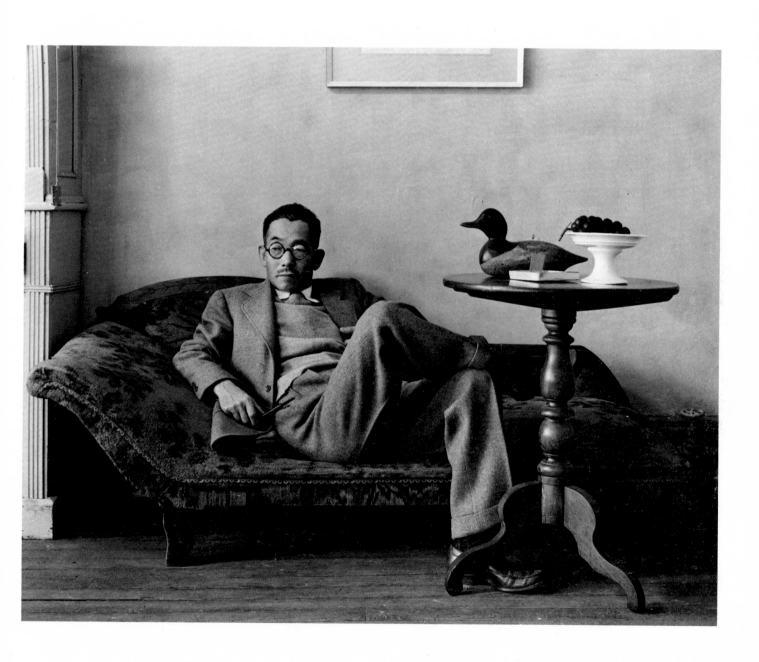

WEEGEE
[Arthur Fellig]
American, born Austria, 1900–1968

[Brooklyn schoolchildren see gambler murdered in street] 1941
11¼ x 14
Gift of Sara Mazo

The best newspaper photographers have understood intuitively that it is not their function to interpret the news; they have left this task to the caption-writers, who ascribe to pictures whatever moral, political, social, or historical meaning seems appropriate in light of the temper of the moment. The function of news photographers is to give us the look and the smell of events that we did not witness.

The importance of these events is sometimes more symbolic than real. It has been pointed out often enough that the significant fresh news of any given day could be engraved on a dime, but this does not vitiate the fact that we expect the daily paper to reassure us that the world is still with us, filled with disasters, beauty queens, purposeful dedication, corruption, wealth and poverty, winners and losers, and auspicious occasions. In the case of most of these it is better to be shown than told. Sports historians will read the box scores, but the rest of us would rather see—for the ten-thousandth time—one more shortstop suspended in mid-air above the sliding runner, making the relay to first base.

The very best news photographs have been the disaster pictures. It is likely that no medium, visual or literary, has accumulated so rich an archive of de-struction—whether the result of bad luck, violent sin, or divine retribution—as news photography has in a mere half century.

Probably few policemen have seen as much violent sin as Weegee did. During his best years as a photographer he lived in a room across the street from Man-hattan police headquarters, waiting for the inevitable call on his police radio that would announce another gangland execution, or botched holdup, or crime of passion. It must be assumed that he was a serious and willing student of his subject; mere professional competence would not have produced the wonderfully intimate and knowledgeable photographs that he made.

Weegee came to be such a virtuoso at photographing violence that he developed variations on the standard themes. Before he could make the picture reproduced here, he had to turn away from the bloody body in the street, and toward the spectators. He had learned from experience that the audience was often as terrific as the event.

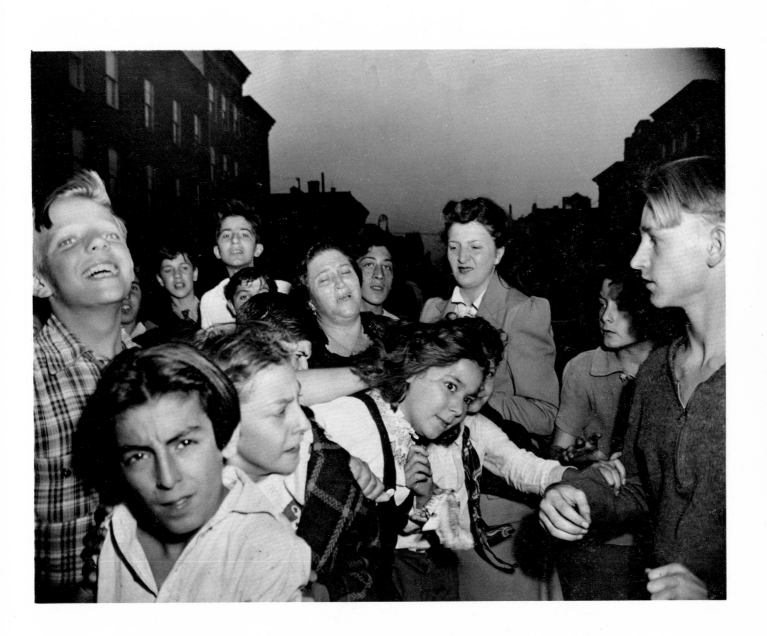

ANSEL ADAMS
American, born 1902

Old Faithful Geyser, Yellowstone National Park. 1941
9 x 6⅜
Gift of David H. McAlpin

The first of the several million photographs that have been made of Old Faithful geyser were made by William Henry Jackson in 1871. Jackson's plates required a much longer exposure than would have been ideal, and in consequence the spout came out looking a little woolly. Nevertheless his pictures were very fine, and if the problem had been simply that of making a generalized document of the great periodical monument the subject could have been considered disposed of one hundred years ago.

Faithful or not, however, the geyser never really repeats an earlier performance; the spout of water itself and the light and the quality of the day are always different. The event is new again each time.

Ansel Adams photographed the geyser on at least three separate occasions during the early forties, and produced pictures that are profoundly different from each other. The difference is due not to a willful act of artistic interpretation, but rather to the precision of Adams's sensibility: He saw what was there not in vague and general terms, but with a rigorous exactitude. The problem (as Cézanne put it) was to realize his sensation.

Much of the best photography of the past generation has concerned itself with giving permanent form to the ephemeral. This concern has expressed itself not only in the analysis of that swarming flux of movement within which Cartier-Bresson found his *decisive moment,* but also in the approach to subjects that the casual observer might think static. A landscape does not move in the conventional sense, but it changes constantly in other ways, most notably through the agency of light. Ansel Adams attuned himself more precisely than any photographer before him to a visual understanding of the specific quality of the light that fell on a specific place at a specific moment. For Adams the natural landscape is not a fixed and solid sculpture but an insubstantial image, as transient as the light that continually redefines it. This sensibility to the specificity of light was the motive that forced Adams to develop his legendary photographic technique. This brilliant technique might be a millstone around the neck of a photographer who did not need it; for Adams nothing less would suffice to to describe his subject.

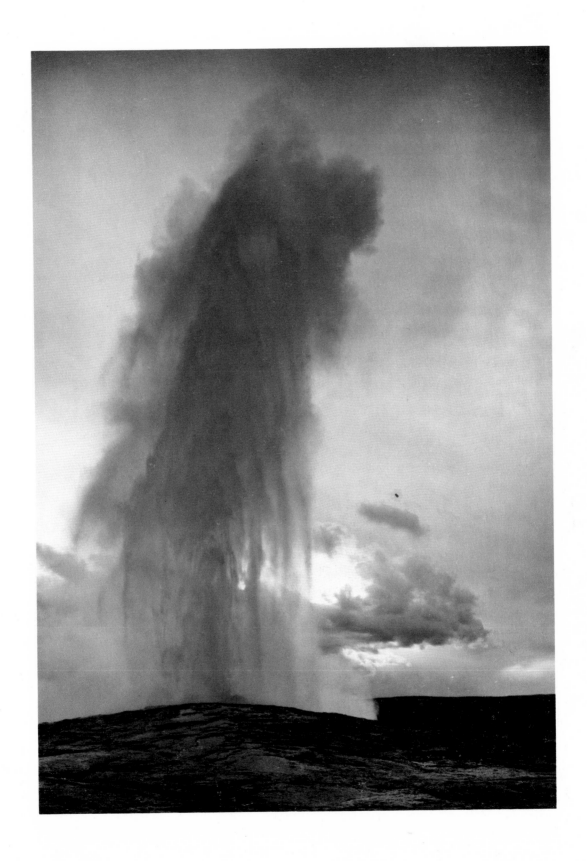

ROBERT CAPA
American, born Hungary, 1913–1954

Collaborator, Chartres. 1944
8⁹⁄₁₆ x 13⅜
Gift of Magnum Photos, Inc.

In his short life Robert Capa photographed five wars, beginning in Spain in 1936, and finishing in 1954 during the French phase of the Indo-China War, when he stepped on a land mine. In his collected work the period becomes one continuing war, shifting from one front to another, the scale of the battle expanding and contracting, but never quite ending.

As a photographer who specialized in war, Capa was kept busy, and did not have much time to investigate other subjects. He understood, however, that war was more than the battles, and some of his most interesting pictures were made on the periphery of the historic events.

The picture opposite was made in the town of Chartres at the time of the liberation of France. The woman with the shaved head is being punished for having loved, or having at least given comfort to, a German, an enemy of her fellow Frenchmen. In recent years it has been suggested that such a spirit of accommodation was less unusual in wartime France than the picture would suggest; perhaps this particular woman or her German lover were unpopular for other reasons, or perhaps the public humiliation of the woman and her child is an exercise designed to demonstrate that still another new order has been ushered in, and that patriotism will once more be enforced.

The horror of the picture resides in the smiles on the faces of the crowd. In a film of the period the director would have kept his mob stern-visaged; in this spirit the punishment would have been acceptable even if cruel. What makes Capa's picture shocking is that the crowd is enjoying itself.

Perhaps the crowd did not realize this. One of the interesting things about photography is the fact that its records of our selves and our works so often do not correspond to our mental images: The photographs make our waistlines look thick, and our postures slovenly, and our houses graceless and ill-proportioned. Generally we assume that the difference between our expectation and the camera's evidence is the result of some kind of photographic aberration. We call it distortion and preserve our faith in the validity of our mental image. Often we are right to do so, for the camera records many unintelligent, insignificant, and circumstantial kinds of truth. Sometimes, however, we can learn from photographs that things were not as we thought they were.

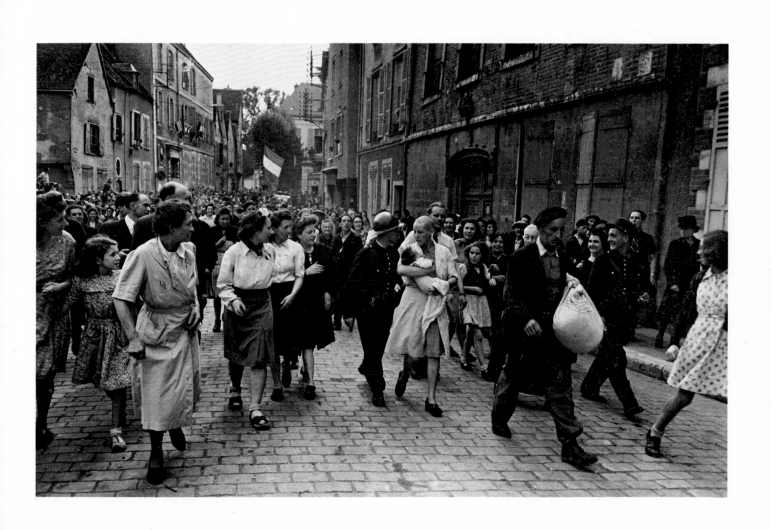

WRIGHT MORRIS
American, born 1910

[Untitled] 1947
7½ x 9½

By calendar measurement Wright Morris's photograph of the Ford is now as old as the car itself was when its picture was made. The calendar measurement, however, is misleading, for the Model T was clearly an ancient relic in 1947— a shard from the past, even more impenetrably mysterious than grandfather, although half a century younger. Morris has attacked the mystery frontally, with the full force of the Nebraska sun behind him, limning every detail of the strange machine.

If it seems an object foreign to its prairie setting, rather like a landing craft on the moon, it should be remembered that the automobile was a creature of the city, and that it finally proved to run best when pointed in that direction, carrying with it as hostages those who had thought themselves its master. It first occupied the open plains only a generation after the buffalo was gone; one generation later it too was in retreat, and is now seen there only in migration.

In 1947 the exodus from the farm was only well begun, and the role of the Ford was still ambiguous. Nevertheless, the photograph recognizes it as the protagonist of an important issue, representing the beginning of something and the end of something: a hinge on which a culture pivoted.

Other and different photographs of Model T's would induce a different line of speculation and association. There is in Morris's picture a quality of ceremony and ritual that speaks to the car's historic and symbolic role. What it is that creates this quality is not easy to deduce, but it relates to the searchlight quality of the sun, and also to the rapidly diminishing perspective of the space, against which the facade of the car stands as flat and static as a sign. (This is a function of the short focal-length lens, which is also responsible for the seemingly irrational drawing of the shadows cast by the wheels.) Finally, the quality of ceremony is heightened by the inclusion of the photographer's shadow, which makes it clear that the Model T is having its picture taken.

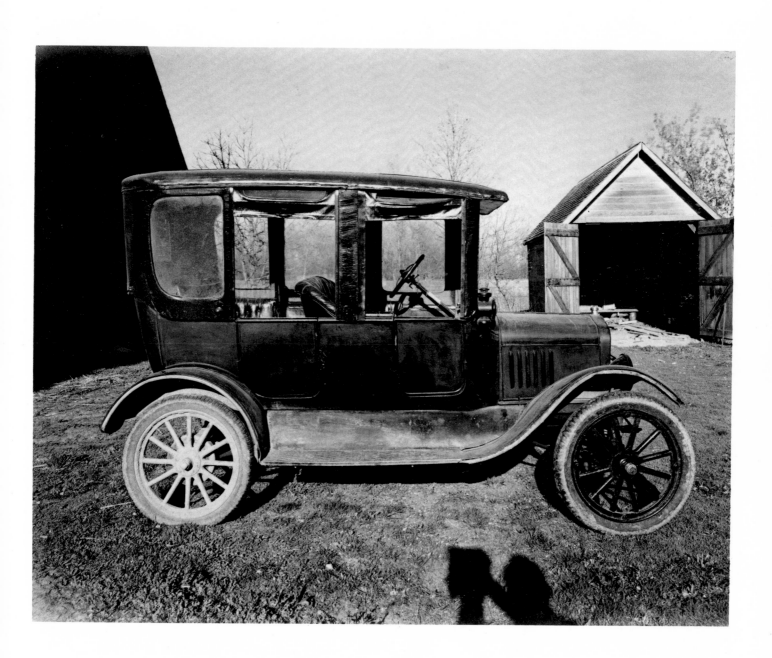

W. EUGENE SMITH
American, born 1918

Dr. Ceriani, 1948
13⅜ x 10¼

By the mid-forties it seemed to most talented young photographers that the future of the medium lay with the great new mass magazines. The reason was simple: In the magazines one's work would be seen by tens of millions of people; outside the magazines it was likely to be seen by one's friends. It was understood that the magazines presented difficulties. One's own interests and opinions were not necessarily identical with those of Henry Luce, for example, and it would presumably not be easy to use his machinery to serve one's private ends. But it would not be impossible, and with enough talent and energy and tenacity one might not only use the establishment, but in time reform it.

In historical fact this is not the way things worked out. The problem was not that the establishment was stronger than the photographer, but rather that it was never precisely located, if indeed it existed at all, except as an abstraction. The enemies of the photographer (it seemed) were editors and writers and art directors and researchers—the other members of the same committee that the photographer was a part of—who were also trying to use and perhaps reform the establishment, each from a slightly different vantage point. As in the case of most committee productions the result generally didn't wholly satisfy any of the collaborators.

Gene Smith was perhaps the photographer who tried most heroically to make the magazine photostory meet the standards of coherence, intensity, and personal accountability that one expects of a work of art. Predictably, his insistence on personal accountability did not fit comfortably into the system of group journalism. Other photographers followed the fever chart of Smith's career with almost as much interest as they followed his work. He was an unquestioned leader of the photostory experiment, but his lead was not invariably followed. His function was sometimes that of bellwether, and sometimes that of the canary that is watched carefully in deep mines.

The essays photographed by Smith during the decade after the Second World War remain memorable; they probably represent the highest success that photography achieved within the format of the magazine photostory. It should be added that the stories, as stories, are less satisfactory than the best pictures in them. The whole is somehow less than the sum of the parts. Conversely, the best photographs—like the one reproduced here—transcend the narrative of which they were a part.

150

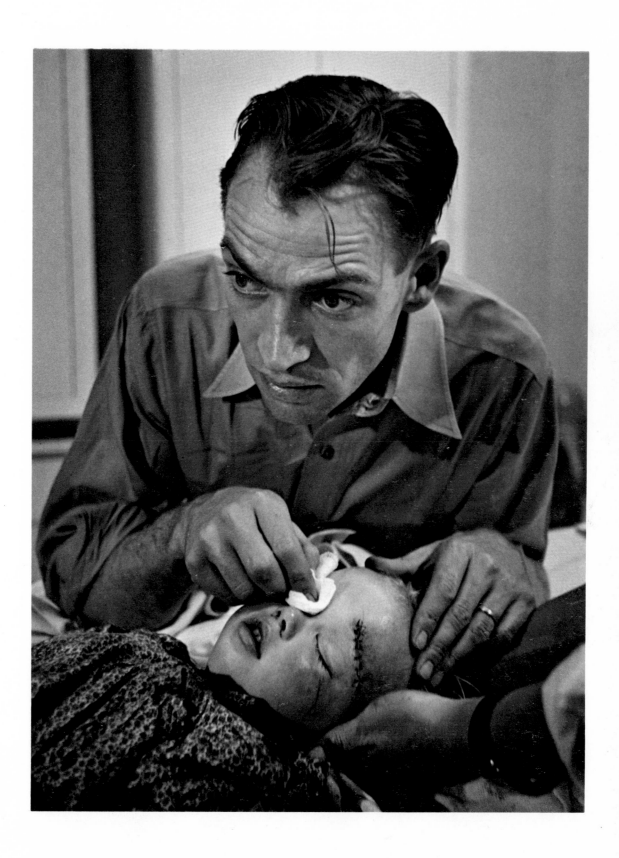

EDOUARD BOUBAT
French, born 1923

[Chicken and tree] 1951
12⅛ x 15⅞
Gift of the artist

The fact that one may misunderstand the content of a picture is of no concern to the picture, which leads its own life independent of our interpretations. For some years the writer thought that the tree in Edouard Boubat's picture grew on the top of a hill, from which a beautiful Sung landscape receded toward a misty horizon. When he finally realized that the tree stands not against the sky but against a wall, it was a momentary shock. But the picture refused to adapt itself for the sake of the new interpretation. It remained precisely as it had been before.

Visually, the tree stands in a large open space. No other explanation accounts convincingly for the clues that the picture provides. If there is a wall behind the tree, it would seem only inches behind the trunk, scarcely allowing room for the chicken to squeeze through, and surely not space for the tree's spheroidal crown. And why, against all rules of nature, does the densely foliated tree cast no hint of shadow on the wall? The eye solves these conundrums instantly and neatly by reading the wall as the sky. A picture is what it looks like.

Those demanding a technical resolution to the puzzle might speculate that the picture was made from a considerable distance, with a long focal-length lens. In this situation the tree and the wall are, relatively speaking, at almost the same distance from the lens, and one's sense of depth is radically compressed.

Such explanations however, true or not, do not fool the eye.

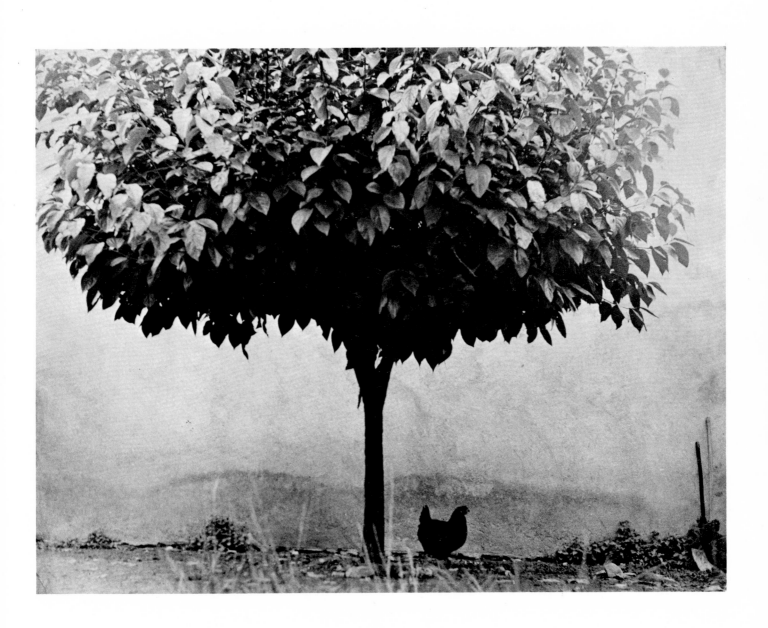

DAVID DOUGLAS DUNCAN
American, born 1916

Capt. Ike Fenton. No Name Ridge, Korea. 1950
18½ x 15
Gift of the artist

The new picture magazines that arose in the thirties were predicated on the idea that if one picture was worth a thousand words, ten pictures would make a short story. This theory ignored the fact that the thousand words that a picture is worth are mostly nouns and adjectives, whereas a story needs verbs.

Notwithstanding frequent claims to the contrary, photography has never been very successful at telling stories. This is not surprising if one considers that isolating single fragments out of the continuity of time—what photographs do—is very close to the opposite of what narrative does. In any event the attempt to make sequences of photographs tell stories was an interesting experiment. In the early days of the genre many photostories were entitled "One Day in the Life of a Jockey," or something similar, and seemed invariably to begin with a photograph of the subject shutting off an alarm clock. Other pictures of the subject getting in and out of things (bed, house, car, office, and so on) did produce a kind of narrative line, but the stories were very simple ones, and the pictures were generally boring.

Photographers gradually came to recognize this, and the best of them began to subvert the narrative idea, and to make instead pictures that memorialized the quality of a particular moment.

When David Douglas Duncan photographed the Korean War, he found that the stories were in any case mostly irrelevant, if not false. What was relevant and true was the effort of men to preserve their lives and if possible their honor under circumstances that made both goals exceedingly difficult.

When Duncan published his Korean pictures in his book *This Is War!*, he reproduced the pictures without captions. The text that he wrote was separate from and independent of the pictures, but from it one can deduce that the man shown in this photograph is Captain Ike Fenton, Commander of Baker Company, First Battalion, Fifth Regiment of the U. S. Marine Corps. The photograph was made in September of 1950, in the third month of the war, while Fenton's company was attacking a hill facing a stronghold called No-Name Ridge. The action lasted less than a day, and casualties were heavy. The hill was won. The photograph proves none of these facts, nor does it indicate whether the victory was important, but it does suggest something of its price.

154

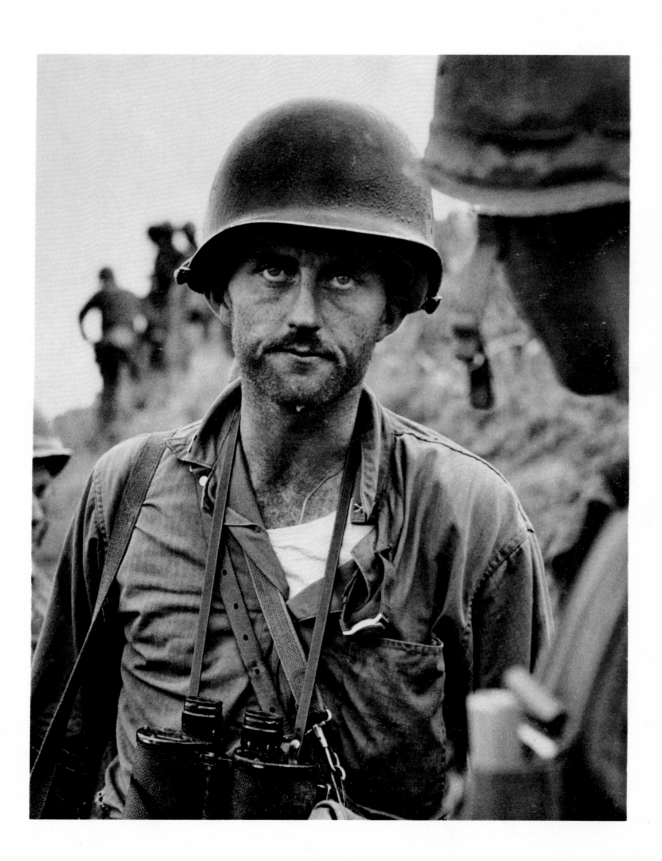

AARON SISKIND
American, born 1903

Kentucky. 1951
13⁹⁄₁₆ x 16½
David H. McAlpin Fund

In Eric Ambler's _Epitaph for a Spy,_ the young school teacher and amateur photographer Joseph Vadassy is detained on suspicion of being a secret agent, because of compromising pictures on a roll of film that presumably came from his camera. The police also find suspicious the fact that the last twenty exposures on the roll are very similar shots of a common lizard. No one, they reason, would spend twenty shots on a lizard unless he were very eager to finish off the roll and get it processed. Vadassy is indignant, and explains: "If you knew anything about photography...you would notice that each one is lighted differently, that in each one the shadows are massed in different ways. The fact that the object photographed is in every case a lizard is unimportant."

In spite of our sympathy for Vadassy, who has been unjustly accused, we must admit that he is wrong. If the subject is a lizard, that fact is important, and only a dilettante would really think otherwise. Vadassy perhaps meant to say that the fact that the object is a lizard does not make the photograph a lizard, which would have been true. The object is raw material, not art, and it is the nature of the artist's adventure to recast this material under the pressure of his own formal will, transforming it into something distinct from what it was. Nevertheless, his choice of the particular dross that he will spin into gold is an important matter, for his raw material is both his collaborator and his adversary.

Aaron Siskind, a child of the city, began his photographic career by making architectural records and genre photographs of city people engaged in their everyday pursuits. He did this well, but soon found himself indisposed to meet the issue on this ground. Beginning in the early forties, he turned toward subject matter that was less obstinate in retaining its intrinsic, public meanings, that would stand still for a closer scrutiny and a more clear, deliberate, and willful molding under the sovereignty of formal concern. The most frequently recurring of these subjects was the detail of the urban wall: a fragment of the city's surface so small and anonymous that it carried neither social nor architectural implications. Within this microcosm Siskind made pictures of great visual beauty, almost (but not quite) free of the tugging presence of the mundane world. Not quite, for the wall, transfigured and metamorphosed, remains, a souvenir of time and men's intentions.

IRVING PENN
American, born 1917

Woman in Black Dress. 1950
16¼ x 11
Gift of the artist

Those who have paid even cursory attention to the vocabulary of the high-fashion magazines realize that English has different meanings in this special-ized context from those of normal usage. For example, the word "simple" (or the phrase "simple little") is generally used to denote matters that would else-where be cited as examples of Byzantine complexity and indirection.

The best fashion photography has often indulged a similar taste for make-believe, and harmless (or almost harmless) mendacity. Irving Penn's simple little picture of a beautiful model in a fancy dress is a masterpiece of the genre. Superficially the picture pretends to a directness and austerity that suggest the nineteenth-century studio portrait: It is devoid of luxurious textures, stage lighting, elegant properties, or an identifiable social ambience. What remains is an almost primitively simple record of a very elegant lady.

The simplicity is of course a sham. Perhaps the essential nature of this picture can be more clearly seen if one covers with a sheet of paper the model's beautiful (and seemingly tiny) head. It is possible that only a modern viewer would be able to identify what remains as representing a woman's body, rather than the silhouette of an orchid, or a scarified tribal priestess in ceremonial headdress, or the rhizome of an iris. As a description of a dress the photograph is even more ambiguous; surely only one with prior knowledge of the fashions of 1950 could reconstruct a reasonable pattern of the dress from the information given by the picture.

The true subject of the photograph is the sinuous, vermicular, richly subtle line that describes the silhouetted shape. The line has little to do with women's bodies or real dresses, but rather with an ideal of efflorescent elegance to which certain exceptional women and their couturiers once aspired.

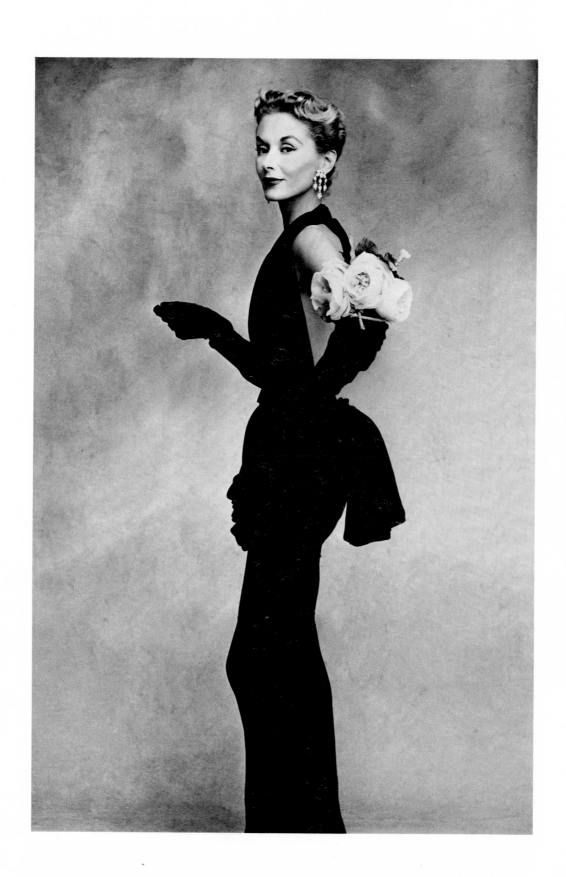

CLARENCE JOHN LAUGHLIN
American, born 1905

The Language of Light. 1952
10¼ x 13

Many of Clarence John Laughlin's photographs actually show ghosts: transparent but nonetheless corporeal ladies draped in sheets or period nightgowns, appearing from behind stone monuments or Ionic columns or other decaying relics of the Old South. In other of Laughlin's pictures, like the one shown here, the ghosts have fled, and only the pattern of their spell remains.

Any child abed in lazy and luxurious convalescence from measles or chicken pox, half-drunk with tea and hot lemonade, learns that the space between the window shade and the casement is a magic place, populated by spirits that cast their shifting, liquid shadows on the screen and tap out their secret messages on the window frame. Once each of us was open to such dramas of the senses, revealed in terms that were trivial and ephemeral: the reflection of the hand mirror on the dressing table, slowly tracing its elliptical course across the ceiling.

Many of us forget the existence of such experiences when we learn to measure the priorities of practical life; some of us remember their existence but find that in the light of day they have become as shy and evasive as the hermit thrush; a few, whom we call artists, maintain an easy intimacy with these wonders of simple perception. In this century many of these have been photographers, and the exploration of our fundamental sensory experience has been in large part their work. It is photography that has continued to teach us of the pleasure and the adventure of disinterested seeing.

FREDERICK SOMMER
American, born Italy, 1905

The Thief Greater Than His Loot. 1955
8 x 5

Like other Surrealists, Frederick Sommer has taken an uncompromisingly egalitarian attitude toward subject matter. In this view, all matter is created equal, and the artist's special relationship to those things that become his work is determined by the imponderables of chance, fate, geography, and psyche. To assign hierarchical values to the varieties of the world's stuff would thus be to discount in advance the revelation that one might encounter in the seemingly most humble of raw materials.

In considerable part, Sommer has made his pictures out of the cuttings and screenings left behind after more conventionally discriminating artists have carried off what seemed of human value. He has photographed broken toys, the entrails of dead birds, fragments of sentimental illustrations, trash piles, and stained boards; even his photographs of the Arizona desert in which he lives seem to select those views and moments that eliminate most completely from the landscape a sense of immediate life.

Sommer has studied these unprepossessing souvenirs of human and geological time with patience and concentration, and has photographed them only when they seem to have shared a portion of their secret. Often he has composed separate bits of his collected findings to create a new fossil by assemblage, arranging and rearranging his awful treasures until the construction has become also a record of his own life and design. Then, when the time and light have been right, he has photographed his conclusions, thus testing and proving the reality of his earlier acts of contemplation and ordering, much as the snapshots in an album serve to distinguish our histories from our dreams.

162

KEN DOMON
Japanese, born 1909

Mr. and Mrs. Kotani: Two Who Have Suffered from the Bomb. 1957
7⅜ x 11

In Japan, as elsewhere, the pictorial and conceptual traditions of painting were a mixed blessing to photography, especially after photographers in that country acquired the Japanese equivalent of Beaux Arts ambitions. The problem in Japan was perhaps even more knotty than it was in the West, for in some ways photography can more easily manage a superficial imitation of Hokusai than of Constable. Thus, Japanese photography before the Second World War was for the most part identified with broad and simple graphic patterns representing a landscape that was a closed aesthetic issue long before Commodore Perry's visit in 1853.

Ken Domon broke away from this romantic convention, and demonstrated that a clear depiction of the pertinent facts could be more challenging, and more surprising, than another mountain view in the mist. It is worth noting that he developed his realistic and contemporary approach in photographing the sculpture and temples of old Japan. Students of traditional Japanese art will know this aspect of his work, which has remained the central and abiding preoccupation of his photographic life. These pictures are distinguished by poise, precision, a sense of judicious objectivity, and a complete absence of pictorial rhetoric. They persuade us that we are seeing the works themselves rather than a translation of them into photographs, although this is of course a deception.

In 1957 Domon was moved to visit Hiroshima in order to photograph that city's survivors. He is said to have worked there with his characteristic deliberation, method, and systematic selflessness, as he photographed the advanced skin-grafting techniques, the lives of the damaged families, and the games of blind children. It is also said that he often wept while he worked.

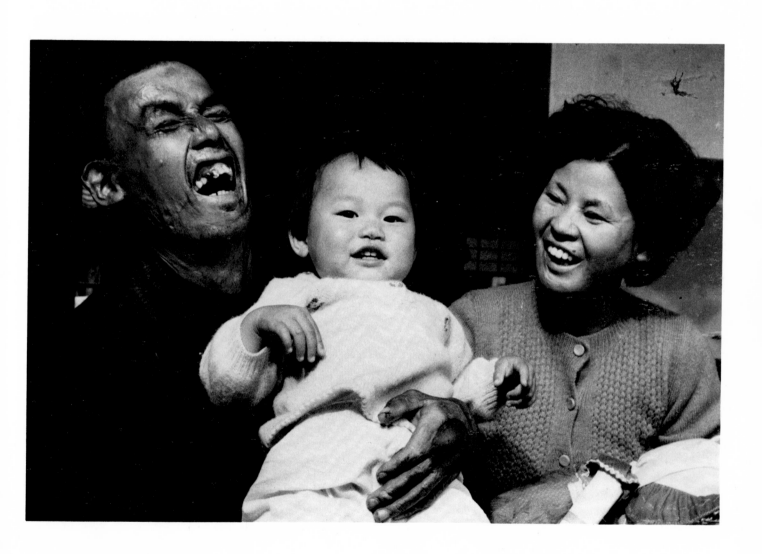

HARRY CALLAHAN
American, born 1912

Eleanor, Port Huron. 1954
6⅝ x 6½
Stephen R. Currier Memorial Fund

Since at least the middle of the nineteenth century, artists have advised each other to find their subject matter close to home, among things native to their own experience, and by and large they have done so. There are not many major painters of the period who, like Paul Gauguin, could comfortably provide the inspiration for a Somerset Maugham novel. Among photographers also, most of those who have produced the medium's memorable work have dealt with issues from their everyday lives, subject matter that they have known well.

Nevertheless, the work of most artists clearly aims at extrapolating from their personal experience, to make it the vessel for a broader and more universal statement. Such work invites us to work our way outward, from the private and specific to the larger world.

Harry Callahan's work is an exception, for it draws us ever more insistently inward toward the center of Callahan's private sensibility. This sensibility is expressed in his perception of subject matter that is remarkably personal and restricted in its range. For thirty years Callahan has photographed his wife and child, the streets of the cities in which he has lived, and details of the pastoral landscapes into which he has periodically escaped—materials so close at hand, so universally and obviously accessible, that one might have supposed that a dedicated photographer could exhaust their potential in a fraction of that time. Yet Callahan has repeatedly made these simple experiences new again by virtue of the precision of his feeling.

The point is not merely that Callahan has responded faithfully as a photographer to the quality of his own life, or merely, even, that photography has been his method of focusing the meaning of that life. The point is that for Harry Callahan photography has been a way of living—his way of meeting and making peace with the day.

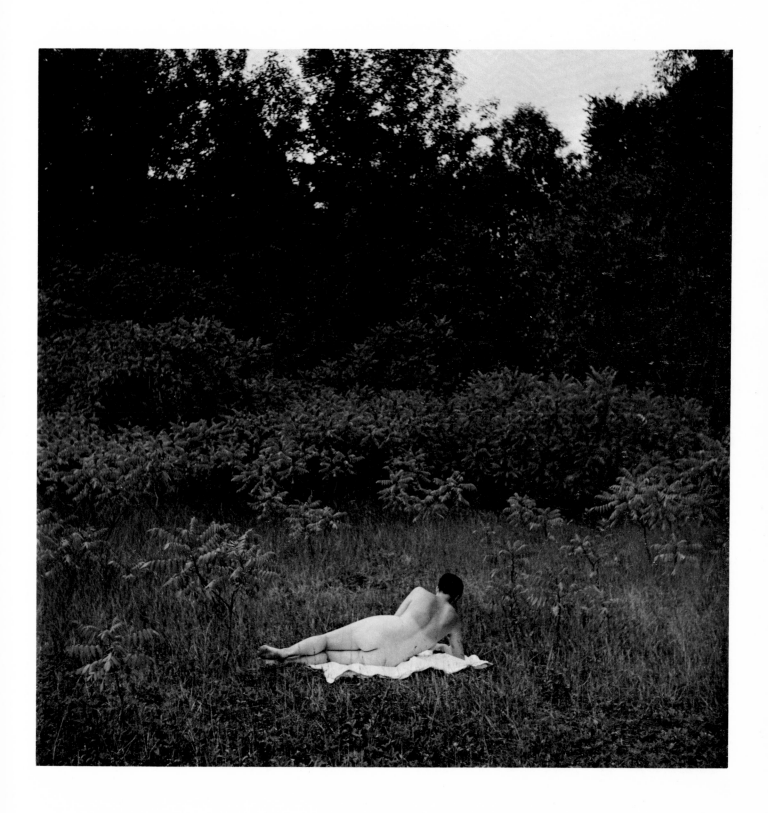

RICHARD AVEDON
American, born 1923

Isak Dinesen. 1958
11⅜ x 9⅞
Gift of the artist

Even in the early years of his work as a fashion photographer, Richard Avedon was much interested in motion, or rather in the *sense* of motion, since his interest was not analytical but hortatory. As a young photographer in the early fifties Avedon seemed to think that motion was intrinsically *a good thing*. It is possible that Avedon was in fact one of the architects, unwitting or otherwise, of the Jet Set concept, which was based on the premise that people with style do not alight. Among his many memorable portraits, it is difficult to call one to mind that shows the subject sitting down.

In the beginning Avedon attempted to deal with the subject of motion in a rather literal way, by shooting moving subjects at slow shutter speeds, thus describing forms that tended to resemble feathery-edged projectiles. Some viewers felt that these pictures expressed movement. Whether they did or not, they did not describe a great deal about the object in motion. Perhaps for this reason Avedon later radically revised his approach to the problem. He decided (it would seem) that the most interesting thing that photography could do with movement was destroy it, and show its crystal-clear fossil, suspended in perpetuity, like the once-human figures disinterred at Vesuvius, seemingly overtaken in mid-stride; or, more nearly, like faces illuminated by a catastrophic explosion, the significance of which has not yet registered in their expressions.

As the newspapers prove again each day, there is something fascinating and subtly disturbing about a photograph of a person open-mouthed in speech. The effect can be comic or ludicrous or tragic, but the root cause is the same. Life has been arrested.

The importance of Avedon's work lies in the fact that it constitutes a coherent and challenging composite portrait of many of the mythic figures and spear-carriers of the worlds of art, style, and higher salesmanship during the past twenty years. The character drawn in that composite portrait is of a piece, persuasive, and less than reassuring. It remains for time to determine whether that character is the product of Avedon's insight or of his fancy.

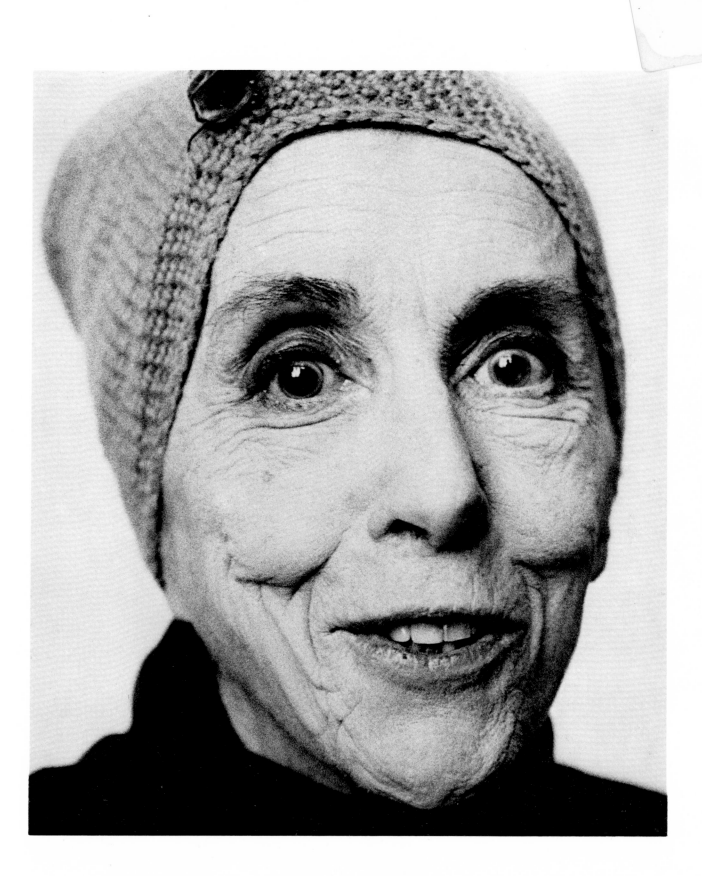

WILLIAM A. GARNETT
American, born 1916

Dry Wash with Alluvium. Death Valley, California. 1957
19½ x 15½
Gift of the artist

Whatever final verdict may be rendered concerning the social utility of the airplane, it was surely, while the sky remained clear enough to see through, a great aesthetic success. Flight provided men a sumptuous feast for the eyes, a sensuous knowledge of the earth as thrilling and exhilarating as Daedalus had promised. The poets of flight, like Lindbergh and Saint-Exupéry, flew so that they might better see the earth.

If technically competent, aerial photographs are seldom truly uninteresting; no matter how thoughtlessly made they almost always contain in their details or their patterns some surprising revelation that enriches our knowledge and our sense of the landscape. On the other hand, aerial photographs that possess true coherence of intention and resolution are rare, and a remarkable number of those that hold firm in our memories were made by William A. Garnett. Garnett is not a flyer who makes photographs, but a photographer who flies. His plane's function is to hold his camera in precisely the right spot at precisely the right moment, in order to achieve not a map but a picture.

The conventional rules of scientific aerial photography state that the photograph should be oriented so that the shadows fall toward its bottom edge, which makes it easier to interpret the picture topographically. Garnett's pictures, being concerned not with how the world is constructed but with the more ambiguous question of what it looks like, ignore such conventions, and in consequence they are often difficult to interpret in topographic terms.

The picture opposite seems on close study to be virtually a perpendicular view. Psychologically, however, we insist on assigning to the subject a bottom and a top. Since we are unaccustomed to seeing the world lighted from beneath, it is impossible simultaneously to read the picture's top as "up" and the dark saw-toothed form at the upper left as cast shadows. The easiest way to resolve this visual conundrum is to read the saw-toothed form as representing a range of mountains, obliquely seen against a distant horizon, and the picture's light top as a sky. According to this reading the viewer is looking toward the light. If the reader is not convinced that a perceptual problem does exist, let him distinguish the peaks from the valleys in the bright corrugated strip in the picture's lower left, and then check the evidence of his eyes by calculating the direction of the sun's shadows.

It is also true that the problem disappears if the picture is turned upside-down, so that the shadows fall downward, but although this solves the topographic problem, it merely evades the artistic one.

170

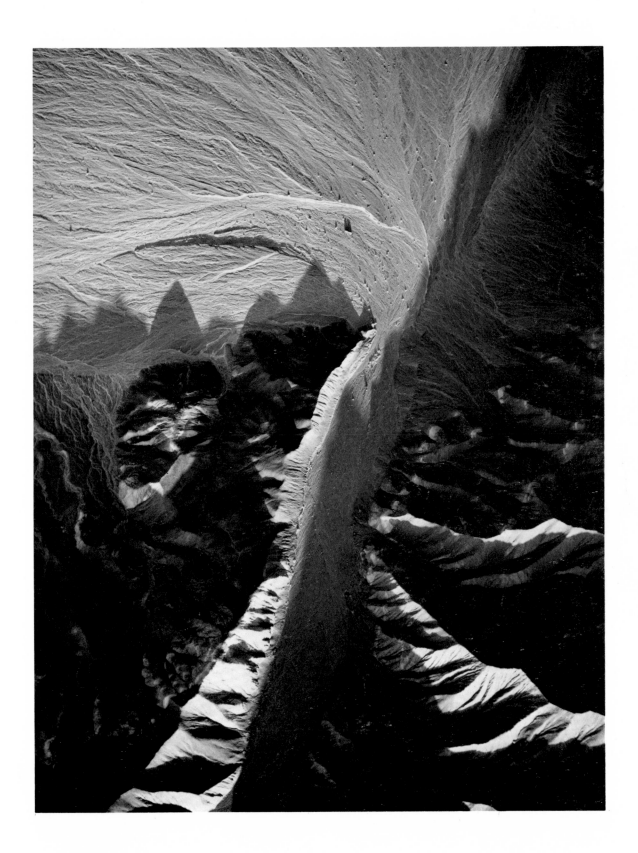

ROBERT DOISNEAU
French, born 1912

At the Café, Chez Fraysse. Rue de Seine, Paris. 1958
11⅞ x 9⅜

Most photographers of the past generation have demonstrated unlimited sympathy for the victims of villainous or imperfect societies, but very little sympathy for, or even interest in, those who are afflicted by their own human frailty. Robert Doisneau is one of the few whose work has demonstrated that even in a time of large terrors, the ancient weaknesses and sweet venial sins of ordinary individuals have survived. On the basis of his pictures one would guess that Doisneau actually likes people, even as they really are.

It has already been pointed out that photographs often appear to mean something quite different from what the event itself would have meant had we been there. It is conceivable that the gentleman in the picture opposite is simply telling the girl that he no longer needs her at the shop, due to business being slow. Regardless of historic fact, however, a picture is about what it appears to be about, and this picture is about a potential seduction.

One is tempted to believe that even the painters of the eighteenth century never did the subject so well. The girl's secret opinion of the proceedings so far is hidden in her splendid self-containment; for the moment she enjoys the security of absolute power. One arm shields her body, her hand touches her glass as tentatively as if it were the first apple. The man for the moment is defenseless and vulnerable; impaled on the hook of his own desire, he has committed all his resources, and no satisfactory line of retreat remains. Worse yet, he is older than he should be, and knows that one way or another the adventure is certain to end badly. To keep this presentiment at bay, he is drinking his wine more rapidly than he should.

The picture however precludes questions of the future. This pair, if less romantically conceived than the lovers on John Keats's urn, are equally safe, here in the picture, from the consequences of real life.

172

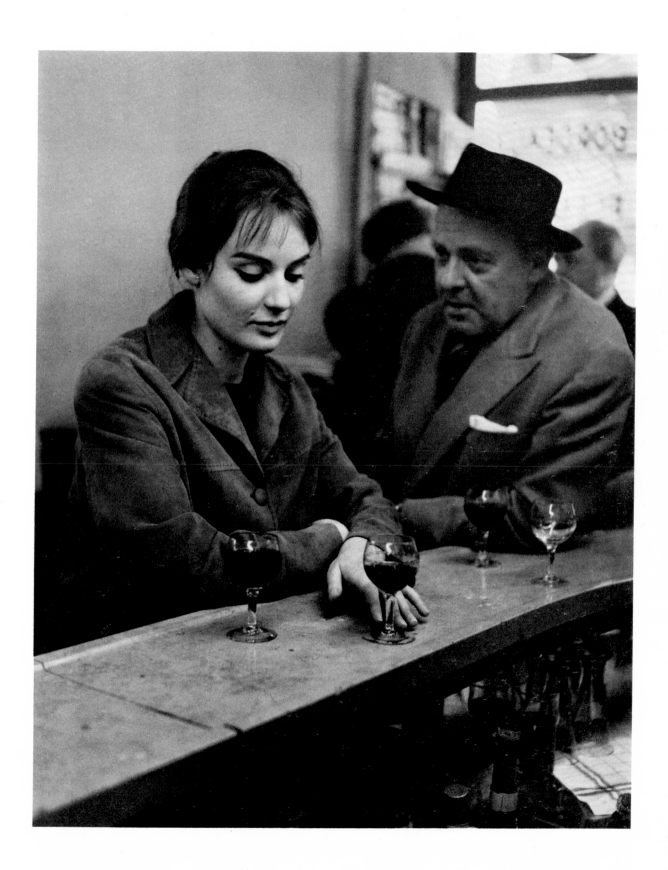

MINOR WHITE
American, born 1908

Capitol Reef, Utah. 1962
12¼ x 9⅜

As a rule, photography has not been especially generous to those of her followers possessed by the romantic imagination, but every student of the medium will have his own considerable list of conspicuous exceptions. The romantic temper is distinguished by its quickness to find universal meanings in specific facts. It would seem that this tendency has more often been productive in the literary than in the visual arts, perhaps because pictures are more resolutely physical than words, and thus less accessible to quick symbolic transmutations. It is one thing to write about seeing the world in a grain of sand, and eternity in a flower, etc., and another thing to make a convincing picture of the idea. Photography especially has generally worked best when it has tried to discover the differences between the world and a grain of sand, rather than belabor their similarities.

On the other hand, pictures that deal only with particulars are useless, if not impossible, and in one guise or another all art doubtless involves a contest between the specific and the generic. In photography Alfred Stieglitz was perhaps the first to make an overt issue of the fact that a photograph could have several meanings (or that the meaning of a photograph could have several faces) when he called his late photographs of clouds and other common subjects "equivalents," suggesting that they held optional, equal, alternative meanings.

The photographer of the past generation who has most tellingly pursued this aspect of Stieglitz's thought is Minor White. White's early career was also deeply influenced by his close contact with Edward Weston and Ansel Adams, and he brought to Stieglitz's concept technical mastery, a sophisticated sense of pure form, and a sensibility to the natural landscape.

In White's picture reproduced here, it is interesting to note that, in spite of the immaculately precise photographic description, one cannot be quite sure what objects are being described: stone, ice, ancient bones, desiccated leaves, fossilized wood—or what? Nor can we be confident of our own vantage point: Does this landscape lie at our feet, or a thousand yards beneath our plane, or in the wall before us? Nevertheless, it is clear that we are being shown a true and terrifying fact of nature: the irreversible and unreconcilable conflict that shapes the surface of our world.

ROBERT FRANK
American, born Switzerland, 1924

Political Rally, Chicago. 1956
18¼ x 12¼

Robert Frank's fine flatulent black joke on American politics can be read as either farce or anguished protest. It is possible that Frank himself was not sure which he meant. In 1956, he was still a relative newcomer to the United States, and his basic reaction might well have been one of dumb amazement as he investigated the gaudy insanities and strangely touching contradictions of American culture. A similar shock has been experienced by many others who have been suddenly transplanted as adults to this exotic soil. A few artists and intellectuals have even managed to turn the experience to their creative advantage, if their direction had not yet been too firmly set, as though a new country might be a substitute for being born again.

It is tempting to believe that Frank's emergence in the fifties as a photographer of profound originality was a measure of his success in meeting on artistic grounds the very difficult challenge of a radically new culture. It is in any case undeniable that his work underwent a remarkable change during these years. His earlier, European work had been in comparison almost luxurious: graphically rich, poetically elliptical, tender in spirit, half painterly in surface. By the time of Adlai Stevenson's second campaign these suggestions of homage to known artistic virtues had vanished: Frank's work had become dry, lean, and transparent. He had forged a new style: a weapon that was as clean and functional and American as a double-bitted ax.

The subject matter of Frank's pictures was not in itself shocking. Everyone knew about chromium and plastic luncheonettes, and tailfins and jukeboxes and motels and motorcycles and the rest of it. But no one had accepted without condescension these facts as the basis for a coherent iconography for our time.

Frank postulated that one might with profit take seriously what the people took seriously. His proposition worked because of the force and penetration of his vision. The photograph reproduced here is a perfect specimen of what was at the time a new genus of picture. The human situation described is not merely faceless, but mindless. From the fine shiny sousaphone rises a comic strip balloon that pronounces once more the virtue of ritual patriotism. On either side of the tuba-player stand his fellows, as anonymous and as dependable as he. It is somehow proper—funnier, sadder, and truer—that the occasion should have been an Adlai Stevenson rally.

ROY DeCARAVA
American, born 1919

Untitled. 1959
9 x 13⅛

It was perhaps André Kertész who first demonstrated the enormous photographic richness of the street. For a generation of photographers since, the street has been the true living theater, where slapstick and tragedy and all manner of sideshows have elbowed each other for performing room, and all of it accessible and free. Had the photographer written the script and directed the action, he could not have done so well.

During these forty years the theater of the street has changed, if we are to believe the evidence of photographs, and the changes in some ways seem to parallel those that have occurred in the formal theater. Plot has become increasingly tenuous, action has become progressively arbitrary (or sometimes invisible), and the players seem less and less often to represent distinguishable characters. Beyond this, both theaters have seemed to concentrate more and more on the odd and unexplained fragments of life, the mystifying pieces that are left over when we had thought the kit was fully assembled.

Roy DeCarava's picture is a case in point. Our reaction is suspended between terror and nervous laughter: What is this strange misbegotten creature, clinging precariously to the ledge of its briefcase? Perhaps it is a chessman in contemporary dress, a bishop perhaps, his folio filled with laws and Latin words. To which square will his principal move him next?

WILLIAM KLEIN
American, born 1926

Moscow. 1959
15¼ x 19¼

It was recognized long ago that so-called good photographic technique did not invariably make the best picture. Sometimes the gritty, graphic simplicity of the badly made photograph had about it an expressive authority that seemed to fit the subject better than the smooth, plastic description of the classical fine print. It was long assumed however that such pictures were invariably accidents—acts of God, by which news photographers and similar types were occasionally rewarded for their bravery and tenacity. The notion that such pictures represented areas of photographic potential that photographers of artistic ambitions might exploit was simply not entertained.

This situation changed in the 1950's with the rapid increase in the sensitivity of new films, which allowed pictures to be made in almost no light at all. Suddenly the world was flooded with photographs that resembled the image of a badly adjusted television screen. Some of these pictures managed a kind of clarity that depended not on modeling but on drawing—not on the description of surfaces, but the description of shape and line. Gradually some photographers came to understand and anticipate the behavior of their materials in the new circumstances, and to adjust their seeing accordingly, to grasp the content of the moment in terms of its broad and simple outlines.

The pictures produced were especially useful to the magazines, which were meant to be flipped through rather than lived with, and in which a picture's first impact was more important than its staying power. It must be admitted that not many of the photographs of this genre were of great interest the second time around.

The experiment, however, taught photography much about the basic and ancient issue of *indication*: the way in which an artist describes what he sees. And the most talented photographers involved—such as William Klein— extended our sense of what might be meant by a clear photograph.

BRUCE DAVIDSON
American, born 1933

Sicily. 1961
7¼ x 10⅞
Gift of the artist

It is a tribute to the tenacity of art-historical thought, if not to its receptivity, that the adjective photographic is still used to describe a style of pictorial indication that was perfected by Jan van Eyck four centuries before Daguerre. The fact of the matter is that photography has managed only infrequently and with difficulty (most often in the studio) to approximate the airless and precisely measured cataloguing of discrete facts that was so handsomely achieved by the painters of the fifteenth century. It is true that for a century most photographers actually did their best to match the neat and conceptual descriptiveness of traditional paintings; and they were regularly frustrated by the fact that their pictures so seldom looked quite as they should—meaning quite as they would have if rendered according to the pictorial conventions of the Renaissance. Judged by these rules, the photographs almost always seemed flawed: The sky was too bright, or the shadows too black; the foliage was not clean-edged and distinct, but burned out by flare and blurred by the wind; even mountains and stone monuments turned to putty if seen against a bright sky; often it was impossible to get the whole picture sharp; perhaps worst of all, the several elements of the picture were scarcely ever in proper hierarchical proportion to one another.

Toward the end of the century, with the rise of the casual snapshooter, the gap between most photographs and accepted pictorial standards widened radically. Most of the countless millions of little pictures that were made with George Eastman's new Kodak were so sketchy and obscure that only with the help of the legend on the back could one distinguish confidently between Aunt Margaret and the native guide. They were, however, pure and unadulterated photographs, and sometimes they hinted at the existence of visual truths that had escaped all other systems of detection.

It was many years before sophisticated photographers began to pursue with intention the clues that the casual amateur had provided by accident. When the attempt was finally made, it meant the beginning of a new adventure for photography. Characteristics of the medium that had formerly been only problems to avoid were now potential plastic controls, adding a new richness to the ways in which a photographer could describe the look and the feel of experience.

MARIO GIACOMELLI
Italian, born 1925

Scanno. 1963
11¼ x 14⅞

Pictures are memorable for different reasons: some because they show us what we did not know; some because they show us differently what we thought we knew; and some simply because we could later draw them tolerably well from memory. These last are pictures that satisfy the appetite of our eyes without necessarily requiring the collaboration of our intellects.

Mario Giacomelli's picture is a pattern of dark shapes on a gray ground, all revolving around the small boy who levitates within the halo of the worn footpath, framed by the trembling, wintry crones—two of a presumably endless line that scuttle past like the mechanical targets in a shooting gallery. The pattern seems at first glance almost symmetrical, but its balance is in fact not so simple: The frame has been shifted leftward from the boy to accommodate the weight of the three figures in the upper left-hand corner. These three vertical black strokes relate to the two black strokes of the figures above the boy's head, and the two formed by the feet of the foreground figure, all of these together describing one of the several triangles of which the picture seems to be constructed. The black squares of the windows in the upper right are equally part of the life and rhythm of the picture, as can be easily demonstrated by covering them with a swatch of gray paper.

Such analysis is of course irrelevant except as a way of wondering why a picture has succeeded. Analysis was surely useless to Giacomelli during the thin slice of a second during which this picture was possible, before the black shapes slid into an irretrievably altered relationship with each other, and with the ground and frame. It seems in fact most improbable that a photographer's visual intelligence might be acute enough to recognize in such a brief and plastic instant the pictorial (two-dimensional) significance of the action unfolding in the deep stage before his lens. Yet many photographers of recent years have educated their instincts so well that they do precisely this, and anticipate their results within narrow tolerances.

Inside the limits of these tolerances, photographers who are concerned with the ephemeral flow of things collaborate with luck. Luck is in the long run impartial; it will degrade many photographs by allowing small graceless errors in drawing or composition, but it will as often contribute an unforeseen detail or rendering that blesses the picture with the felicity of happy surprise. And whether good or bad, luck is the attentive photographer's best teacher, for it defines what might be anticipated next time.

GEORGE KRAUSE
American, born 1937

Untitled, San Francisco. No date
From the series "Qui Riposa." Begun 1962
6³⁄₁₆ x 4¹⁄₈

Since David Octavius Hill, photographers have haunted cemeteries. They have had good reasons. Nothing takes the light more gratefully than a sheet of weathered marble, and a company of stones rising from the greensward is an irresistible opportunity for exercises in the organization of planes in space. Furthermore, photographers (locked as they are to the eternal present) have found in old monuments a way of touching at least the shadow of the past.

Nevertheless, the subject need not be regarded as inexhaustible, and after Paul Strand's great tombstone pictures one might have suspected that cemeteries had become a dead issue for serious photographers. George Krause's long series entitled "Qui Riposa" thus came as a surprise and a puzzle. Made in the 1960's, the pictures were on the surface neither clearly innovative nor intellectually relevant; they should have seemed merely beautifully made photographs of conventional subjects. But they were moving and mysterious. It was as though Krause's pictures managed somehow to concern themselves not with social history, or old bones, or the art of the stone carver, or issues of abstract form, but with the presence of particular spirits.

Pictures that are formally or conceptually new can be discussed with relative ease, and perhaps with profit. More precisely, one discusses not the picture but some question of formal mechanics or intellectual posture related more or less closely to it, as a *curriculum vitae* or an obituary is related to a human being. Such discussions should not be scorned, for they can lead us closer to the picture's habitat. But the issue of the picture itself must finally be met without words.

GARRY WINOGRAND
American, born 1928

Untitled. c. 1962
9⅛ x 13½
David H. McAlpin Fund

Granted that simplicity is a virtue; beyond this it is too complex a matter to generalize about with impunity. One might add with reasonable confidence that simple does not mean vacuous, obvious, plain, habitual, easy, formulated, banal, or empty.

The ability to produce pictures richly complex in their description would seem to be intrinsic to photography; indeed, this characteristic might almost be considered a simple fact of the medium. Nevertheless, much of the best energy of photographers during the past seventy years has been dedicated to the task of thinning out the rank growth of information that the camera impartially records if left to its own devices, in favor of pictures which have been— for lack of a better word—simpler. This has been achieved in many ways: by printing techniques that have allowed radical manipulation, by soft-focus lenses, stage lighting, high-contrast negatives, exaggerated grain, corrective filters, or worm's- or bird's-eye perspectives; by photographing details close up, or two-dimensional subjects (such as old walls); or simply by printing the picture very dark or very light. Stated this baldly these various experiments sound less interesting and less productive (and simpler) than they were in historical fact. In practice the struggle for visual coherence is continuous; when one problem is solved, a more difficult one rises in its place.

In photography the formal issue might be stated as this: How much of the camera's miraculous descriptive power is the photographer capable of handling? Or how much complexity can he make simple? Or, conversely, how much diversity must he sacrifice for the sake of order?

Consider Garry Winogrand's picture: so rich in fact and suggestion, and so justly resolved; more complex and more beautiful than the movie that Alfred Hitchcock might derive from it.

NAOMI SAVAGE
American, born 1927

Mask. 1965
Line-cut photoengraving on silver-plated copper, 18¾ x 14⅛
Joseph G. Mayer Foundation, Inc., Fund

A thousand photographers must have looked admiringly at the copper halftone plate from which a printer had reproduced their work, envying the physical richness of its color and surface. It would seem, however, that none before Naomi Savage had focused on the fact that the copper plate was itself a variety of photographic print, and that as such it had an aesthetic potential that might be pursued for its own sake.

The plate reproduced here is a mutation of what the printing industry calls a line cut, as opposed to a halftone. The latter provides the illusion of a continuous gradation of tone by means of a fine variable pattern of black dots. The line cut—like a very high-contrast photograph—is based on a binomial (yes-or-no) evaluation of the subject. In it, thousands of tiny areas within the subject are measured for brightness and sorted into two categories: blacks and whites. The result is an odd but specifically photographic kind of drawing, in which a subtle change of contour can be recorded as the line of a bent wire, or as a joint between two flat planes. Although this indication seems at first glance strange and unfamiliar, its fundamentally photographic character soon reveals itself. It is, in fact, the same sort of image that one gets from an enormous enlargement of a sharp-grained conventional negative, which under a microscope is also a yes-or-no system.

Pictures like Savage's differ from traditional photographs chiefly in that the photographer must be able to enjoy a different kind of adventure. Rather than attempting to anticipate as precisely as possible the look of one's finished picture, the photographer arranges a procedure that will result in interesting surprises. It is less a matter of getting what one wants, and more a matter of being open to the possibility of wanting what one gets.

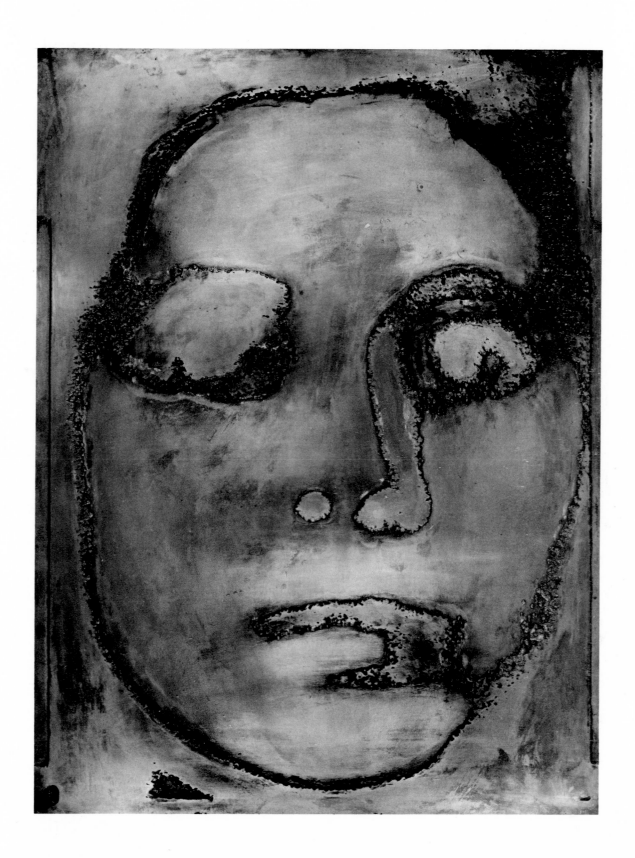

PAUL CAPONIGRO
American, born 1932

Ardara Dolmen, County Donegal, Ireland. 1967
7⅝ x 9⅞
Mr. and Mrs. John Spencer Fund

There are times when the process of photography seems invested with magic. At these times it is as though the camera points the photographer and leads him to the place where the camera will work its revelation. Paul Caponigro has expressed in words the nature of such occasions:

"Of all my photographs, the ones that have most meaning for me are those I was moved to make from a certain vantage point, at a certain moment and no other, and for which I did not draw on my abilities to fabricate a picture, composition-wise or other-wise. You might say that I was taken in."

To be "taken in" is a richly ambiguous phrase, evoking both the good Samaritan and the used-car dealer, but both of its meanings touch the idea of trust. It is in the spirit of trust that a photographer pursues the ephemera of appearances, believing that the appearance of things is not only often interesting but sometimes true, in a sense inaccessible to syllogisms.

What it is that makes a photograph truly work is in the end a mystery, as success doubtless is in any art. Finely hewn critical standards may help us explain the admirable, but between the admirable and the wonderful is a gulf that we can see across, but not chart. Photography, being only precariously under the control of the photographer's hand and mind, is a tool well-fitted for the exploration of those areas of our experience in which we recognize but do not understand meaning. Such meaning, if we understood it, might deal with issues as fragile as the contrast between the age of a stone and the freshness of the light. Not often, but occasionally, the meaning will be so nearly invisible that it will be present in one print and absent in another, only marginally different, made from the same negative, even though both prints may be exemplary by exacting academic standards.

Photography, if practiced with high seriousness, is a contest between a photographer and the presumptions of approximate and habitual seeing. The contest can be held anywhere—on a city sidewalk, or in a scientific laboratory, or among the markers of ancient dead gods.

ELLIOTT ERWITT
American, born France, 1928

Venice. 1965
9¼ x 13⅞

People who accept the evidence of their senses can be divided into three non-professional categories: saints, simpletons, and humorists. The mass of mankind is insulated from these several species of misfortune by virtue of the fact that they know better than to trust plain experience. For example, innumerable visitors to the museum in which Elliott Erwitt's picture was made saw precisely what he saw—or would have seen it if their catalogue had not told them that they were seeing interesting early- and middle-period works by X, Y, Z, and two anonymous masters. Faced with a contradiction between what he sees and what he reads, the average person will ignore what he sees.

No mechanism has ever been devised that has recorded visual fact so clearly as photography. The consistent flaw in the system has been that it has recorded the wrong facts: not what we knew was there but what has appeared to be there. This Achilles' heel of the medium has long been recognized by theorists, and has been identified as "superficial photographic accuracy," or "surface naturalism."

The only way in which this criticism might in theory be met with reference to Erwitt's photograph would be to claim that the picture demonstrates some general philosophic truth; *e.g.*, it shows that the true function of museums is not to exhibit pictures, but to house treasures.

Those who may like the photograph and dislike the explanation are free to regard the picture as a vision, perfect nonsense, or a joke—with the understanding that they are thus clearly identifying with one of the three groups named above.

KEN JOSEPHSON
American, born 1932

Season's Greetings. 1965
4¾ x 5
Gift of the artist

The primary technical issue that concerns people who make pictures is the relationship of the appearance of pictures to the appearance of the exterior world. The secondary (and closely related) technical issue is the relationship of new pictures to prior pictures. Both issues are familiar in a pure though simple formulation to children who have pondered the meaning of the breakfast food box which bears a picture of itself, which bears a picture of itself, *etc. ad inf.*

The general question has taken special forms in the case of photography. Throughout photography's history it has been generally assumed that for the purposes of visual knowledge a mountain and a photograph of a mountain are fundamentally the same thing. Presumably no one has really believed this, but it has been a convenient and useful fiction. It has not generally been in the photographer's interest to make an issue of the fact that the photograph of the mountain was only one man's opinion, for his customers did not want opinions. They wanted unchallengeable and objective truth. The popular formulation of this convention was expressed in the claim that the camera does not lie. The question of mendacity was of course not to the point; the relevant question would have been, Why were the camera's innumerable truths so fragmentary and so apparently contradictory? But to pursue this question would have been to undermine the authority of photography as faithful witness.

As long as the world and sharp photographs were considered virtually inter-changeable, the photographer of artistic ambition was placed in a very difficult position. It was incumbent on him to take pains that his work did not resemble the mountain too closely, lest it be mistaken for mere fact rather than art.

In the past generation, however, as photographic facts have proven more and more clearly to be relative and plastic, they have become artistically more interesting. They have become *aspects.* It is now possible for a photographer to look at his own sharp and precisely-rendered picture of a commonplace fact and wonder what it signifies.

Many of Ken Josephson's pictures attempt to deal directly with the question of how photographs differ from the real world. Any philosopher will point out that to try to explore this question in photographs is a logical fallacy, if not a fool's errand. Like a good photograph, this statement is clear, but not neces-sarily true.

JERRY UELSMANN
American, born 1934

Poet's House [First Version] 1965
13¾ x 9¾
David H. McAlpin Fund

Perhaps the first question that a young photographer must answer in defining his relationship to the medium is this one: Does he wish his hand to show, or will he try to make the picture look as though it were made by a machine? It is not a technical but an aesthetic issue. On one hand, no end of sly manipulation is dedicated to making the picture look more purely photographic; on the other hand, the obviously constructed photograph may be technically the result of purely photographic procedures. The question concerns intent and effect, not rules of procedure.

Synthesized photographs—pictures assembled from a number of separate parts—rarely seem the product of a machine. Such pictures were relatively common in the nineteenth and early twentieth centuries. They were made both by serious artistic photographers, who tended to construct their pictures after the models of important dead painters, and later by anonymous photographers working for the publishers of popular prints (generally souvenir postcards), who used the technique with a good deal more abandon and inventiveness. These latter pictures were generally concerned with bereavement, tragic love, or romantic conceptions of patriotism. In the early years of this century, the head of the late President McKinley, wreathed in flowers, often hovered like an exploding shell over the battleship *Maine*.

This tradition was abandoned about the time of the First World War. The early work of Paul Strand and the late work of Alfred Stieglitz established the philosophical basis for a concept of the medium that viewed such photographic cabinetmaking with ill-concealed contempt. To most of the photographic generation that came of age between the two World Wars, the notion of making one good photograph from two negatives was either nonsense or blasphemy.

It seemed indeed that the fundamental question had been answered once and for all, notwithstanding the formidable challenge of photographers such as Barbara Morgan, Clarence John Laughlin, Val Telberg, and others. The predetermined triumph of straight photography seemed a self-evident truth.

The self-evident truth was repealed in the early sixties, very largely on the basis of the work of Jerry Uelsmann, which convinced many younger photographers that the preference for pure photography was merely another superstition of the elderly.

Uelsmann was particularly well-equipped to make his challenge: He is a brilliant technician, who can print a half-dozen negatives on a single sheet of paper with such seamless precision that the result seems to be a simple record of a complex dream; he has an excellent graphic sense; and he takes a genuine, intuitive delight in the ambiguity of visual form. Conscious symbolism does not play an important part in his work; like most working artists he seems to believe that symbolic meanings will survive equally well with or without his personal concern.

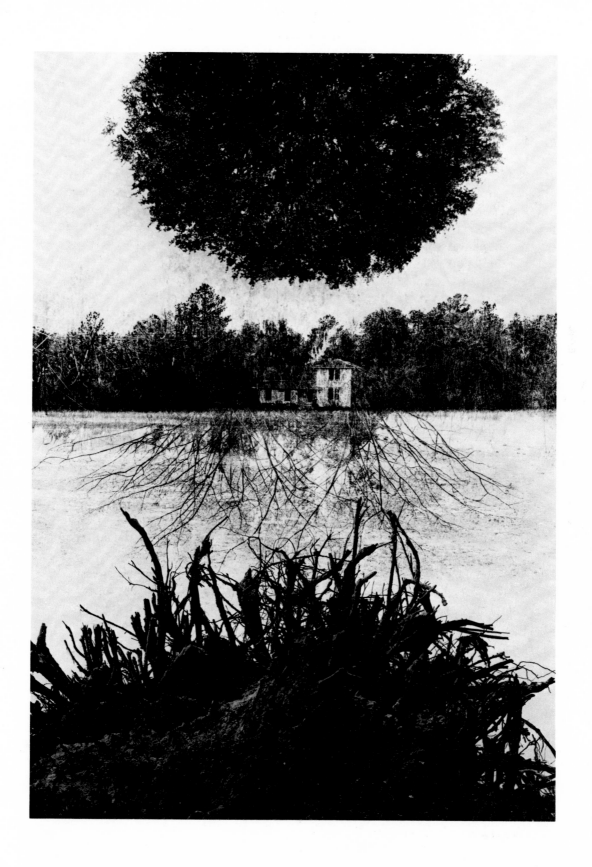

RAY K. METZKER
American, born 1931

Untitled. c. 1969
9 x 6¹⁄₁₆

A proof sheet is a rough print of several or many negatives on one piece of photographic paper. Most photographers have at one time or another discovered on their proof sheets congeries of exposures that have worked together to produce meanings distinct from those of the individual pictures. These meanings may depend on the fortuitous confluence of associations, or on a surprising redefinition of spatial relationships, or on both. Since the effect on the proof was not intended, the photographer has generally remarked it in passing, and promptly forgotten it.

Ray Metzker accepted the hint, and adopted the potential as a matter to be pursued with purpose. Since the early sixties he has developed a half-dozen variations on the basic concept of cumulative meaning through multiple imagery, employing in various combinations multiple and overlapping exposures, sequential exposures, repetition of the same or similar negatives, repetition with variation of tone, and so on—all of these combined both photographically and mechanically. The most ambitious of these pictures are exhibition pieces of remarkable complexity; others, more satisfactory for reproduction in book scale, are as simple as that shown here, which deals with the idea in its most basic terms: the consideration of two adjacent exposures as a single picture.

Viewing the two frames as one image effects a profound change in the visual character of the two component elements. Viewed singly, each exposure represents a figure on a plane which recedes into deep space; viewed together, the ground no longer recedes. Since the two figures are seen from the same distance, they are read as existing in the same plane, and the beach becomes a backdrop, as ambiguously located as the sky. Visually, the two figures are not resting but falling, or, perhaps more precisely, floating: as weightless and disoriented as two astronauts, or two unlikely angels in a Correggio dome.

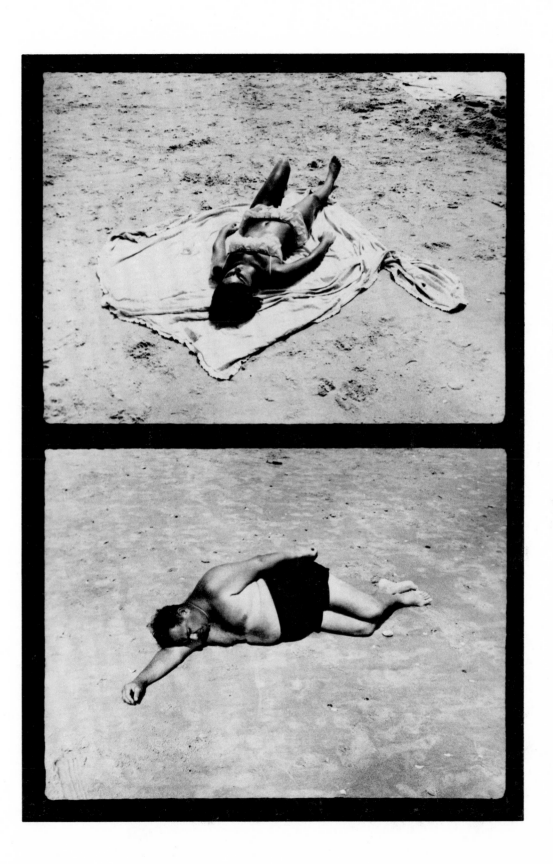

JOSEF KOUDELKA
Czechoslovakian, born 1939

Untitled. No date
7¼ x 11½
David H. McAlpin Fund

Josef Koudelka has spent as much as possible of his brief life as a photographer making pictures of the Gypsies of Eastern Europe. He has done this not because he was asked to, or because he thought that the world would be grateful, but because he has found the subject inexhaustibly fascinating, and perhaps also because Gypsies seem an endangered species, unlikely to survive much longer in Eastern Europe or elsewhere.

Although many of Koudelka's pictures contain information concerning the specific daily details of Gypsy life, such anthropological data does not seem their real point. They seem instead to aim at a visual distillation of a pattern of human values: a pattern that involves theater, large gesture, brave style, precious camaraderie, and bitter loneliness. The pattern and texture of his pictures form the silent equivalent of an epic drama.

The picture reproduced here is atypical in that its subject matter is of extraordinary narrative interest, but it shares with the rest of Koudelka's work a sense of myth and a rough-textured lyricism consonant with the rhythms of ancient ballads.

The young man in the photograph has been found guilty of murder, and is being led to the place of his execution. The officials that accompany him are not visible in the picture; he appears alone even in body as he advances toward the place. The handcuffs have compressed his silhouette to the shape of a simple wooden coffin. The track of a truck tire in the earth, like a rope from his neck, leads him forward. Within the tilted frame his body falls backward, as in recognition of the terror.

In the background the village fulfills its role as witness. Policemen keep the schoolchildren and a scattering of adults at the proper distance. The higher officers pace the ground, carrying nothing. The soldier at the left aims his folding camera, ready to record the event.

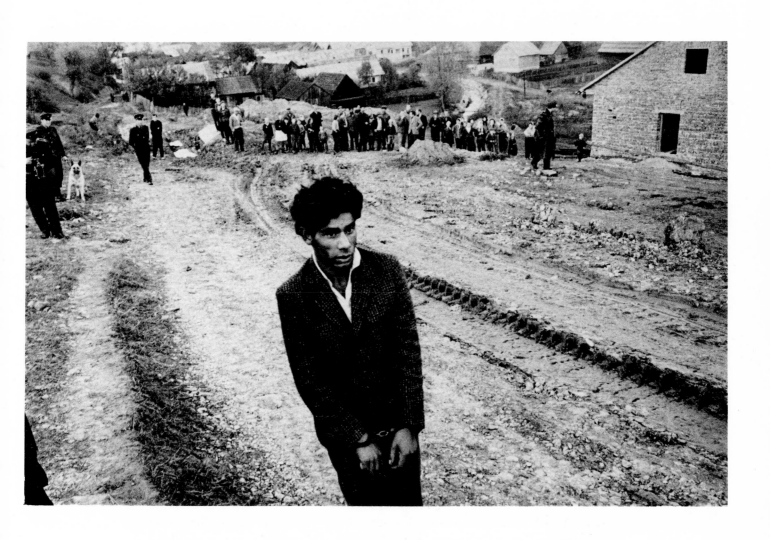

LEE FRIEDLANDER
American, born 1934

New Orleans. 1968
7 x 10¾
Stephen R. Currier Memorial Fund

Photography has generally been defended on the ground that it is useful, in the sense that the McCormick reaper and quinine have been useful. Excellent and persuasive arguments have been developed in this spirit; these are well known and need not be repeated here. It should be added however that some of the very best photography is useful only as juggling, theology, or pure mathematics is useful—that is to say, useless, except as nourishment for the human spirit.

When Lee Friedlander made the photograph reproduced here he was playing a kind of game. The game is of undetermined social utility and might on the surface seem almost frivolous. The rules of the game are so tentative that they are automatically (though subtly) amended each time the game is successfully played. The chief arbiter of the game is Tradition, which records in a haphazard fashion the results of all previous games, in order to make sure that no play that won before will be allowed to win again. The point of the game is to know, love, and serve sight, and the basic strategic problem is to find a new kind of clarity within the prickly thickets of unordered sensation. When one match is successfully completed, the player can move on to a new prickly thicket.

The larger, dark figure reflected in the shop window is (obviously) the photographer. Friedlander has made many such fugitive and elliptical self-portraits, partly no doubt because of the easy accessibility of the subject, and partly because of his fascination with transparency and reflection in relationship to the picture plane, and partly because such pictures remind him later of where he has been and what it felt like to be there. The small figure in the bright square over the photographer's heart is also the photographer, reflected in a mirror in the rear of the store. The man standing by the Mustang (like the donor in the altarpiece) is merely a bystander, wondering what the photographer might be looking at.

It would of course be possible to draw a diagram, with lines and arrows and shaded planes, to explain crudely what the picture itself explains precisely. But what conceivable purpose would this barbarism serve?

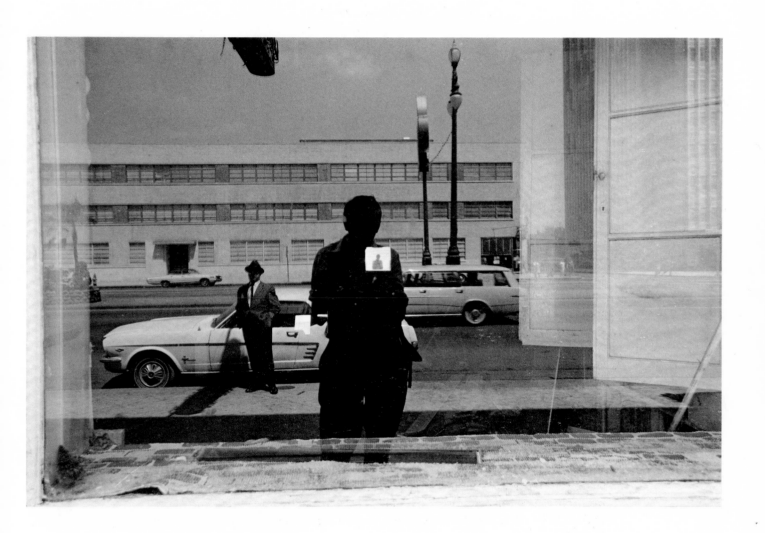

DIANE ARBUS
American, 1923–1971

Pro-War Parade. 1967
14¾ x 14½
Ben Schultz Memorial Collection. Gift of the artist

In a working life of less than a decade Diane Arbus effected a profound recon-sideration of photography's intentions. Her work turned away from the central concerns of the preceding generation. She valued psychological above formal precision, private above social realities, the permanent and the prototypical above the ephemeral and the accidental, and courage above subtlety. These intuitions were pursued with acute intelligence and fierce dedication—the latter almost perfectly concealed by humor, and a precisely calculated measure of self-deprecation.

With rare exceptions, Arbus made photographs only of people. The force of these portraits may be a measure of the degree to which the subject and the photographer agreed to risk trust and acceptance of each other. She was inter-ested in them for what they were most specifically: not representatives of philosophical positions or life styles or physiological types, but unique mysteries. Her subjects surely perceived this, and revealed themselves without reserve, confident that they were not being used as conscripts to serve an exterior issue. They were also doubtless interested in her. At times it may have been unclear which was the mariner and which the wedding guest.

The powerfully individual presences that exist in her pictures transcend the abstractions of role; indeed, the categorical badges that her subjects wear often seem disguises, costumes to conceal from the casual viewer a more intimate truth.

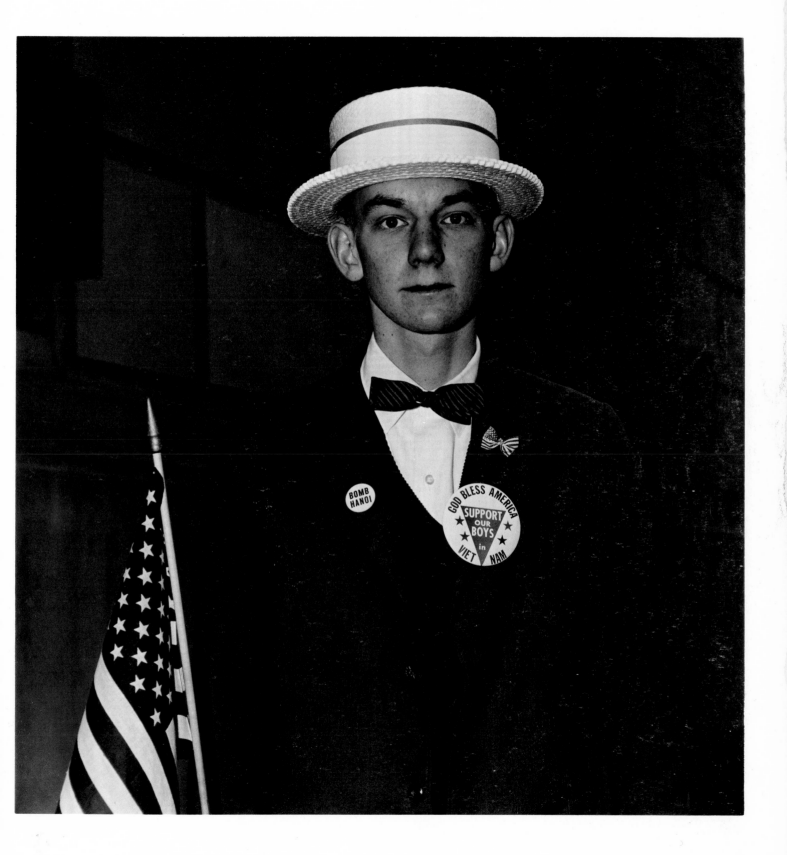

JOEL MEYEROWITZ
American, born 1938

Untitled. 1966
9 x 13¼
Ben Schultz Memorial Collection. Gift of the artist

Today's best photographers discover more and more within what would seem less and less. Who would have thought that a picture, a mystery, and a joke might be coaxed from subject matter as profoundly banal as that represented in Joel Meyerowitz's picture?

For better or worse, the nature of the content of such photographs seems progressively less susceptible to translation into words. Possibly the point can be demonstrated by suggesting in capsule form a number of critical approaches that would clearly be irrelevant:

1. *Cultural.* One's home is not so much one's castle as one's theater. Even the openings between rooms are designed to recall the proscenium arch. In this typical contemporary house the traditional main stage is dark and abandoned. The puppet theater with its modernistic tripod stand is relegated to a corner. Both have been superseded by the Kodachrome slide show, which is more consonant with our faith in science, technology, and results.

2. *Sociological.* When one visits friends who have fully adapted themselves to modern culture, one must be prepared for the possibility that the host will act only as projectionist, and the hostess only as stage manager. During the evening they may not appear at all in the pastel hues of real life, but only in fortified color, against skies of cerulean blue.

3. *Formalist.* The picture is essentially an arrangement of six potential picture frames, or windows, each of which has been cleansed of traditional anthropocentric "content" in order that their plastic relationship might speak without anecdotal interruptions.

4. *Symbolist, or Psychoanalytical. . . .* The central and brightest area of the image obviously reveals a sublimated mammary fixation. It is perhaps significant that the real woman in the picture is hidden from the waist up, and

DUANE MICHALS
American, born 1932

Death Comes to the Old Lady. 1969
Each about 3¼ x 4¾
John Parkinson III Fund

An individual photograph is locked to some past present, and is blind to what preceded and followed, except as these events are hinted at by relics and signs. Since the early days of the medium, photographers have sought ways to release their pictures into the flow of time, to involve them in duration, development, and climax. The multiple image, the photostory, the sequence, and some photographic books have attempted to encompass the continuity of time.

The photostory often foundered on the necessity of choosing between good pictures and clear narrative. In practice dull pictures broke the thread, regardless of how relevant their subject matter. Unlike film, in which time is truly plastic and continuous, a series of photographs is a sequence of arrests in time; the interstices are filled by the viewer, out of the knowledge and associations with which he surrounds the individual pictures. Each time a picture fails to involve the viewer, the precarious continuity is cut.

Duane Michals has adapted the photostory form to the function of recording original fables which touch on his intuitions concerning affairs of the spirit. The action is wholly and frankly stage-managed, which simplifies the matter of achieving both narrative clarity and visual interest. Surprisingly, we accept these tableaux as being in some sense real. Our acceptance entails an interesting paradox: We would be likely to reject the manipulation of the action if it dealt with natural phenomena; we accept Michals's playlets with the understanding that they are somehow sacramental: They show us the visible symbols of an invisible reality.

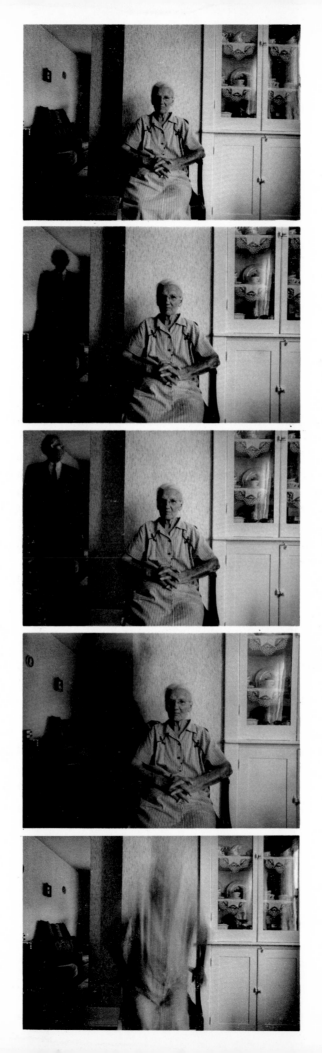

HENRY WESSEL, JR.
American, born 1942

Untitled. 1968
9 x 13½

Most photographs deal with meanings that seem intrinsic to their subject matter, or that are at least firmly attached to it by association or tradition. Many meanings are attached to mountains, for example, having to do not only with geography but with innocence, aspiration, retreat, gods and prophets, independence, and loneliness. Most pictures of mountains touch on such generic and inherited meanings, but if they are good pictures they also have a specific and unique meaning, which has to do with the particular experience of an individual artist at a particular place and time.

Other pictures do not concern themselves with known meanings, but begin with the substance of specific experience: existential fact. Those who make such pictures may hope that generic meanings will accrue to them in time, but this is not a prior condition for making them. The pictures are made to clarify an experience that was for unknown reasons compelling in itself. If this is managed successfully, and if others view the picture and say to themselves, Yes, it is true, then a meaning will probably be discovered in it, or attributed to it.

It would be only half true to say that anyone could have made Henry Wessel's picture, even aside from the fact that Wessel was probably the only one present when he made it. The basic point is that one would have had first to determine precisely what one meant by *it* (since the picture did not exist as a guide), and then consider it worth making. Granting these two conditions, almost anyone could have made Henry Wessel's picture.

A long generation ago photographers still worked under great black focusing cloths, which hid not only their faces but (it seemed) their magic secrets. Old photographers smelled of hypo, and had fingernails black to the cuticle, and were surrounded with an aura of esoteric alchemy.

In fact, the basic techniques of photography were never enormously difficult, and they have now become very easy. Like belles-lettres in a land of universal literacy, the art of picture-making is now open to everyone—or at least to anyone. It is today quite simple to make pictures that are as intelligent, cultivated, and original as the person who makes them—who remains, of course, the most interesting and undependable link in the system.

INDEX TO THE PHOTOGRAPHERS